Pictures & Tears

Pictures & Tears

*A History of People Who Have Cried
in Front of Paintings*

James Elkins

Routledge

New York and London

Excerpts from "A Rake's Progress" by W. H. Auden. Copyright © 1951 by W. H. Auden. Reprinted by permission of Curtis Brown, Ltd.

"On the Death of His Wife" by Mei Yao Ch'en, translated by Kenneth Rexroth, and "A Dream at Night" by Mei Yao Ch'en, translated by Kenneth Rexroth, from *One Hundred Poems from the Chinese,* edited by Kenneth Rexroth, copyright © 1971 by Kenneth Rexroth. Reprinted by permission of New Directions Publishing Corp.

Published in 2001 by
Routledge
29 West 35th Street
New York, NY 10001

Published in Great Britain by
Routledge
11 New Fetter Lane
London EC4P 4EE

Routledge is an imprint of the Taylor and Francis Group.
Copyright © 2001 by James Elkins
Printed in the United States of America on acid-free paper.

10 9 8 7 6 5 4 3 2 1

Library of Congress Cataloging-in-Publication Data

Elkins, James, 1955–
 Pictures and tears : a history of people who have cried in front of paintings /
James Elkins.
 p. cm.
 Includes bibliographical references and index.
 ISBN 0-415-93713-2
 1. Painting—Appreciation. 2. Visual perception—Psychological aspects.
 I. Title.
ND1143.E44 2001
750',1'1—dc21

 2001019659

Contents

Colorplates

Preface

THIS IS A BOOK about the ways that pictures can move us—strongly, unexpectedly, and even to tears.

Most of us, I think, have never cried in front of paintings, or even felt anything very strong. Pictures make us happy. They're bemusing. Some are lovely and relaxing to look at. The best are gorgeous, mesmerizingly beautiful—but really only for a minute or two, and then we're off to see something else.

Our lack of intensity is a fascinating problem. I'd like to understand why it seems normal to look at astonishing achievements made by unapproachably ambitious, luminously pious, strangely obsessed artists, and toss them off with a few wry comments. Are pictures really nothing more than spots of beauty on the wall, or (in the case of people in my line of work) index cards for intellectual debates? What does it mean to say that you love paintings (and even spend your life living among them, as professionals do) and still feel so little? If paintings are so important—worth so much, reproduced, cherished, and visited so often—then isn't it troubling that we can hardly make emotional contact with them?

The playwright Georg Büchner has a wonderful line about how dry people have become, and how parsimonious they are with the little bits that they do manage to feel. "We will have to start measuring out our spirit in liqueur glasses," one of his characters says, raising a tiny aperitif. Büchner is right: most of us have so few really

important, moving experiences with art that they stand out against the parade of routine afternoons in museums. These days a visit to the museum is an opportunity to learn something, and take a little sip of pleasure here and there. For some art, that's just fine. But many artists, from many periods, would be entirely disgusted with us.

That need not be so. Paintings repay the attention they are given, as I hope to show in this book: the more you look, the more you feel. This isn't a manual of tears—there's no way to teach strong reactions, let alone crying—but I have tried to capture the frames of mind that have led people to cry. Paintings can exercise a strange grip on the imagination, but it takes time and an openness to unusual experiences. I don't mean that just any picture could bring you to tears, or that it's a good idea to walk around museums with a handkerchief in your hand. Pictures have many things to say, and there is pleasure in even the most sober history lesson. From books on Monet you can learn that he began by drawing caricatures (an interesting business for someone who later spurned the human figure), and you can even learn that the little river that runs through his garden, which he painted many times, is named the Epte. I love history, and I wouldn't give up any of its richness. But paintings can also work differently, in a way that isn't easily put into words, that slides in and out of awareness, that seems to work upward toward the head from somewhere down below: a way that changes the temperature of your thinking instead of altering what you say. That other kind of experience can tunnel into your thoughts and bring tears to your eyes. It's the one I want to find in this book.

Happily, there is no lack of evidence that people have had strong responses to pictures. It turns out that viewers cried in front of paintings in the late Middle Ages and early Renaissance, and again in the eighteenth century, and again in the nineteenth, each time for different reasons and with different pictures. Few centuries, it seems, are as determinedly tearless as ours. Some people still do cry over paintings—a small group, nearly invisible in the masses of unmoved museum visitors. To find them, I posted inquiries in newspapers and journals, asking for stories from anyone who had responded to a

painting with tears. I wrote my colleagues and people I knew who cared for art. I suppose I didn't expect many replies (I might not have responded to such a letter myself), but I was surprised: in the end I got more than four hundred calls, e-mails, and letters. Most are confessions from people I don't know—a remarkable gesture, given that in many instances the writers had seldom shared their experiences. (Some had told their husbands and wives, but no one else until I had asked.) The letters are an invaluable source, because they show that the reasons people cried in past centuries are still with us, even though they are muted by collective disapproval. I refer to the letters throughout the book, and I've put a number of them in the Appendix.

Initially, I thought that crying would prove to be very personal, and that it would come in as many varieties as there are people. Again I was surprised, because the scattered stories started falling into patterns. I saw that people cry for particular reasons. Roughly half the cases converge on two kinds of experience that are very close to each other, and yet completely opposed. In one, people cry because pictures seem unbearably *full,* complex, daunting, or somehow too *close* to be properly seen. In the other, they cry because pictures seem unbearably *empty,* dark, painfully vast, cold, and somehow too *far away* to be understood.

From there the road begins to twist, and I don't want to give it all away. (It takes time to acclimate to tears.) The story progresses in stages: every other chapter, starting with the first, explores a single painting and someone who was moved by it. The alternate chapters (the even-numbered ones) are meditations on those encounters. That is the best way I know to show how pictures can be moving, and it lets me edge my way slowly toward the central problem of our nearly perfect tearlessness.

James Elkins
2001

Acknowledgments

Many specialists have helped me round up the available facts; I want especially to mention Ann Adams, Leah Garchik, D'Arcy Grigsby, Elizabeth Honig, Margaretta Lovell, Marilyn Lavin, Tom Lutz, Richard Lowry, David Morgan, Loren Partridge, and Tomaš Vlček. Frank Tarbox helped reorient the much-rewritten preface. Bertrand Rougé wrote me a series of brief letters without preparation, on the spur of the moment: all the more amazing, then, that they have crystallized so many of the thoughts that follow. Patricia van der Leun showed me how to break up the jostling pieces of my prose, which were clattering against each other like icebergs: she helped melt them into something more fluid. Gary Schwartz put my question ("Who has cried in front of paintings?") on his listserve on the Internet, and in *Het Financieele Dagblad,* a Dutch newspaper. (The inquiry also ran in the *New York Review of Books.*) Some of the letters I quote were written to both of us, or directly to Gary; he gets special thanks for tirelessly collecting, copying, and forwarding those letters. Thanks as well to my editor, Bill Germano, who gave me another year to try—once again!—to find the right tone between forensic detachment and maudlin mist.

But most of all I owe the many people, from all walks of life, who answered my requests for memories of crying. Without them, this book would have had no present-day witnesses to verify its history.

1

Crying at nothing but colors

All through the dark the wind looks
for the grief it belongs to
 — W. S. Merwin, "Night Wind"

TEARS! tears! tears!
In the night, in solitude, tears;
On the white shore dripping, dripping, suck'd in by the sand;
Tears—not a star shining—all dark and desolate;
Moist tears from the eyes of a muffled head:
—O who is that ghost?—that form in the dark, with tears?
What shapeless lump is that, bent, crouch'd there on the sand?
 ... away, at night, as you fly, none looking—
 O then the unloosen'd ocean,
Of tears! tears! tears!
 — Walt Whitman, *Leaves of Grass*

The scarlet would pass away from his lips and the gold steal from his hair. The life that was to make his soul would mar his body. He would become dreadful, hideous, and uncouth. As he thought of it, a sharp pang of pain struck through him like a knife and made each delicate fibre of his nature quiver. His eyes deepened into amethyst, and across them came a mist of tears. He felt as if a hand of ice had been laid upon his heart.

> "Don't you like it?" cried Hallward at last, stung a little by
> the lad's silence, not understanding what it meant.
> "Of course he likes it," said Lord Henry. "Who wouldn't
> like it? It is one of the greatest things in modern art. I will give
> you anything you like to ask for it. I must have it."
> — Oscar Wilde, *The Portrait of Dorian Gray*

MARK ROTHKO LEANED BACK in his armchair, studying her
through his thick glasses. His lips were pursed, his eyes half-closed in
a smoker's squint. She stepped forward.

It was a late afternoon at the end of November 1967, and the light
was failing. Even at midday, the Old Fire House studio on East Sixty-
ninth Street was a dark place, and Rothko had made it gloomier by
hanging a parachute over the skylight. He wanted a muted effect, so he
could study the faint mottled surfaces of his paintings with exacting
precision. At first his visitor could barely see. Then, slowly, out of the
darkness, she found the outlines of several huge unfinished canvases.

For a minute she stood still, looking up and down the height of
the paintings. They were almost fifteen feet tall, dark and empty like
the open doorways of some colossal temple. As her eyes got used to
the half-light, she began to see their surfaces—dull, blank, nearly
black. She walked up to one. It was tar black, veiled with washes of
deep maroon. The paint was not flat like a wall: you could look into
it, and it had a kind of watery motion. As she stared, the matte can-
vas moved, and flowered into shifting planes of darkness. It was
entrancing, and perplexing.

Rothko remained quiet even when she brought her face up to
within a few inches of the canvas. Ulrich Middeldorf, her professor at
the University of Chicago, had gotten her into the habit of always
carrying a magnifying glass when she went to see paintings; but she
couldn't bring herself to take it out with the artist sitting right there.
Yet there was something in those surfaces, something waiting to be
seen. They were elusive but mysteriously comforting. "I felt as if my

eyes had fingertips," she wrote in her journal the next morning, "moving across the brushed textures of the canvases." The more she stared, the more she felt at home. Then she was crying, and the two of them remained that way for several minutes: the art historian looking at the canvases through a blur of tears, and the painter smoking, watching her. It was a moment, she told me, of "very strange feelings," but mostly of relief, of perfect ease, of pure peacefulness and joy. After a few more minutes she dried her eyes and went over to begin the interview.

Today, Jane Dillenberger is retired from the Graduate Theological Union at Berkeley. She was trained as a conservator, but her interests took her toward the religious side of art; her business cards read JANE DILLENBERGER, ART HISTORIAN AND THEOLOGIAN. When she interviewed Rothko, she was a member of a religious discussion group that included Alfred Barr, then director of the Museum of Modern Art, and Paul Tillich, the Protestant theologian. The group was called ARC, for Art, Religion, and Contemporary Culture. The first thing she wanted to know that afternoon was if Rothko had ever attended.

No, he said, he thought it would all be very boring.

She knew the paintings had some religious significance, since they were going to be shipped to a chapel in Texas, and because there were fourteen of them—the same number as the Catholic stations of the cross. There had been talk of assigning each painting to a specific station. One would say "Crucifixion," and another "Deposition," even though they were all empty blank rectangles. Did he think of his pictures that way, as abstract stations of the cross?

Rothko told her he did not want titles, but that he had proposed putting numbered plaques on the floor in front of each painting. It wasn't clear what would happen, he said, but it looked as if the plaques were going to be put on the *outside* walls of the chapel, so no one would know which painting stood for which station. (As it turned out, no labels were used, inside or out.)

Jane wondered what to ask next: if he wasn't interested in what other people were saying about art and religion, and if he didn't care whether his paintings were identified with the stations of the

cross, then how *did* he think of his work? She knew that he was a friend of Barnett Newman's, and that they had often been compared to one another. Had he seen Newman's series of the *Fourteen Stations of the Cross?*

No, he had intentionally avoided them in order to remain, as he put it, "within my own experience." Was he then a religious man? When he first got the commission for the chapel, he told them he was not. "My relation with God was not very good," he told her, "and it has gotten worse day by day. I started out thinking the paintings should have a religious subject matter, but they became dark, on their own."

An odd idea, that paintings would get darker in order to avoid being religious. She thought again of the strange feeling, and her tears. Maybe she could draw him out by taking about the paintings themselves. She praised them, saying they were "darkly luminous," and wondered how he gave some a silvery gleam, and made others velvety dark. But he was not about to tell her what he was doing.

"It's just the paint," he replied.

She remained a while longer, talking about trivial things—his gallery, the rent on the studio—and left when the afternoon gave way to night.

Two years after that interview, in February 1970, Rothko slit his wrists in a little bathroom just off the room where they had been talking. Almost exactly a year after that, the chapel was dedicated in Houston. Rothko never visited his chapel, and no one will ever know what he would have thought. People said the pictures looked bleached and flat. Jane attended the opening and felt only a "blast of Texas light."

A visit to a damp chapel. There is no survey to prove it, but it is likely that the majority of people who have wept over twentieth-century paintings have done so in front of Rothko's paintings. And of all Rothko's paintings, people have been moved most by the fourteen huge canvases he made for the chapel that now bears his name. (The runner-up would be Picasso's *Guernica;* I think it would come in a distant second.)

It's hard to get a sense of the place from photographs, and I decided if I was going to understand what people have said about it, I had better spend some time there. I booked a flight for early April so I wouldn't be distracted by the Texas summer heat. (Houston has especially long summers, and the city has been known to provide *outdoor* air conditioning for visiting politicians.)

The chapel is in a quiet neighborhood, with clapboard houses and broken sidewalks shaded by overarching trees. On the outside, there is not much to see. It's all brick, with no windows—the kind of building that would look at home at the far end of a vacant lot. When I visited, the grass was overgrown from spring rains, and the grounds already had the exhausted look southern towns get when they have been beaten all summer by heat and humidity.

Officially, the Rothko chapel is an interfaith church, hosting a range of denominations including the local chapter of Zoroastrians. Between scheduled events, it is open as a one-room museum, giving it an unusual mixture of religious and artistic purposes. There's a small foyer with a reception desk and a shelf of the holy writings of various faiths.

From the foyer two doorways, one on either side, lead directly into the chapel's main room, an octagonal space with Rothko's paintings hung all around (see colorplate 1). When I first walked in, it was warm and humid and very still. Four people were meditating, two in lotus position. One was looking at a stretch of white wall between two of the paintings. Another had his eyes closed. An attendant, an elderly woman, sat on a folding chair reading a book. A mourning dove called from somewhere outside. Its toneless voice seemed to come from the wall itself, as if it had seeped through the aging bricks.

I was surprised at the simplicity of it, the water-stained walls and the stray cobwebs and the giant paintings. In photographs like the one I am reproducing here, the paintings have luscious dark surfaces, full of shine and mystery. They look very professional. Jane's story had led me to think I was in for a mesmerizing experience, and—who knows?—I thought I might even cry. But the real Rothko chapel is not overwhelming, at least not at first. I may have been tired from the

flight, and a long rush-hour drive from the airport, but the paintings looked worn and flat and dull—like pots scrubbed too hard with steel wool. They were weak and frail, like that dusty black fabric that is stretched over old audio speakers. Rothko's subtle modulations had faded in the "blast of Texas light," and the pictures looked exhausted. It did not seem a likely place for revelation.

Even so, it was a peculiar experience, standing in an empty room surrounded by fourteen gigantic purplish-black canvases. I turned around, to see the paintings behind me, and then I turned again. Which way was the front? I realized I needed to get my bearings, and so I sat down on a bench facing the twin entrance doors. That way I could look at just one canvas at a time, and put off seeing the whole room.

The painting I was facing has a huge vertical black rectangle, almost twice the height of a person, with a dark maroon frame painted around it. (The paintings themselves don't have any frames, and their sides are painted to match their fronts.) The black rectangle is up at the top as if it has floated there against the law of gravity. Like the other paintings, the one I was looking at has no subject, no title, and nothing to see except the hard-edged black rectangle. The Rothko chapel paintings are said to be entirely blank, and I wondered how long I could look at this painting without getting bored.

It took a moment or two, but I realized that Jane was right: the pictures are not painted flat black like a wall. In the painting I was looking at, the lower edge of the black region was straight and horizontal—Rothko used masking tape to make a perfect line—but then it was blurred a little with a light purple line, which he painted freehand. The lighter line undulates as it crosses the width of the canvas, and softens the geometric line. There is also a place, just above the double line, where the black area is splattered with maroon paint. Rothko's brush must have slipped, and he decided not to clean it up. The maroon itself is unevenly painted. It looks like an old sepia photograph of the sky on a cloudy day: soft matte patches drift by, and shiny streaks move up and down, like rain falling through clouds.

I looked around. Each of the paintings had a few faded marks, splotches, and odd shapes. None was entirely blank. Many reminded

me of dark skies or deep water. (Later, someone told me a visitor had said they are like windows into the night.) I got up and walked over to the next painting, the one just to the right of the right-hand entrance door. It is all purplish black, with no painted border. It is full of streaks: cascades of paint that look again like rain, and dull passages that reminded me of high, flat cirrus clouds. My eye was drawn to a defect, right about at head height: something had damaged the picture there, and it had been poorly patched, leaving a purple circle like the fading afterimage of a bright light. I sat down and looked at that painting quite a while, just looking up and down, thinking of clouds and quiet, fine rain.

Outside, the forecast was for rain. It had been cloudy and threatening since I had arrived in Houston, and the dull gray light from the rainclouds was fading into a warm evening glow. The chapel is lit by natural light from a skylight, and as it got darker the top of the painting began to shine. The lower portions got very dark. It looked as if the streamers and fine lines at the top of the painting were falling into a deep gloom down below. I found myself staring directly across into a featureless darkness, with a shape so uncertain it shifted each time I blinked. The painting took on an irresistible motion, sliding downward into a formless shadow. I looked around. Three of the people had gone. One remained, sitting with his eyes closed and his palms upturned on his knees.

It was getting late. I got up and walked around the room looking at each painting in turn. Each one had its quirks and "errors," its particular stains and flaws. One painting has the unmistakable outline of a soft, round-edged rectangle, like one of the floating shapes in Rothko's earlier paintings. He had tried it, and then painted it out. It remains as a ghost, black on black. Just to its left is a painting with a high constellation of shining black sparks, like fireworks that darken into embers as they fall, leaving dark trails as they disappear, black in black. The sparks are little knobs of paint, like the cinders on a railroad track.

As the evening turned into night, I kept walking from one painting to the next, playing at seeing rainclouds or afterimages. I spent an

hour making a little sketch map of all the pictures, noting their quirks and half-hidden forms so I could remember them. I had it in mind to master the chapel by getting to know each painting, so I could say I had really seen it. It seemed like a good idea—like reporters, historians are trained to take notes—but I began to feel unsure of what I was doing. It dawned on me that I was trying too hard, being too systematic. There is a novel by Günter Grass, *Dog Years,* in which a little boy studies flocks of starlings until he can tell each bird from all the others. It struck me that that was what I was doing with Rothko's paintings: something clever, perhaps, but also something misguided. In a way the chapel is also a gathering of identical objects, just like a flock of starlings. It isn't a code that can be broken by finding tiny marks and flaws—but that evening I didn't know how else to look at it.

Finally it was closing time. The young man who was meditating or praying got up very naturally and quickly, as if he had only just sat down, and walked away. I went outside into the warm twilight. A squirrel was walking along the rim of a reflecting pool. The young man got into a red car and drove away. I was happy to be able to see other colors, and to look at things in motion. I watched as the squirrel tried to lean down and drink from the pool, flicking its tail back and forth to keep its balance. I was tired from looking so long at so little, and I thought that things like squirrels and red cars are the simple pleasures of vision that Rothko's paintings deny.

The confession books. The next morning I avoided the chapel, and went instead to the chapel office. Ever since it was dedicated in 1972, the chapel has kept books filled with visitors' comments. There are now several books with a total of around five thousand entries. I picked a book at random and began to read. Almost immediately I found an entry that tallied with my own experience: someone had written that his eyes "got lost in the shifting fields, finding forms and shapes." A number of entries were by children, and it sounded like they wouldn't have visited if their parents hadn't insisted. "I liked it," one wrote. "I didn't like it," wrote another. One entry, written in a

childish handwriting, said simply, "I believe that what I saw had only one Picture. A Cat." Reading that, I was sure that what I had been doing the day before was wrong. The paintings don't have Cheshire cats in them, any more than they have rainclouds. Perhaps I had been overanxious to uncover a meaning that wasn't there.

The visitors' books also record comments by people who think the pictures *are* uniform, like painted walls, and that they don't harbor any shapes at all. For those visitors blankness is the whole point: the pictures say nothing, and simply reflect whatever thoughts a viewer brings to them. One person wrote simply, "We all need to look at a tabula rasa." That seemed right for the people who had come to meditate. The ones who hadn't closed their eyes had been staring impassively, the way you might stare glassy-eyed at a book you aren't reading.

I felt I knew that the paintings were not meant to be looked at quite as closely as I had, but I also didn't want to think they were nothing more than empty mirrors for any stray thought. Not looking is relaxing, but then it doesn't matter much what you're in front of. Look too closely, and the paintings turn into catalogs of brushstrokes and cats and colors. Rothko, I think, was aware of that tension, and I imagine he sometimes clung to the little idiosyncrasies in his canvases, as I had done. After all, it is comforting to be able to recognize each painting and tell it apart from the others. That way each painting has a personality; it says something different from what the other paintings say. It's like one bird in the flock of starlings, which suddenly has its own style and its own personality.

But at the same time, I think Rothko was trying to learn how to live with pure unrelieved darkness. The paintings have differences, but he tamped them down. As he left them, they are somewhere in between individual images and uniform blanks, and that makes them exceptionally difficult to see. A viewer is bound to notice the little marks and mistakes, and to wonder what they might be—but it is also clear that they aren't anything, that they do not add up to anything. That first day I had given up because it was finally just too hard to take in so much darkness (whole walls of it), and too exhausting to

play the game Rothko played, toying with a world of pure featureless black. It had felt a little dangerous, like playing at drowning.

On the second day I also spent some time talking to people who had worked as attendants and guards, some for a decade or more. They told me most visitors stay only a few minutes. They take a tour around the room, and then they're on their way. Judging by the visitors' books, the majority of visitors don't get involved at all. The books are full of simple positive comments. "It's very, very pretty," one person writes. Another says, "it is an oasis of peace and serenity," and another "the Chapel is a very beautiful and quiet place." People find it a "haven," wonderfully calm, tranquil, refreshing, relaxing. A place filled with "infinite peace," another remarks. "What an important, beautiful place," one person writes, "it makes so much sense, and heals so perfectly."

Other visitors stay longer, and end up sitting on the benches, staring vacantly into the dark canvases, meditating, praying, or dreaming. They also leave their traces in the visitors' books; one says, "I have not meditated so long—so peacefully—in quite a while. I could hardly pull myself away from this place." "It can be used as a tool for relaxing," another says.

The long, daydreamy visits made good sense to me: after all, it would be hard to keep concentrating after the first few minutes. I wondered more about those short visits—could it be that people turned and left out of a sense of self-preservation? Maybe they got a dim feeling that the place is not as serene as it appears, or that they wouldn't be happy if they stayed longer. The attendants told me that the visitors who are most moved are the ones who stay for more than a few minutes, but do not sit and meditate. They look intensely, and for a long time. Again that made sense: in the first few minutes, the chapel can't be much more than a novelty. In contrast to the streets of Houston it is quiet and relaxing, and it might even seem serene. But I think visitors who keep looking, and try to imagine what Rothko could have intended, might begin to notice how dark his mind was, how drained and empty. The paintings are like black holes, absorbing every glint of light, sopping up every thought. Wherever you turn,

they face you, and show you nothing but blackness. They say nothing and depict nothing: they just bear down. I had felt some of that the day before, and I had started taking notes partly to avoid thinking about it. Other people just close their eyes and meditate, released from Rothko's weird unhappiness into their own more pleasant thoughts.

A few viewers report that turning point, the moment when they have seen everything they can, and they sense it's time to look away. "So absolutely antagonistic and chilling," one visitor writes. If those people then stay on, if they stick it out and keep looking, they begin to feel much stronger emotions. They are the ones most likely to cry. Their entries in the visitor's books are usually short—a line or two. "It is a visually and viscerally stunning experience," one writes, and another says, "I can't help but leave this place with tears in my eyes." The books have dozens of similar entries: "Was moved to tears, but feel like some change in a good direction will happen." "My first visit moved me to tears of sadness." "Thank you for creating a place for my heart to cry." "Probably the most moving experience I have had with art." A few are very brief, and I wondered if the visitors were still crying as they wrote:

"This makes me fall down."

"The silence pierces deeply, to the heart."

"Once more I am moved—to tears."

"A religious experience that moves one to tears."

"Tears, a liquid embrace."

And the saddest one: "I wish I could cry."

Later in the afternoon, when I had finished reading the visitors' books, I went back in for a last look. The paintings, and the place, looked terribly sad. Two more people were there meditating, sitting on the black cushions the chapel provides for that purpose. A woman walked in, pushing a stroller, and sat down on one of the cushions. Her baby cast a few bewildered looks around the ceiling. In a few minutes he began to whimper. At first she reached out a hand and tried to calm him, without moving or opening her eyes. But he was restless, and at last she got up and wheeled him out. She smiled happily to me as she left.

Rothko's troubled reputation. The majority of the comments in the visitor's books are heartfelt and openly emotional. They are not the kind of reactions you might expect from visitors to the museums of modern art in New York, Chicago, or Los Angeles. Emotional responses are part of the mystery of Rothko, and the reason why he has always been a bit different from the other painters in the New York school.

In the history books, each painter of Rothko's generation has a "signature style": Jackson Pollock is all wild bravado; Robert Motherwell is genteel and decorative; Clyfford Still is dry and rocky; Barnett Newman huge and overambitious; Hans Hofmann harsh and vulgar. They were all working on their places in the history, weighing New York against Paris, thinking of what American art could be. They were testing the limits of abstraction, and investigating how space and ideas might exist in an abstract painting.

Rothko doesn't quite belong. He was doing those things, and he has a signature style—his softly glowing rectangles—but he was also working on another project, one that hasn't sat so well with art historians: he wanted to make private religious art. He was trying to create paintings that would have a religious effect on viewers, and crying was the principal sign that people had gotten his point. As far as I can tell, viewers have always cried at his paintings; the stories begin shortly after he found his signature style in late 1949. Since then people have wept in galleries, in museums, and even looking at unfinished paintings in his studio, as Jane Dillenberger did.

Rothko is also the only major twentieth-century painter who accepted the possibility that people might cry in front of his paintings. "The people who weep before my pictures," he said in an interview in 1957, "are having the same religious experience I had when I painted them." He did not say whether he cried over his own paintings, though I would like to imagine he sometimes did. His idea of "religious experience" was very melodramatic—just the kind of over-the-top notion that could lead to tears. "I'm interested only in expressing basic human emotions," he said in the same interview,

"tragedy, ecstasy, doom, and so on—and the fact that lots of people break down and cry when confronted with my pictures shows that I *communicate* those basic human emotions."

In a talk with Motherwell, Rothko said that "ecstasy alone" is the point of painting: "art is ecstatic or it's nothing." That is a very unguarded claim, and I believe that Rothko meant it pretty much as he said it. Usually he shied away from anything as clear as that, and he also denied his paintings had religious meanings—or any other meanings, for that matter. As his biographer James Breslin puts it, "when Rothko wasn't urging the religious import of his paintings, he was denying the religious character imputed to them by others." He'd say, for example, "I am not a religious man." Art historians have generally taken Rothko's evasiveness as a strategy, but of course it is also possible that he meant what he said about religion, ecstasy, and tragedy, even when it ended up sounding silly.

Over the years, Rothko's public has divided into viewers who are affected in some way, and those who are not. People who think of the New York school as the defining moment of painterly abstraction are put off by Rothko's religious aims. If the New York school is all about the flatness of the "picture plane," as Clement Greenberg famously insisted, then Rothko is one of its bigger embarrassments. His work is interesting from Greenberg's point of view, but it is less challenging and important than Pollock's. If Rothko had kept quiet and let the critics do the talking, his reputation might have grown more smoothly, and he might even have been initiated into the first rank with Pollock and de Kooning. But he kept insisting on religion, tragedy, ecstasy, and doom.

From a historian's point of view, Rothko was simply mistaken about what he was doing. He thought his work was about religion, but it was about nonobjective painting in the wake of surrealism. He used words like "ecstasy" and "tragedy," but he should have been using words like "picture plane" and "color field." The schism runs deep, and people who feel strongly about Rothko's religious or emotional meaning are excluded from serious academic discussions. Art

historians occasionally make a point of saying they don't "get" the teary, religious Rothko, even though they do "get" Rothko the ambitious abstract expressionist.

Why theories about Rothko don't work. It's all very tidy to say that Rothko was nonobjective, and that his paintings are about painting, or about the flat canvas. But what *are* those blank rectangles, exactly? Even people who don't "get" Rothko's ideas about ecstasy and religion still want to know what his paintings mean. Breslin says the rectangles may be open graves: "some of Rothko's narrower horizontal rectangles," he suggests, "pull us into a dark, choking, gravelike space." Other paintings remind him of "windows or doors or empty stages or tombstones or landscapes or geometrized human figures, as many viewers have testified." There is some evidence for the open-grave theory, since Rothko reported that when he was a child he dreamt of an open grave. His friend Al Jensen knew about that dream and thought that "in some profound way" graves might be "locked into his painting."

There are other theories, just as provocative. The art historian Anna Chave has argued that some of Rothko's paintings preserve faint echoes of figural shapes; and in 1975 Robert Rosenblum proposed that Rothko's color fields are the final dying echoes of romantic landscape painting, as if Rothko had put a magnifying glass to some painting of a sunset, and copied the colors on a gigantic scale. The painter Sean Scully endorses Rosenblum's view in a review of a recent Rothko exhibition; for Scully, despite the gulf between romantic narratives and modern abstraction, "with reference to Romanticism," Rothko "has it all." I find theories like Breslin's, Chave's, and Rosenblum's can be convincing for certain paintings, but Rothko knew his success depended on avoiding any single explanation. The rectangles are like all kinds of things, but they aren't really anything; and as that conviction settles in, the paintings become stranger.

Rothko's signature blurry rectangle is a particularly vexing invention. It is a shape that should, by all rights, be something. We don't expect to see things in Pollock's daggles and spatters, or de

Kooning's curves and splashes. But Rothko's paintings are like out-of-focus portraits: you can see a hazy shape against a background, but you aren't allowed to see who it is. The basic idea of a single shape on a rectangular canvas is irresistibly reminiscent of all kinds of ordinary recognizable subjects: a person's face, outlined by darkness; a house in a dusky landscape; the shadow of a figure, thrown against a mottled wall; a teacup on a shadowed tablecloth.

At a fundamental level of human existence, the shape and its background are reminiscent of a thing, any thing. Rothko gives us an imperfect memory of an object and its background, and withholds the object itself: a deeply disappointing move because it fails, deliberately, to make human contact with the way the world is arranged. You might say he shows us, in the most profound and general sense, what loss looks like. Or as he put it, the paintings have "intimations of mortality." They are insistently empty, and that is disturbing.

Breslin comes back repeatedly to feelings of loss, uncertainty, and despair. He sees "ominous shadows, vacant expanses, frayed or torn edges, narrow bars holding two shapes apart, stern blacks"; for him they mean separation or loss. He finds sadness even in the supposedly cheery canvases Rothko painted in 1949, the year after his mother died. "He began to paint his deprivation," Breslin observes, "and he painted his deprivation as *full*—of colored light, sensual pleasure, fluctuating movement, charged feeling." Jane Dillenberger reports a similar experience when she saw the garish paintings Rothko did in the two years before his suicide. For her the occasion was already tragic: it was April 1969, and she had recently lost a son. She decided to buy one of Rothko's paintings as a memorial, and she asked Rothko if he would sell her a painting. He told her he was under contract not to sell outside his gallery. So she went to the gallery, expecting to find the dim monochrome pictures he had recently started to paint. Instead she found brilliantly colored canvases in garish reds and yellows. "I just sat there in fear," she told me. "I was literally shaking." For her, the paintings just "said death." She told an assistant, "Someone needs to get to him." He went on ten months before he committed suicide.

The facts of Rothko's life have driven people to tears: the fact that the rectangles look like graves, that Rothko suffered losses, that he finally killed himself. That way of responding is literal minded and very melodramatic. Most writers prefer to keep a little more distance between themselves and Rothko's weepy world. Some historians prefer to say the paintings are not about death and loss as much as they are about the *idea* of death or loss. Leo Bersani and Ulysse Dutoit, both professors at Berkeley, have written a meditation on the idea of loss, in a book called *Arts of Impoverishment*. They say Rothko promises us something transcendent, beyond the world of viewers, painters, and paintings, but nothing appears. Viewers then begin to wander among the colors; they don't discover any sudden revelation, and so they turn inward, and start thinking of the ways their own minds are made of empty frames, vague hues, and shifting distances.

It is a plausible idea, but it leads Bersani and Dutoit into philosophic abstractions: "Under the pressure of that blinded seeing," they write, "the viewer's self can momentarily be reduced to the cognition of consciousness of the world—of the self and nonself—as nonoppositional, as boundary-free fusions or, in other terms, the cognition of being as incommensurable with identities." Despite their dry writing, I know what they mean, and I have felt that way myself; but such abstractions can only be part of the story. *Arts of Impoverishment* is an emotionally distant book; there is no "ecstasy" or "tragedy" in it, and the authors agree with viewers who find the Rothko chapel a place of "reposeful meditation." They report standing in the chapel, thinking about the shadow play between the paintings' vaguenesses and the mind's vaguenesses, and they conclude Rothko's achievement is "rigorously secular." For them the paintings evoke philosophy, the relation of mind and world, and not an ecstatic transcendental religion. Nothing is known for certain, they say, in Rothko's universe: neither ourselves, nor our minds, nor the shape of our thoughts. Rothko makes a "transcendental promise," but he breaks it and gives us ourselves, reflected in a darkened mirror.

Those are dire conclusions, yet I wonder if they aren't a little easier to accept than the possibility that Rothko *does* make a "transcendental promise," that his art *is* religious, and that it could move

viewers to more than philosophic reflection. The driving force behind Dutoit and Bersani's book is a sense of absence, of "impoverishment" as they say. It's what really matters about Rothko's work, but somehow in the course of being made into an academic treatise, it gets clothed in cold abstractions. There *is* something disturbing about those empty rectangles: they're unsettling because they are empty, because they start out to be something—a thing and its background—and end up being nothing. Bersani and Dutoit make Rothko into an academic, puzzling out the existential implications of his own blank canvases. As far as I can see, Rothko entirely lacked the calm, scholarly clarity that could give sense to a very low temperature phrase like "the cognition of being as incommensurable with identities." For Rothko it was important that the shifting emptinesses are awful, "tragic." The paintings are only pleasant if they are painted philosophy; as experiences, they are nearly unbearable. *Arts of Impoverishment* also has a good discussion of Beckett, who fits the mood of static melancholy much better. Rothko's paintings strike a different note, a nonphilosophic one. As Wittgenstein said, philosophy can be less a cure than an illness in its own right.

The visitors' books attest that the really hard part about looking at Rothko is just looking: looking, and resisting, as long as possible, the temptation to say what is missing. The really unendurable fact is that meaning is what's absent, and people who intellectualize Rothko use history and philosophy as a balm that soothes the nameless loss. "Tragedy," tears, and religion sound over the top, but Rothko *was* that way, and anything more sober may well be a misuse of words.

The majority of the testimonials at the Rothko chapel were written by people who cried over the loneliness or emptiness of Rothko's paintings. Some thought of death, as Jane did, and others felt a kind of anonymous loss. Strangely, there are also people who cry for the opposite reason: they think Rothko's paintings are too full, and there is *too much* going on.

From a distance a Rothko painting can be pleasing and even pretty. But if you walk up to it, you may find yourself lost in a smear of colors. The paintings are like traps: harmless looking from a distance,

disorienting or bewildering from nearby. Most Western paintings get flatter the closer you look: if you're too close, you start to see the canvas weave and even the dust that covers the paint. But if you step too close to a Rothko, you may find yourself *inside it*. It is not hard to see why people say they are overwhelmed. Everything conspires to overload the senses: the empty incandescent rectangles of color, entirely encompassing your field of vision; the sheer glowing silence; the lack of footing, or anything solid, in the world of the canvas; the weird sense that the color is very far away, yet suffocatingly close. It's not a pleasant feeling: the painting is all around you, and you feel both threatened and comforted, both cushioned and asphyxiated. Jane says when she looks at Rothkos she walks backward without thinking what she's doing, and she has bumped into people and even tripped and fallen over.

There is reason to think Rothko wanted people to feel this suffocating feeling, as well as to think of loss or emptiness. Sometime in the mid-1950s, he was asked how close people should stand to his paintings, and he answered "eighteen inches." (Barnett Newman had also made a similar request, and Rothko may have gotten the idea from him.) People have said that Rothko was joking; but I think he meant it, even if he didn't mean exactly eighteen inches. In my experience, viewers do tend to congregate about two feet from the canvases—about the distance you'd stand from someone in a crowded bar, or on an elevator.

In an interview in May 1951, Rothko said he painted large canvases because they put viewers inside the work: "you are in it," he said, "it isn't something you command." His large pictures sweep forward, curling around you, filling the very air you breathe with color. It's as if the world has been melted into washes of thickened light. The delicate edges of Rothko's color fields are just visible in peripheral vision, reaching out like smoky fingers. The effect can be exhilarating—it may be part of what Rothko meant by "ecstasy"—and disquieting. Viewers can feel "hemmed in," as Breslin puts it, "threatened by fusion, by an absorptive, smothering unity."

This close-up experience is wilder, less detached, than the one people have when they keep their distance. Each painting behaves a

little differently. When there are bars of color laid on top of one another (as in Rothko's earlier "signature style" paintings), the bars can seem oppressive, as if they had tremendous weight. Some paintings have rectangles that shove forward—frequently at the level of your stomach or head—or dark panels that collapse as you get close. Bright colors push outward at you, pulsing and refusing to snap into focus; dull colors subside like glowing piles of mulch.

As an experiment, I walked up to one of Rothko's canvases in the chapel and stood eighteen inches from it, pressing my shins against the low metal guard rails. That is closer than I like to stand when I am talking to someone, and the result was an uncomfortable feeling of intimacy—"the perfect pain of being so near," as one visitor put it. Vague shapes presented themselves for my consideration: some looked distant, and I peered at them as if they were far-off mountains in a landscape; others seemed very near, right in front of my nose. I kept looking around, focusing and refocusing my eyes to fix the shapes I thought I saw. I felt coddled, nearly smothered, in a smooth but impalpable softness. I remembered that one historian compared Rothko's paintings to an infant's sense of its mother's breast. That would be right, except for the utter lack of anything genuinely tactile. The painting I was looking at had nothing to touch, no ground on which to stand, no comforting horizon. It seemed airless and uncertain.

I felt the experience was getting away from me, as if I were losing control of what I saw. For a moment, the hopelessness of it really came home, and I felt what I took to be Rothko's impending sense of despair. I began to get a little dizzy. I felt like stumbling backward, and after a few minutes I did.

2

Crying no one can understand

Tear ... A drop of limpid fluid secreted by the lachrymal gland appearing in or flowing from the eye; chiefly as the result of emotion, esp. grief, but also of physical irritation or nervous stimulus.

— O.E.D., *vide* "tear," meaning 1

tear-compeller; tear-compelling, -creative, -distilling, -falling, -shedding, -wiping, ... tear-baptized, -bedabbled, -bedewed, -besprinkled, -blinded, -commixed, -composed, -dewed, -dimmed, -disdained, -dropped, -drowned, -filled, -fraught, -freshened, -glistening, -shot (cf. bloodshot), -stained, -stubbed, -swollen, -washed, -wet, -worn, -wrung ... tear-nourish ... tear-bright, tear-like, tear-shape, tear-thirsty (cf. bloodthirsty) ...

— O.E.D., *vide* "tear," meanings 6b–d

WHEN I FIRST CAME UPON the two ways of reacting to Rothko— the one close up, the other far off—I thought I had a theory about what makes people cry. It would almost be a simple biological rhythm: some viewers see more than they expect, others not enough. One experience is unpleasantly overfull, the other painfully vacant. One reminds people of smothering, the other expels them into a vacuum.

But as I read further in the visitors' books I became less sure. The majority of people who cried in the chapel did not say what their tears meant, and it appears many didn't know. The short entries are enigmatic. "Once more I am moved—to tears": was that written by someone who knew what happened, and didn't want to disclose it to a visitors' book? Or by somone who was moved, and had no idea why? My theory began to look a bit pat.

It's certainly the case that some of the visitors most moved by the chapel keep their own counsel. A guard told me about one woman who comes every year from Germany and spends three days in the chapel; she cries and leaves without speaking to anyone. Even now, more than thirty years after her visit, Jane Dillenberger has no idea why she wept. When Rothko sat watching her cry he may have been thinking about his dark religious experience, but Jane certainly wasn't. His canvases made her feel happy and peaceful: she was disarmed, but content. James Breslin doesn't discuss crying in his entire six-hundred-page biography, but he says the original impetus for his book was his own experience crying in front of a Rothko painting shortly after his father died. I suspect he must have shed tears on occasion but kept them to himself. His tears may have been very different from the ones described in the chapel's visitors' books—and different from Jane's tears, and from the tears cried by the anonymous German woman.

Crying is often a mystery, and for that matter so is not crying. I have no idea why I was not moved by the Rothko chapel. I was entranced—so much that on the second day, I forgot to check the time and came close to missing my plane—but I didn't come close to crying. The paintings made me unsure about my lack of emotion, and they unsettled my certainty about the "case of Rothko": having spent time in the chapel, I've grown suspicious of people who know for sure why they don't "get" Rothko. I doubt Dutoit or Bersani, for example, would even consider crying; it would seem naive—but how can they be so sure? If one of them were to cry, I imagine it would be by mistake, and they would wonder where they'd gone wrong—but that's odd, because the Rothko chapel is steeped in tears. The guards

say they often see people cry, and the visitors' books are full of testimonials. (Even the climate contributes: the grass is damp, and the walls weep from the humidity.) The place is obviously thick with emotion, or the promise of it. I can't explain why I didn't cry, except that I may have been too well armed with my research on the lore and philosophy of crying. Sometimes philosophy is like a levee, keeping back the flood of disorderly thoughts. Philosophers keep the levee in good repair, and that's why philosopher's tears are so rare: they're like incipient cracks in the dike, leaking one drop at a time. Clearly the Rothko chapel is a dangerous place for philosophy. Orderly thoughts and preconceptions are under continuous pressure, and after enough time passes, they crumble and dissolve.

Maybe I didn't cry because I left too soon, before the chapel could undermine the few ideas I had left. Maybe I was thinking about philosophy too much, or trying too hard to be an assiduous scholar. Or perhaps it was because I kept myself busy noting other people's tears: I was like a doctor who tries to be sympathetic, but is too professional to really feel anything. So if I hadn't behaved like a doctor, or a philosopher (or a doctor of philosophy!) I might have cried . . . perhaps. I'm not sure if any of those are good explanations.

Many tears people have shed for Rothko's painting are inexplicable. Fullness and emptiness are important, but they are only part of the story. Some tears were mysteries even to the person who cried them. ("Tears, a liquid embrace.") They came from nowhere, and in a minute they evaporate, like a dream that can hardly be remembered. What can be said about tears like that? I want to spend awhile now considering tears of all sorts, just to see how few of them make sense. Then I'll try to say more exactly what tears are when they happen in front of paintings—as opposed to movies, photographs, or concerts— and whether it is possible to make sense of tears evoked by paintings. Gradually I'll make my way back to Rothko, and he'll appear again at the end of the book.

The Prince de Ligne. In ordinary life, if you see someone crying—say, at a bus station, off in a corner—you can make a fair guess about what's wrong. Babies cry for reasons they can't explain, but when

they're old enough to talk there is no end to their explanations. Most crying has a reason, and usually it is obvious. Still, that's not always the case, and tears that don't make sense are among the more interesting. Here is an example from the very earliest dawn of the Romantic era, when people first started writing about their thoughts with the sensitivity we've come to recognize as modern. It concerns a certain Charles Joseph, prince de Ligne, who was one of the first to be sensitive to trivial, "feminine," meaningless emotions like crying. His kind of sensibility, as they called it in French literary circles, was highly valued.

Standing on a high cliff in the Crimea on an autumn day in 1787, the prince fell into a solitary meditation. He forgot about his business, and the reasons that had brought him there, and turned instead to his own heart. How sad it is, he thought, that empires rise and fall, and never stay the same; it must be that way with love, so that if I do not love a woman more each day, I must therefore love her a little less. Love comes up from nowhere, and then subsides, and there is no way to stop it. "I melt into tears without knowing why," the prince wrote to the princesse de Coigny, "but how sweet they are! It is a common emotion, it is an outpouring of sensibility, which cannot identify its object. At this moment where so many ideas meet, I cry without sadness."

Perhaps the prince wept from loneliness or because of the distant place—so far from Paris, in alien mountains—or perhaps he was thinking of a woman, and falling out of love. Maybe a sad memory was welling up from his childhood; or he may have cried because of something trivial—an irritation, a change in the weather. We will never know, because he never knew. His tears came over him like a wave, washing through his thoughts, leaving him neither sadder nor wiser.

This, I think, is the first thing that needs to be said about crying: no one really understands it. Strong emotions shut down our ability to reflect. They come and go when they want, without letting us know what they are trying to tell us. Even reflective people like the prince de Ligne can find themselves bemused and unable to say exactly what happened.

The key that unlocks the heart might be so mercurial that it can't

even be grasped before it's gone. In Marcel Proust's *Remembrance of Things Past*, Charles Swann is listening absentmindedly to a piece of chamber music, when he is suddenly entranced by a few fleeting notes. His heart races. What has he just heard? Proust leaves us guessing: "Without being able to distinguish any clear outline, or to give a name to what was pleasing him, suddenly enraptured, he had tried to grasp the phrase or harmony—he did not know which—that had just been played." It could have been a tune, a chord, or just some shifting sounds that were gone before he could comprehend them. Whatever it was—music, or music mingled with his thoughts— it gives him an odd pleasure and a kind of sadness. He listens in vain, waiting for the moment to be repeated, but the music goes on and the "little phrase" is lost forever.

No one, not even Swann, can explain why he felt so strongly. Proust offers us various possibilities: Swann's trance might stand for his jealousy, or for the intrinsic value of art. (The same thing happens with a painting elsewhere in the book.) If Swann were a musician, he probably could have found the exact chords, or the melodic fragment, that so captivated him. But he wasn't, and the moment was doomed to be so personal that it could never be explained. And even if he had found it—if he had purchased a copy of the score, and circled the "little phrase" in red pencil so he would never lose it again— even then, would he know why it affected him so strongly? And if he took it to a specialist in music theory, and had it all glossed in terms of harmonics and rhythm, would he be happier?

Crocodile tears, beaver tears, John Barrymore's tears. From Aristotle to the present, people have been unable to agree about what crying is. There are dozens of competing theories, with more appearing every year. Some people say it's a catharsis, a release of emotional energy; others say it's the special language of the eye, or the overflow from a reservoir of sadness that we call carry within us, or the only external proof of love. There are philosophic, psychological, and biological theories, all competing for possession of the truth. As I write this, in the winter of 1999, I know of two other people who are working on

books on crying, and it looks as if there will be a surge of teary books to mark the millennium. Aristotle, Spinoza, Condillac, Locke, Sartre ... many philosophers have offered theories of crying, and the more I read the more I become tired of wanting to know what crying is.

Most of us cry at the ordinary human tragedies of life—at funerals and for losses of all sorts, from loved ones down to dogs, and even, if we're drunk, to disastrous performances by our favorite football teams. We cry, too, when we're deliriously happy. We weep at weddings, even weddings of people we don't know, and even weddings on TV of people we don't know.

Humans are almost alone in their weepy habits. It is said that the only animals that cry when they're emotionally disturbed are some primates, elephants, and beavers. (I can easily imagine monkeys and elephants weeping, but somehow I can't picture a distraught beaver.) Apparently many animals can tear up, but they only cry crocodile tears, without the essential emotional push.

Humans, on the other hand, cry at absolutely everything. We cry over onions, over spilled milk, over the frustration of threading a needle. If we laugh too hard, we cry; if we get too tired, we cry; if we hear someone else crying, we are apt to join in ourselves. What don't we weep at? We weep from fear and frustration, from joy and grief, from too little sleep and too much sleep, from unbearable sadness and simple boredom, from the thought of the future and the memory of the past. Crying is so common it might mean nothing, or just about anything.

Crying is also hard to think about. It mangles and ruins our thoughts, blurs our eyes, fills up our noses and throats. There is pain in it, but also pleasure: there can be happiness in knowing you are about to cry, and a lovely relief when the weeping is over. Tears can feel hot on your cheek, and they can be signs of hot anger—or they can run cold, betraying an icy detachment. They can hurt, as if they were little stones caught in the eye, and they can also leak out silently without our noticing. Some people are nearly tearless, and for them even a profound tragedy might yield only a single tear. Others cry inwardly, withholding their tears, or cry outwardly but deny they have cried.

Some people are predisposed to be sad, and they leak tears all day long. I found a book written in 1915, called *On the Origin and Nature of the Emotions,* with a picture of a miserable-looking woman wrapped in a shawl and a checkered blanket. Her lips are pursed, and she looks up with a bleary, suspicious expression. The caption reads, "Photo of a homesick patient in hospital whose brain threshold had been so lowered that the slightest stimulus resulted in tears." Presumably the photographer who took the picture set her off again. There are also happy weepy people who cry as naturally as singing, in "abundant and easy tears which mingle with the grace of a smile, and give to the face an expression of compassion and joy." (So said Beaumarchais in 1767.)

Crying can be ostentatious, a show of grief for everyone to witness, or it can be perfectly discreet. The fashion editor Jean-Dominique Bauby, who was paralyzed so completely he could only blink one eye, cried when his ambulance took him past his favorite café. "I can weep quite discreetly," he reports in his memoir. "People think my eye is watering." Crying can be beautiful to watch, when a few tears linger on a cheek, and it can be repulsive, when the eyelids puff and the throat fills with phlegm. It can be silent (only the invisible sound of the teardrop falling) or piercing. Men bellow in despair, women shriek and keen.

How could it be possible to herd all these things into one category, and explain them by one theory? Tears can't even be trusted: some signal unbearable emotion, while others mean next to nothing. In the right hands, a tear can be like a trump card, played for effect. The novelists Stendhal, Thackeray, and Dickens each worried over callous women who make themselves cry so that they might appear to be in love. Their women coldly "worked the tear-pump," as they used to say. (I once knew a woman who "worked the tear-pump" to get a higher grade in German class. She started up the pump outside the teacher's office, and came out ten minutes later, perfectly content with her new grade.) There is a story that John Barrymore once said he could cry tears to order—any number at any time. He announced he would cry two tears from one eye, and one tear from

the other; and then he did it. There is no way to tell honest tears from deceptive tears, and there is no way to anatomize a tear, and tell which part is which.

Tears in front of paintings are no more reliable. In Paul Schrader's film *Mishima,* the young Mishima cries when he looks at one of Andrea Mantegna's paintings depicting the martyrdom of St. Sebastian. Mishima weeps, but his tears are a mixture of grief, envy, unfulfilled ambition, hysteria, and sexual arousal. Who knows what they really mean? In a BBC series on the life of Mahatma Gandhi, he weeps in front of a painting of Christ. Who would be willing so say what he might have been thinking? In Julian Schnabel's movie *Basquiat,* the painter's mother cries looking at Picasso's *Guernica.* She may be thinking of Picasso's triumphant art, or of the oppressions of the Spanish Civil War, but it seems unlikely the young Basquiat could understand much of what she is feeling. (Nor is it easy to know what Schnabel thinks of *Guernica.*) It seems there is no way to disentangle what happens in a crying mind.

And then, if all that weren't enough, there are tears that mean nothing at all. Every once in a while, I am surprised to feel a tear on my cheek, and I wipe it away quickly before anyone notices. It could have been caused by dust in the air, or a brilliant light, or fatigue. Tears can escape from our bodies like sweat, without our wanting them to. Our eyes water in the cold, and at the sulfuric acid produced by a chemical in onions. (In the medical nomenclature those are "reflex tears" and "irritant tears," as opposed to "emotional tears." Doctors are always sure about such things.) Some people weep whenever they laugh; other people suffer from dry eyes and require a continuous flux of eyedrops. Sjogren's syndrome is a condition, often associated with rheumatoid arthritis, in which the eyes are permanently dry. Some people who suffer from the syndrome require droplets of "artificial tears" every ten to fifteen minutes. Such people might feel like crying, and even look like they're crying, but when they cry their tears aren't their own.

People who have strokes can cry endlessly, not from emotion but from neurological malfunction. Their condition is called "emotional

incontinence" or "pathological crying," and there are drugs that can help alleviate the meaningless tears. "Pathological" tears are not signs of a state of mind, but of the damaged state of the brain, just as the tears I get peeling onions are a sign of acids in my eye. But there is no sharp line between tears and feelings. Some victims of pathological crying are also depressed, and the medications that stop their tears may also help to cheer them. Tears are like smiles, in that they can be true or false: but they are also worse than smiles, because they can mean absolutely nothing.

So what kind of thing is a tear, when it can mean the opposite of itself? Known and not, cold and hot, crucial and trivial, false and true, rare and common, profound and superficial, obvious and hidden, heartfelt and inadvertent: it seems there is nothing a tear can't mean. At least one philosopher of tears was wrong, the one who said tears are the eye's special language. They couldn't be like words, unless they are all the languages of Babel condensed into one. They express so many parts of us—thoughts we have mastered and those we have repressed, bodily urges, subterranean desires, chemical malfunctions—that they seem to say everything, and anything, and often also nothing, all at once.

Here's the point of this little meditation: I do not *want* to understand these wonderful phenomena, or press them into the box of some little theory. Some tears may make sense—I hope they do, because that's what I'm interested in—but I don't want to forget that no one knows what crying is. I have tried to honor the mystery by letting tears of all kinds fall into this book.

She had no arms, but she was so tall. I mentioned in the preface that I have more than four hundred letters, in the post and by e-mail, from people who have cried in front of paintings. Many of them have no idea why they cried. They were affected, but their minds were left in the dark. A French man wrote to tell me about a trip that he made with his wife to London, to see watercolor paintings by Joseph Turner. While they were walking through the Tate Gallery, his wife suddenly burst into tears. "She had no explanation at all," he says.

"She was happy to be in London for a few days, and she liked Turner's work, but not to the point of expecting such a phenomenon." Tears were streaming down her cheeks. He asked her what was wrong, and all she could say was, "I don't know."

A short-story writer named Robin Parks, who lives on an island in Puget Sound, wrote me an especially mysterious letter. It is eloquent and enigmatic. "Hello," she writes in the informal manner that seems right only on e-mail. "I cried in a museum in front of a Gauguin painting—because somehow he had managed to paint a transparent pink dress. I could almost see the dress wafting in the hot breeze. I cried at the Louvre in front of Victory. She had no arms, but she was so tall."

It is a simple letter (there's a bit more to it, which I'm going to save for later), and decidedly odd. I wrote her in reply, asking why a person would cry just because a dress was transparent, but she had no answer. I asked her what she meant by saying *Winged Victory* had no arms, "but was so tall." I said I could see her crying over someone who has no arms—even in sympathy with an ancient sculpture—but I couldn't quite figure out the other phrase, "but she was so tall." Why not "*and* she was so tall"? Robin wasn't sure.

I hope she never figures it out, because the letter is perfect just as it is. What could be more wonderful, more impenetrable, than her nonsensical explanation? "She had no arms, but she was so tall." If the words weren't so incomprehensible, they would be a wonderful title for this book. Robin tells me her ambition is to "make something beautiful and as close to perfect as is humanly possible. Even if it's just one small thing. One small perfect thing." In that line about *Victory,* I think she might have done it.

It's not that tears can't be explained—I have a number of theories, and points to make about history—it's that crying is always at least a little mysterious. *Winged Victory* is sad because she has no arms, but that is not enough to bring a tear: yet to Robin she was worth crying over because she was *also* tall. That doesn't make sense, and yet it does: it's like the half-confused reports people sometimes give after they have witnessed traumatic events.

The seventeenth-century philosopher Spinoza had a good theory about semirational statements like Robin's. He said, in effect, that the mind is routinely surprised by things that happen to the body, and so it makes up stories to explain them away. We tend to think that tears are a symptom of something we experience. It stands to reason that something should be explicable. But what if the tears came first, and the rationalizing followed along behind it? First would be the tear—the pure mystery—and then the mind scrambling after it, inventing all kinds of stories about transparent dresses and armless statues. Spinoza said that our minds tell us these little lies in order to make it look as if we are in control of our bodies and our lives. Without the little lies, our bodies would be revealed for what they are: incomprehensible appendages over which we have no power. So perhaps Robin's explanation is self-contradictory because her mind hadn't quite got its act together. What she ended up writing was a thought stuck halfway between her unexpected tear and her mind's attempt to play catch-up. Robin has a good ear, maybe the kind a fiction writer needs: she saw that she had said something odd, and she decided to leave it just as it was.

Even a philosopher like Spinoza, with his respect for the mindless life of the body, would be sorely tempted to take Robin's little phrase and iron it out. For example, you could put a nice crease between "she had no arms" and "she was so tall," dividing the single thought in two: "I cried because *Victory* had no arms. Then I noticed how tall she was." The two sentences would be two different reasons for crying: "I cried because *Victory* has no arms, or else because she is so tall." Once the logic is repaired, all kinds of interpretations become possible. Perhaps Robin has an inferiority complex about her height (I haven't asked her). Perhaps she was frightened by the unexpected apparition of an enormous mutilated figure on the stairway of the Louvre. Maybe she has always dreamed about headless women with wings. Maybe she has some Freudian obsession with transparent and opaque dresses.

The tricky thing is to see that explanations can be self-defeating. A prudent interpreter knows just when to stop interpreting. Robin has

an exemplary attitude, very close to Wittgenstein's: take note when an explanation starts to make less sense than the thing it sets out to explain, and then stop. Tears make us unreliable witnesses to ourselves: that's part of the pleasure of the subject.

How to fly in your dreams. I'm promoting Robin's attitude because it is an antidote to our ordinarily insatiable drive to comprehend everything. When I read theories about tears I often want to say to the author: Go ahead and say what you want, but by all means notice it doesn't make sense. Thinking about crying is nearly a contradiction in terms, an absurdity.

Writing a theory about crying is like flying in a dream: it is possible only until you wake up. When I was younger, I used to have elaborate dreams about flying. (These days I can't seem to get off the ground.) Even in the dreams I knew it was impossible to fly, and I kept rationalizing about it. In one dream I remember saying to myself, "This is impossible, but luckily I'm asleep." In another dream I was reasoning with myself, as if I were trying to convince a judge that he should let me keep flying. "If I were awake," so I argued, in my sleep, "I would know too much about flying, and I wouldn't be able to stay in the air, so it's a good thing I'm dreaming." Most of the time the faulty syllogisms satisfied my sleepy faculties, and I kept on flying.

Philosophy is nothing but an extension of those arguments, strung out to the length of a book. It has its own dreamy logic. Perhaps I was flying to escape childhood anxieties. Maybe I had a young boy's fear of sex. Or maybe I was regressing to infantile memories of swimming in the womb. Are those satisfying explanations? Are they, as Wittgenstein would say, working as explanations at all? According to one theory, tears expel toxins from the body. (Does that explain crying, or chemicals?) According to another, they are a catharsis. (Is that an explanation, or a redefinition?) Other people think tears are the overflow of emotional reservoirs. (That sounds more like a theory of hydraulics than an explanation of crying.) All theories are shaky, from the mazy thoughts that are dreamt inside the dream to the sober treatises that get written by experts.

Happily there aren't many of us who are as much in love with theories as Freud or Aristotle. We fly in our dreams, and we cry, and that's that. If it takes a little fancy reasoning to keep me flying in the dream, then that's what I concoct. Afterward, when I'm awake, I am unlikely to be convinced by Freud or anyone else: there is just too much of a gap between the cold slab of theory and the lovely swimming feeling of flying or the sharp surprise of tears. When an experience makes as little sense as flying in a dream or crying at a green dress, it is probably best to stop thinking as soon as possible.

Why do people theorize about such things? Because the sheer impenetrability of the teardrop is infuriating: it makes us throw up our arms in exasperation, and creep out on the shaky limb of some theory. If only tears made sense! Among the letters I received are several that propose elaborate theories of crying. A couple are pages long, flecked with terms and definitions and dead certainties. The writers' minds are full of concepts: mystical harmony, inner rhythm, emotional economies, hidden affinities. To my ear, they are suffering from an unslaked desire to explain an emotion they have felt, to remake the weird wordless tears into a shelf of philosophy.

If there's a solace in reading those letters, it's knowing that none of us is immune from the theory virus. I do intend to try some theories of my own in this book, although I am also going to be careful not to make too much sense. The longest, most elaborate letters conjure so many ideas, and stray so far from anything I could accept as common sense, that they end up capturing much of the sheer strangeness of crying. I would never say that Bonnard's paintings have a "template which bonds with my brain patterns," as one of my correspondents thinks. A template bonding onto a brain: that's an unpleasant and slightly threatening image. It is vague, because I can't find templates in Bonnard's painting, and its flavor is all wrong, because Bonnard didn't entertain mechanomorphic theories of depiction. But the brain-bonding theory is just as weird in its way as the feeling that washes over me when I see an especially iridescent Bonnard. The weirdness of the theory reminds me of the weirdness of what I felt.

Theories don't work, and they are often a little crazy: but so are the tears that prompted them.

A brief theory of beauty. Few of the people who wrote me are determined brain-bond theorizers. Many people *do* hold to another theory, though: one so simple it nearly isn't a theory. They say, in effect, I cried because the painting was so beautiful.

We cry because paintings are beautiful: is that an explanation? It's certainly a very common response, and when I began collecting material for this book, I thought beauty might be my hidden subject, the driving force behind people's reactions. After all, paintings can be astonishingly beautiful. Some can be so beautiful that they ambush unsuspecting viewers, provoking floods of emotion. At one point I even thought of calling this book *Pictures Too Beautiful to See.*

But there is a problem with beauty, and it's a serious one for a project like this, where the aim is to make sense of at least some crying. The difficulty is that when people talk about beauty, they really say very little: "The painting was just beautiful, and I cried," or "I couldn't stop crying because it was so beautiful." Are those explanations? If anything, they are *more* mysterious than Robin's sentence. Explaining tears by appealing to beauty may be like explaining water by saying it's wet. It is an explanation, but it's a very small one. On the one hand I have a tear, a small acid droplet, and on the other I have the word "beauty," a little sound, a motion in the throat. Can I really hope to make sense of one of those things using the other?

A woman named Gré Bravenboer-Beekenkamp, who lives in the Netherlands, sent me a lovely letter about words for "beauty" in several languages. "The word *szép* in Hungarian," she says, "is the same as the Dutch word *mooi,* and I think the English word is beautiful, fine, or nice." She tells about an experience she had once, "on a cold autumn morning in the museum of art in Budapest," when she found herself weeping, looking at a Madonna and Child by El Greco. "A guard in the room," she writes, "smiled and nodded. 'Szép-szép,' she said, quietly and sympathetically."

Szép, it turns out, is the only word Gré knows in Hungarian; it

was the family name of her best friends in Hungary. But she mentions the guard not just because of the word she said, but because of the way the guard said it. "I don't remember this just because of the word *szép,* but because of the feminine gesture of understanding that the guard made when she said it." Since Gré didn't tell me, I can only imagine the guard's "feminine gesture"—perhaps a hand to her cheek. When words count for so much, it's important to get them just right. Szép is pronounced "s-thaip," Gré informs me (or more simply "saip"), and the Dutch word *mooi* is pronounced 'moy.'" With beauty it is the tone that matters: the sound, the gesture, and the occasion—and not the sense.

Gré's letter evokes the scene very well, as I discovered when I visited the museum in Budapest. The rooms around the El Greco are large and quiet, with high ceilings. The museum has a large collection of late Renaissance paintings, many of them dim browns and blacks. (It also has one of the darkest and loveliest Giorgiones.) In a room of duller paintings, the El Greco gleams silvery and light blue. It is stunning, and it would be in any setting. The quiet event Gré describes is easy to picture, but of course her letter is not a theory or an explanation.

There are many ways to ring changes on the theme of beauty, without ever finding out much about the crying that provokes the thought. Another woman, this time an art historian, wrote to say she cried over a pastel by Odilon Redon in the Petit Palais in Paris. For her too, there is nothing to explain: "The only thing crossing my mind while shedding tears was: 'How beautiful this is.'" Often the best that people can do is add an adjective: "amazingly beautiful," they say, or "immensely beautiful." I know what they mean: when I experience beauty, in a person or in a painting, I usually don't have much to say. My lack of words is what shows the thing is beautiful. It's enough to say "szép-szép"—anything more would be too elaborate.

The beauty of beauty is it simply exists. It calms our drive to understand what we're feeling, damping our desire to write or research or theorize: and for that very reason, beauty is a word that many contemporary artists, and most people in my profession, would rather

do without. Mathematicians still use it, and so do physicists, astronomers, and some music critics—that's a list complied by the architectural historian Joseph Rykwert, and it sounds about right. In the art world, beauty is nearly a synonym for pallor. Saying an artwork is beautiful is a bit like calling someone "nice": it means that stronger, more definite qualities are probably missing. Working artists treat the word even less respectfully: you might visit artists' studios for several months before you even hear the word—and then it will be uttered quickly, as if it were not quite proper. In a gallery, a conversation that starts out "It's beautiful, but … " might well turn into a savage critique.

Because beauty fails to mean anything in particular, it might mean just about everything. There's an excellent demonstration of beauty's meaninglessness in Stravinsky's opera *The Rake's Progress,* when the young Rake is asked to define beauty. He says it is:

> That source of pleasure to the eyes
> Youth owns, wit snatches, money buys,
> Envy affects to scorn, but lies:
> One fatal flaw it has. It dies.

Someone asks him: since you say beauty is pleasure, then what is pleasure? He answers:

> The idol of all dreams, the same
> Whatever shape it wear or name;
> Whom flirts imagine as a hat,
> Old maids believe to be a cat.

These verses were written by W. H. Auden, and I can't do better. Beauty is a red herring if you're looking for explanations of art. It is a mystery, one of the best, and it continues to vex philosophers and annoy artists and historians. I'd say the people who wrote me saying they'd cried because paintings were beautiful were soothing themselves, without really saying anything. They were using a sweet sound,

the word "beauty," that has almost no meaning. "Szép," "mooi," or "beautiful": each has its own flavor, and none makes much sense of the world.

France, 1942. Over time, the memory of beauty sits in the mind like a question mark. Why did Gré cry that time? What was so beautiful about that painting? The longer you reflect on beauty, the less you may finally understand.

For the most part I prefer mysteries that remain unsolved—like the one about a woman who cried once when she was a teenager, in 1942, and tried for more than fifty years to understand why. Her family had fled Paris ahead of the Germans, going south to Nice. She was out bicycling one day, and her attention was caught by an art gallery with two paintings in the windows. One was a harbor scene by the early-twentieth-century painter Maurice Vlaminck; it was sparkling, "riotously joyous and pleasing." In the next window was a dull canvas by the midcentury painter Maurice Utrillo, depicting a gray, overcast day on a narrow curving street somewhere in the outskirts of Paris. The street, she remembers, was unevenly paved, and edged by a weathered fence. A tree "with meager foliage" and a "blind wall" completed the scene. She stood looking at it for some time. "It was as if I could walk along that dismal lane, along that old fence which would surely be followed by another one no less ugly, no less secretive. All the dullness and drabness of the northern banlieues of Paris oozed from this picture." Finally, she says, she tore herself away from the painting. When she got back on her bicycle, she discovered she couldn't see because her eyes were blurred by tears.

She had grown up in such a neighborhood, and now here she was, a stranger, in an exotic southern town, enjoying "the light, the palm trees, the blue Mediterranean, the gaily colored houses." Could she have been feeling nostalgic about her drab old neighborhood? She doesn't think so. She knows that her circumstances at the time may have contributed to her tears, because she was exiled in a "lovely" place where she didn't belong. But she also recalls that she came from a neighborhood she didn't like, a banlieue of Paris. Banlieues are

outskirts or outlying areas, not tidy new developments like American suburbs; hers was dull and drab, and she didn't want to go back.

"To this day," she says, "I cannot explain those tears. Was the cause objective: the evocative, slightly childish style of the painting? The absence of 'beauty,' caught by Utrillo's almost photographic eye? Was it subjective: the unconsciously repressed feeling of being but a stranger, an onlooker in this lovely Nice which was not my home?" She is very careful with her memories, and she knows enough about painting to know there is a history of paintings of banlieues, going back to the Impressionists, and that Utrillo is a late and not particularly good example. She says she wouldn't fall for his pictures again, even though she has never cried for any other picture. She concludes: "It remains a mystery."

The old, drab neighborhood; the unexpected melancholy of a bright tropical city; a painting that looks unskilled and "childish"; the contrast between the happy Vlaminck and the morose Utrillo: any one would be enough of an explanation, but she has had half a lifetime to think it over, and she rejects each of them.

As far as I am concerned, this is the real wisdom of old age: not accumulating memories and growing wise, but becoming acclimated to not knowing, to never knowing. It gets easier to acknowledge mysteries, instead of rushing to find explanations. And if you're very wise, as this woman is, you may come to realize that many of the theories you constructed in your youth were wrong. As her memory of the art gallery in Nice subsided deeper into her past, it gently detached itself from the reasons she had invented. Eventually it was floating by itself, out of reach of her explanations. The encounter had taken its place among the things that make the world interesting and inexplicable, and when I last wrote her, she had left it at that.

Tears are unreliable witnesses, but they are the only witnesses. Later in the book, I am going to try to make as much sense out of crying as I can. But a tear, I want to remind myself, doesn't speak in any human language. The prince de Ligne knew he was crying, but he also knew his explanation wasn't a good one. Robin knew her funny sentence

was a kind of nonsense, but she liked it that way. The woman who cried over the Utrillo painting has pondered her reaction for nearly fifty years, and she is no longer waiting for a sudden flash of insight that would tell her what happened. Many tears are not like clues in a murder mystery, where everything is revealed at the end. Often enough tears are just what they appear to be: little pellucid drops of salty water, that come from an unknown place and don't mean anything that has a name.

A tear, like a blob of mercury, can't be pinned down. So why should I try to understand people who cry in front of paintings? Why bother searching through history for stories of people who have cried? For a simple reason: tears are the best visible evidence that a person has been deeply moved. Strong emotions are my real subject. I am not really interested in counting teardrops, and this book is not just about people who cry. I want to find instances of genuinely powerful responses to pictures, reactions so forceful and unexpected that they can't be hushed up. I want to know what happens when a painting suddenly means much more than the dry information on the museum label, or the intellectual symbols and stories in books of art history. When a painting is not a game, when it no longer matters who knows more about the painter, then painting can be an art that might actually deserve the high value we put on it. I am fascinated by that possibility, and by the unnatural vigor with which we have excluded any such experiences from our official textbooks and tours.

If I cling to the theme of crying, it's because when there are no tears there is no way to gauge the depth of a person's feeling. If I had told my friends I was writing a history of people who have had strong reactions to paintings, everyone would have chimed in. In my profession of art history, we're all attached to paintings—we're all enthusiastic, we all say we love what we study. I guess that millions of people who visit museums would say the same. But relatively few people have cried, because few people have been really moved by pictures.

Tears may mislead me, and in some cases I suspect they have. Not all tears signal deep disturbance, and most tears cannot be understood. Certainly, tears belong to a twilight tribe of thoughts and feel-

ings so dim we hardly know them. They are kin to dull depressions, moods not given voice, gnawing discontents, hidden illnesses, instincts out of control. But tears do one thing that separates them forever from the inarticulate parts of our inner life: they leak from our eyes, and run down our cheeks. They show, without room for doubt, that *something* has happened. They are witnesses.

I like to think of tears as travelers who have come to see us from some distant country. Ever since Herodotus, travelers have said unbelievable things about the places they have visited. But even the least dependable traveler—the one who doesn't speak the language, the one who seems to be making things up just for the effect—has one unimpeachable quality, which makes him fascinating: he comes to us from that distant place. For that reason alone, tears are my unreliable but indispensable criterion.

Undoubtedly tears are hard to interpret. Yet some would say that the root problem is that they are irredeemably subjective. They belong to the eye that cries them, and not to the world of public discourse, culture, and history. Even though they leak out, they belong inside.

In that view, authentic experience is *thought* experience, and anything emotional is bound to be solipsistic. Crying is the fault of the crier, and tears have nothing to say about what hangs on the walls of our museums for everyone to see.

If you subscribe to that view, then you'd probably want to say this is a book about weepy people, and not about paintings. It is an opinion I resist, and I am going to spend the next couple of chapters rehabilitating tears so they can take their place alongside more sober reactions.

3

Crying from chromatic waves

HANDKERCHIEF, n. A small square of silk or linen, used in various ignoble offices about the face and especially serviceable at funerals to conceal the lack of tears.

— Ambrose Bierce, *Devil's Dictionary*

"If I wasn't real," Alice said—half-laughing through her tears, it all seemed so ridiculous—"I shouldn't be able to cry."

"I hope you don't suppose those are real tears?" Tweedledum interrupted in a tone of great contempt.

"I know they're talking nonsense," Alice thought to her self: "and it's foolish to cry about it." So she brushed away her tears, and went on.

— Lewis Carroll, *Through the Looking-Glass*

FRANZ WAS IN A FRENZY. It wasn't at all the vacation he had expected. Here he was, finally arrived in Florence—the heart of the Renaissance, the very center point of Western culture—and he was at loose ends. He had planned his trip very carefully. He was a Bavarian bureaucrat like his father, and his father had always told him Bavarians are especially adept at organization. Franz had made himself a detailed itinerary, calculating each leg of the journey. He estimated

the time it would take to get from his house to the train station, and then from the train station to his hotel in Florence. He mapped out each day, factoring in the time required to get to each day's attraction, even estimating how long he would stand in line for tickets. But it hadn't worked, and already he had fallen behind.

All because of that painting.

Yesterday, he had arrived at the Uffizi gallery punctually at 10:30 and gotten in fifteen minutes later, exactly as he had expected. He had begun his tour by going straight to the rooms with the earliest paintings. That way he could finish with the sixteenth century by lunch, and do the entire museum by closing time. Today he was supposed to be off on the other side of town, touring the Pitti Palace and the gardens. But here he was again, back in the Uffizi, a full day late.

On top of it all he didn't feel good. He was overexcited, his heart was pumping too fast. His head felt hot. When he had first seen the painting, about eleven-thirty yesterday morning, it hadn't registered. He had stopped for a minute and admired the figure's easy pose and the lovely wide-rimmed wine glass with its concentric ripples (see colorplate 2). A half hour later he was back, to see it again. And then again, several more times—he just couldn't keep to his schedule. Each time he looked into the figure's eyes—deep brown, nearly black—he felt more unsettled, and less sure about his own behavior. In the end he skipped lunch entirely, and stayed looking at the painting until ten minutes before closing, when the guard ushered him out.

That evening, at dinner, he had taken an outside table in the Piazza della Signoria, within sight of the museum. That was when the eyes came back to him. Deep, glassy eyes, with an astonishing confidence. The full lips, like a woman's, pouting just a little. One more time, he had thought: I'll see the painting tomorrow morning, on my way to the Pitti, and that will be an end to it.

Early in the morning he was upstairs in the Uffizi, ready for his last look. He rounded a corner and saw the picture. He slowed, and walked gingerly up to it until he stood just in front of the cordon, so that the dark, beautiful eyes were looking squarely into his.

A visit to the hospital. What a strange day! Who would have guessed such a thing could happen. But here he was, drenched in sweat, weak as a kitten, trying to explain to a doctor what had happened next.

"Do you have any family history of heart trouble?" she asked, turning to a new page in her notebook.

"No," he said, "my father is still healthy, even though he is over eighty years old."

"And what profession do you practice?" she asked, without looking up. She was a middle-aged woman, with sharp features and a soft voice.

"I am an official, a bureaucrat. As my father was, before he retired. We have lived in the same region of Bavaria for three generations."

"And you have never had an experience like this before?"

He looked at her. Her face was kind but impassive. He felt he should try again to convince her, to explain that what happened to him was really extraordinary, unprecedented.

"I didn't notice anything much the first few times," he said. "But I kept coming back, and each time I saw it I got more agitated. Twice I left just as soon as I saw it. I wandered up and down the long hall. I tried to get my mind off it, to look at the other things—the older pictures—"

"But you couldn't."

"Yes, I couldn't." He looked up and saw he had gotten her attention. "And then I started noticing the brightness of it, the shine. I suppose at that point I must have been straining my heart, because I felt very tired, as if I were going to faint. It affected my eyes, because I saw colors, waves of colors, coming toward me out of the painting. That's when I began to feel dizzy. When I looked, I thought I could somehow see *beyond* the painting, that there was something *behind* it. I couldn't focus properly, my eyes were full of tears."

"And did the colors stop when you sat down?"

"I couldn't stay sitting, I kept walking back and forth. I tried to close my eyes, like you do when you are a child and you want an imaginary monster to go away. I thought when I opened my eyes I would see just the painting, like everyone else saw it. I saw many

people just walk by without giving it a second's notice. So I tried closing my eyes for a minute. It didn't work. After that, everything was worse."

He was reliving it now, seeing it happen all over again. "The colors were brighter, shining, scintillating, and they were strange colors, colors that I think have never been seen before, colors that are not part of the spectrum. I felt as if I were going blind. Chromatic waves were coming at me from behind the picture. My eyes just gave out."

"That is when you left."

"I was so tired, I felt as if I were going to faint. My head and my heart were on fire. I came out into the sunlight, and I realized I should check myself into the hospital, that I must be sick."

"You're exhausted," she said, putting down her pencil, "and you may have a virus. If you want, we can do some tests to see for certain."

Franz was bone-tired. If he could just go back to his hotel, he thought, things would be better.

"Perhaps rest and a little quiet will do you good. But just in case, I recommend you don't do much more touring on this visit. Perhaps you can return to Germany a few days early. And above all, I recommend you do not visit the Uffizi again."

Yes, he thought, that is exactly right. I need to go home. Back to familiar surroundings. Back to the old routine, where there is no rushing from place to place. Certainly away from that painting, with its horrible flaccid brown eyes.

The Stendhal syndrome. That is Franz's story of his chromatic waves, which I have adapted from an account written by the psychiatrist who interviewed him. His experience has some unique features (especially colors "never seen before"), but in outline it is typical of hundreds of other stories told by tourists whose long-awaited vacations became emotional disasters.

Tourists first started having experiences like Franz's around the second decade of the nineteenth century. They cried, they trembled, they fainted, they ranted, they ran fevers and got hallucinations. The most famous of the hysterics was the novelist Stendhal, who suffered

from a kind of nervous exhaustion during his visit to Florence in January 1817: "I was in a sort of ecstasy," he confesses. "I had arrived at that emotional point where one meets the celestial sensations given by the fine arts and by passionate sentiments. I had heart palpitations leaving Santa Croce—what they call 'nerves' in Berlin—and the life was nearly drained out of me." It's clear that Stendhal responded very emotionally to Italian art, but it's hard to know exactly what happened. Was he reacting to Santa Croce, or to his own overheated imagination? It almost sounds as if he could have used the same words to describe one of his encounters with a beautiful young woman. The "passionate sentiments" of fine art are perilously close to the passions and sentiments he felt when he was in love: if a girl caught his eye, she could make him tremble and faint just as much as Santa Croce did. (His book *On Love* has a lot of the same rhetoric as his feverish letters from Italy.) Perhaps Stendhal didn't see any essential difference between women and buildings, or perhaps Florence was just another woman in his book. From what he says in this letter and elsewhere, it looks like Italian art put him on edge, sexually. Whatever he felt, his ecstasy, his palpitations, and his swoon were repeated many times by later visitors. His letter has become a classic in the history of tourist hysteria.

The tide of unbalanced tourists swelled in the 1850s and 1860s, when increasing numbers of Americans visited Europe with their guidebooks in hand, trembling in anticipation of Great Experiences. The charismatic preacher Henry Ward Beecher contracted an appropriately religious fever at the Palace de Luxembourg: he underwent an "instant conversion, if the expression be not irreverent," and found himself "absolutely intoxicated ... so much affected that I could not control my nerves." He began shaking, laughing, and weeping, and became "almost hysterical, and that in spite of my shame and resolute endeavor to behave better." Nine years later, the critic James Jackson Jarves wrote about a time he had wandered in the Louvre, "oppressed, confused, uncertain, and feverish," making what he calls, with a certain lack of poise, "a convulsive effort to maintain equilibrium."

If anything, there are more such people now. Among the letters I

have received, about 10 percent are stories of attacks people suffered during their European vacations. One woman wrote me about her son's astonishment when he saw Tintoretto's paintings in the Scuola di San Rocco in Venice. He was sobbing, she tells me, saying over and over, "Why didn't someone tell me about this? Why didn't someone tell me about this?" She knew his reaction wasn't unique, and as evidence she cites a passage from James Morris's book *The World of Venice*: "No collection of sacred pictures is more overwhelming of impact than the immense series of Tintorettos in the Scuola di San Rocco ... often dark, often grandiose, often incomprehensible, but culminating in the huge masterpiece of the *Crucifixion,* which Velázquez humbly copied, and before which, to this day, you may still see strong men moved to tears."

Tintoretto has played a large part in the history of hysterical tourism; his paintings have gotten the better of many people, including the nineteenth-century art critic John Ruskin. There are also histories of "convulsive" reactions to Michelangelo, Raphael, and Leonardo, and to the great public spaces in Venice, Florence, Rome, Paris, and Jerusalem—a flood of overwrought tears, from the early nineteenth century up to the present.

Currently, the center of hysterical tourism is the hospital of Santa Maria Nuova in Florence. Each summer during the tourist season, it admits dozens of patients suffering from ailments brought on by the local art. In 1989 Graziella Magherini, head of the department of psychiatry, invented the name "Stendhal syndrome" to cover her patients' miscellaneous complaints. She wrote a book on the subject, describing the syndrome and proposing it as a medical affliction. (My story of Franz is adapted from her book.)

For most patients, Magherini reports, the syndrome is not a serious illness. It is less like a mental breakdown than a bout of the flu: it may not be pleasant, but it goes away of its own accord. A few of Magherini's patients weep; most sweat, swoon, suffer from vertigo, or vomit. She prescribes tranquilizers and advises bed rest, and she reports that most people recover as soon as they have spent some time away from the artworks.

In a few cases, the Stendhal syndrome is more serious. Some report delusional symptoms; one felt persecuted, and claimed the artworks were following him around. A patient named Brigitte suffered from prostration, tachycardia, depression, and vertigo. She had been overwhelmed by the "violent sensuality" of Fra Angelico's colors. Kamil, a young man from Czechoslovakia, collapsed when he saw Masaccio's paintings in the Brancacci Chapel. "I couldn't move," he told Magherini. "I was stretched out on the ground, and I felt as if I were leaving my body . . . as if I were leaking out of myself like a liquid."

Magherini's book, *The Stendhal Syndrome,* got wide media coverage both in Italy and America. Her critics alleged that she was describing a number of unrelated ailments and lumping them together under a dubious name. Some of her patients, it was said, were just lightheaded from jet lag or too little sleep, while others had longstanding mental problems. A few were clearly incipiently psychotic. When the media interest died down, the consensus was that there is no Stendhal syndrome, only a grab bag of complaints, from heat exhaustion to schizophrenia.

I wouldn't disagree with that diagnosis, but the Stendhal syndrome is still a good name for a historical phenomenon that covers the period from 1817, when Stendhal thought he was having heart palpitations, to the present. Even if it is problematic as a medical phenomenon, it makes good sense as history. Its beginnings coincide well with the rise of bourgeois tourism. In the opening decades of the nineteenth century, people were writing the first guidebooks, called *ciceroni,* for neophyte tourists. By the last third of the century, the guidebooks had become more sophisticated, even telling people how and what to feel for an authentic experience of the old masters.

Early nineteenth-century *ciceroni* are the precursors of yesterday's Baedeckers, and today's *Blue Guides* and *Fodor's.* Even *Let's Go!* and the *Rough Guides,* which affect such an air of no-nonsense traveling, help put people in the same places, in front of the same masterpieces. Guidebooks of all generations put Italian art on such a pedestal that people's hopes can rise to fever pitch before they have even crossed the Atlantic or the Alps.

The same decades—the 1810s and 1820s—saw the flowering of Romanticism, where individual sensibility was valued above all else. Romantic writers from Schelling to Keats, from the prince de Ligne to Coleridge, promoted intense personal experiences over systematic knowledge, and propelled the cult of the artist-genius to medically inadvisable heights. In those days Romantic tourism could easily endanger a person's equilibrium. Today the Stendhal syndrome continues as a cultural fossil, sustained by an educational system that instills high expectations of high culture. Art has moved on—all the way to post-postmodernism, where high culture is mingled with low, and cynicism and detachment rule the day—but the tourist industry sticks to the old Romantic war-horses, treating people to a heady mixture of genius worship and expectations as inflated as they are unfocused. No wonder Magherini's wards are still full.

Was Franz seeing things? In the debate around *The Stendhal Syndrome,* both sides agreed that what happened to Magherini's patients didn't have much to do with the artworks they saw. Magherini treats her patients in proper medical fashion, by attending to their physical and mental complaints. The artworks aren't her concern, any more than a doctor might care about the cold evening that brought on a cold and flu. "Different people have strong reactions to the same work of art," Magherini said in an interview for *Art News,* "but the cases we have seen have more to do with the history and personal experience of the patient than with the object." In her account, the patients suffered because of jet lag, strange Italian food, or the trials of translating a new language, and not because of the works themselves. If they hadn't expected so much, and pushed themselves so hard, they might have had the calmness and presence of mind to attend to the artworks themselves. Then whatever reactions they felt would have been prompted by the art and not by their personal weaknesses.

Magherini and her critics agree on this general principle: it's the people's fault, and the masterpieces they saw aren't really relevant. Surely, though, that is a matter of emphasis. The tourists succumbed

in Florence, while looking at particular artworks. They didn't faint at the airport, or in the taxis on the way to the museum. Further, the artworks that provoked their trauma were the most famous ones, not the minor works that fill the wall between masterpieces. Could the tourists' thoughts really have been entirely their own?

Take Franz, for instance. Magherini says he had problems with Caravaggio's *Young Bacchus* because he was a latent homosexual. She points out his delirium sounds distinctly sexual: his head and his heart were "on fire," he was beside himself with his attraction to the painting. He was unmarried, she says, and had difficulty realizing what he really desired. When he encountered the painting, he read his own life history into it and precipitated an identity crisis.

Not knowing Franz, I can't tell if this is a fair diagnosis. But even if it is, the painting is already a showpiece of homosexual desire. Franz's delirium is certainly beyond the pale, yet the tenor of his reaction is well in line with what Caravaggio intended. The painting was definitely meant to stir up a kind of passion in certain viewers: for people who knew how to read it, the painting was about homosexuality. Given the officially homophobic atmosphere of late-sixteenth-century Italy, Caravaggio would have known that his painting might also stir up a strong revulsion. Even so, he painted a half dozen such pictures, in which young boys look seductively out at their viewers. Some explicitly invite sodomy, and others play with suggestive props. (Several of his boys, as we would say today, are clearly underage.) Caravaggio was partly a *provocateur,* hoping for the best; and partly a purveyor, working for a specialized market. There is historical proof of the painting's wildness: it appears that the *Young Bacchus* was too much for its first owners, and they put it in storage, where it languished forgotten for three centuries until it was rediscovered in 1913. (Recently scholars have denied Carvaggio dealt with homosexual themes, and there has been an attempt to reinterpret the paintings as evidence of Counter-Reformation piety. There are certainly many pictures that have nothing to do with the ones I'm describing: but the early works, and especially the *Young Bacchus,* were seen as overtly pagan at best, and as openly sodomitic at worst.)

The clues are as apparent today as they were at the end of the six-teenth century. The boy holds the sash of his fake-antique robe (probably a bedsheet), as if to suggest he might just slip out of it. His eyelashes are darkened, his eyebrows plucked, his lips full. His flesh is as pink and soft as a boy's can possibly be. The fruit he is eating is overripe—one peach already has a spot of mold. The picture smolders with forbidden sex; even the wine trembles as he holds it out. One art historian noticed the wine in the carafe isn't level, and there are bubbles around the rim. Perhaps this "Bacchus" has just put it down, and it is still sloshing back and forth. The earliest viewers would also have realized he is an accurate self-portrait of the artist, so the paint-ing is essentially a come-on in antique disguise.

Clearly, Franz's delirium was a direct response to the central facts of the picture, as much as a trauma brought on by his repressed Ger-man upbringing. Historians prefer to be a bit more circumspect than Franz was, but it's hard to find a historical description that doesn't make reference to the painting's disconcerting sexuality. One German art historian—a bit repressed himself—says the picture shows a "curi-ous spiritual wantonness." Others have called it disturbing, perverse, intimate, airless, and androgynous. Not everyone would want to say it's perverse, exactly; but it is unarguably perverse by the standards of Caravaggio's time. The *Young Bacchus* is willfully extravagant and overt. It has been pointed out, for instance, that the picture is a male version of a popular subject, in which a half-undressed woman offers her viewers wine and fruit. As such Caravaggio's "male version" couldn't fail to be aggressive and surprising, no matter what its first viewers thought about what we now call homosexuality. The paint-ing's subject has never been a secret, and Franz's reaction was simply more intense than most. He was reacting to this particular painting: there are plenty of other paintings in the Uffizi with homosexual undertones, but this is one of the most powerful.

Each of Magherini's diagnoses can be reinterpreted the same way. Brigitte, the woman who was overcome by Fra Angelico, explained that she was from northern Europe, where everything is less colorful. She found Florence "intensely sensual," and contrasted it with the

restrained "spiritual life" of the north. "I had a puritanical, Protestant education," she told Magherini, "which left me unprepared." Like Franz, Brigitte felt a stronger version of something many people feel. Until this century, northern European art was markedly different from the art of Italy, and despite all the sensual experiments of the Baroque and rococo, the Italian Renaissance remained the example of moral and artistic freedom. Most people wouldn't say Fra Angelico is violently sensual, but he *is* sensual, and so was his place and time.

Even Kamil, the young man who melted in the Brancacci Chapel, was feeling an intense version of a common reaction. Such viewers are literally floored—thrown to the ground by paintings. (I'll have more to say about them later in the book.) Masaccio's frescoes are still presented as one of the seminal moments of Renaissance naturalism, and naturalism is still the *sine qua non* of Western art. The young Michelangelo studied in the Brancacci Chapel, diligently copying Masaccio's figures, and generations of art historians have put the Brancacci Chapel among the highest Renaissance achievements. It remains famous for its amazing realism: the feeling that the figures are standing, with us, in our space, breathing real air and walking on real ground. Again, historians would be more circumspect, and they would want to point out all the other things that happen in Masaccio's paintings that are specific to the early fifteenth century. But it's no wonder Kamil collapsed: the wonder is that more people don't.

It is not likely that the Stendhal syndrome will ever be listed in psychiatrists' manuals of mental disorders, but the phrase "Stendhal syndrome" got wide enough play in the media that it stands a chance of becoming common in English usage. (There is already a "Jerusalem syndrome" for people who get religion by visiting Jerusalem.) Magherini's book is valuable both as a contribution to the history of taste, and because it inadvertently demonstrates that even the most overexcited and unstable tourists, the ones most closely programmed by the tourist industry, are still feeling things that are incited by the works themselves. Or, to invert Magherini's formula: their experiences have more to do with the history of the objects than with the history of the patients.

The funny thing about Magherini saying that Franz's reaction has "more to do with the history and personal experience of the patient than with the object" is that it strips the artwork of its power just when its power is strongest. Franz's bizarre hallucinations, the colors "never seen before," and the chromatic waves shining out from behind the canvas, are way off the scale of normal responses. But they *are* responses, and they are responses to that particular painting. It is as if Magherini wanted people to have only moderate reactions to art, and not to get carried away. (She doesn't exactly say that in *The Stendhal Syndrome,* but it seems that she would diagnose *any* strong reaction as an instance of the syndrome.) Where's the room in that scheme for people who feel what everyone else does, but more strongly? Is it suddenly their fault that they are overwhelmed?

Caravaggio's painting is about homosexuality. It is suggestive, and even lewd. Whether you're homophobic or homophilic, the painting makes a sexual advance. And who doesn't get a little dizzy when it comes to sex?

The anti-Stendhal syndrome. For every person who falls ill with the syndrome, there's another who claims art has essentially no emotional effect. For every person who cries, there is another who claims not to feel anything at all. One person can't stop gasping, and another can't get his pulse going. The two are mirror opposites: they are both off the scale, in opposite directions.

A reporter who covered the Stendhal syndrome for the *New York Times* gave the nerveless affliction a name: the Mark Twain malaise. It was an apt choice, because Twain and Stendhal were themselves opposites, even down to their pen names: Stendhal took his in honor of the very serious connoisseur Johann Winckelmann, who had been born in the town of Stendal; Twain took his from a Mississippi River boatman's call, meaning water two fathoms deep. Stendhal was enraptured by music, poetry, plays, and painting; Twain was a self-confessed ignoramus about art. In many ways they were dead opposites, but they shared at least one thing: they both made art pilgrimages to Italy. Stendhal's trips were fervent and pious; Twain's was a no-nonsense

trip he almost didn't make: if it hadn't been for the flood of American tourists, I wonder if he would have even thought of it. The episode that prompted the *Times* reporter to coin the term "Mark Twain malaise" happened when Twain visited "the mournful wreck of the most celebrated painting in the world"—Leonardo's *Last Supper.*

"We don't know any more about pictures than a kangaroo does about metaphysics," Twain says happily, "but we decided to go anyway." The painting was a big disappointment. "It is battered and scarred in every direction," he complains, "and stained and discolored by time, and Napoleon's horses kicked the legs off most of the disciples when they were stabled there more than half a century ago. So, what is left of the once miraculous picture? Simon looks seedy; John looks sick, and half the other blurred and damaged apostles have a general expression of discouragement about them. To us, the great uncultivated, it is the last thing in the world to call a picture. Brown said it looked like an old fire-board."

At first Twain pretends not to be able to see anything but stains and scars, and then he looks a bit closer and says he recognizes the Lord's Supper. It's not much of a revelation, he says, and he declares he has "got enough" of the old masters; he has "shook" them. "You wander through a mile of picture galleries," he concludes, "and stare stupidly at ghastly old nightmares done in lampblack and lightning, and listen to the ecstatic encomiums of the guides, and try to get up some enthusiasm, but it won't come—you merely feel a gentle thrill when the grand names of the old kings of art fall upon your ears— nothing more."

Over and over, he claims he tries to feel something, and gets nothing more than a little laugh and a "gentle thrill." His letter, written in 1867 and later adapted for *Innocents Abroad,* has been quoted with admiration from his time down to the column in the *Times.* The reporter dubs this show of studied indifference a malaise, and proposes it as the American antidote to the Stendhal syndrome. Twain would have loved it: if you're suffering an attack of the syndrome, take two tablets of the malaise and you'll feel better right away. A dose of American pragmatism will cure any cultural virus you might pick up in Europe.

Now I don't believe Twain for a minute. He compares himself to a kangaroo, and numbers himself among the great uncultivated, but he makes the pilgrimage anyway. He looks, and he sees *absolutely nothing*. Oh yes, he says, now I see it, there's a painting there: the whole thing is a ruse. It sounds as if he's terribly anxious not to feel anything. And the ruse doesn't quite work, because there are definitely legs there, and parts of apostles. So he thinks, Better make another joke! He keeps insisting the painting is ruined—it's scarred, he says, a mournful wreck, battered, blurred and damaged, stained, discolored, just another ghastly old nightmare. In the end, he protests too much. He really does have a malaise: he is so rigidly determined not to feel anything, so anxious to fight free of the European cult of culture, that he can't see anything. He blinds himself with Yankee bravado.

Like the Stendhal syndrome, the Mark Twain malaise isn't a proper medical discovery, but it also exists as a historical phenomenon. I have gotten some delightful letters from people who have "suffered" from it. One woman wrote that she had seen a film of Michelangelo's work while at Cornell University in the 1950s. She was overcome, and she cried, on and off, through the whole film. "Swore I'd return to Florence after graduation," she says, and eventually she did. It was a terrible experience. "I nearly wept for despair. The statues were not as great as the *photographs* of them!" She wonders if she would have cried over Michelangelo's works if she had seen them for the first time in Italy, and she comes close to saying that Michelangelo might need a good cinematographer to bring his audience to tears. If I were diagnosing patients, I would say she had a mild case of the malaise. She isn't quite as cynical about art as Twain was, but she is not about to fall for one of the "old kings of art."

The Stendhal syndrome and the Mark Twain malaise are two sides of a single coin. For each tourist who is looking for a revelation, there is another who is hardened against anything disorienting. The one is soft; the other jaded. The one wants to feel everything; the other insists on feeling nothing. Stendhal's tourists throw their arms wide and are overcome. Twain's put on dark glasses and sneer. Yet they both look, and they both react to the works, and not just to their own frayed emotions.

Let's say they are two extreme cases of ordinary viewing. Most of us look at paintings and feel a little something as the images sink in. Magherini's patients are nearly drowned by tidal waves of emotion. People who suffer from the malaise know there's something to be felt, but they won't let themselves. It is a matter of degree, not of kind. Who is to say that Magherini's patients didn't feel *better* as well as more, and that they didn't get *more* from the works than we do?

The moral I take from the histories of the syndrome and the malaise is that even outlandish experiences in front of paintings need to be taken seriously, because they are part of the spectrum of human response. I wouldn't feel comfortable if I were on a trip with Franz, Brigitte, or Kamil, but I don't see any reason why people should be in full control of themselves when they look at artworks.

There is no reason looking should be easy, because pictures are not just decoration. They are peculiar objects that pull at us, tugging us a little out of the world. A picture will leave me unmoved if I don't take time with it, but if I stop, and let myself get a little lost, there's no telling what might happen. Caravaggio put Franz into a sexual frenzy. Fra Angelico, the sweetest of the pious Florentines, made Brigitte dizzy and gave her an irregular heartbeat. Masaccio melted Kamil into a helpless puddle. Their experiences must have been embarrassing, but they are part of the risk of really looking. Who among us (besides Mark Twain) is so stable that we can say no painting could move us? And who among us is so superficial that we don't *want* art to affect us? What exactly would paintings be, if they didn't have the power to hit us where we live? The experience of looking can be, should be, hard to manage.

Another of my letters is from Rob Klinkenberg, an editor and translator who works in Amsterdam. He cried once looking at Anselm Kiefer's gloomy landscapes, and he has an open mind and a good eye for the kind of attention paintings need. Kiefer is one thing, he says, but Rothko is another. He wouldn't cry in front of a Rothko—but once, he felt a nearly irrepressible urge to clap. It happened in the Museum of Modern Art in New York. He was walking

by a side room when he felt as if something had pushed him. He says it was like the feeling of sleeping on a train, when "you suddenly have to open your eyes because you feel someone is staring at you." He looked into the recess, and saw a painting of Rothko's. "Its presence was so unmistakable," he writes, that "I nearly wanted to step forward and warm my hands on it. That was when I lifted up my hands in an involuntary gesture, because I wanted to applaud. But I immediately felt ridiculous, and refrained. The sound of two hands clapping does not go well with paintings."

Now *that's* crazy, clapping for a painting—or is it? The history of the Stendhal syndrome shows that tears aren't the only litmus test of a heartfelt encounter. Our thoughts and feelings are too wayward for that. Rob isn't sure about clapping, and neither am I. (It would certainly attract the attention of the guards.) But that feeling of sleeping, and knowing you're being stared at, that feeling of being tapped on the shoulder, being pushed from behind—those are sure signs that something unusual is happening.

The syndrome and the malaise are like the two tail ends of the bell curve of human response. On the far left are Magherini's wild patients. (Rob is in there somewhere, too.) On the far right are the stolid people who suffer from the malaise. They're the cold fish. Some are perverse, like Twain, and others are just cynical or so hardbitten by postmodern irony that they can't let themselves feel much of anything. The bell curve runs from hot to cold: from the heat of impulsive crying or clapping, to the frigid decorum of the silent museumgoer. Both tail ends are interesting in their own right.

Sadly, most of us huddle under the middle part of the curve, where we feel about the same amount: not too much, not too little, and pretty much what everyone else feels. We're not quite sure how to behave, so we look around to see how other people see. Those other people are mostly silent. They whisper politely, they smile, they make gentle decorous gestures. Naturally we look askance at people like Franz.

4

Crying because you've been hit by a lightning bolt

Scene IV
The forest.
Enter ROSALIND, *dressed in boy's clothes, and* CELIA.
ROSALIND. Never talk to me; I will weep.
CELIA. Do, I prithee; but have yet the grace to consider that tears do not become a man.
ROSALIND. But have I not cause to weep?
CELIA. As good a cause as one would desire; therefore weep.
— Shakespeare, *As You Like It*

"Give me some tea—I'm thirsty—and then I'll tell you," he answered. —"Mrs. Dean, go away. I don't like you standing over me. —Now, Catherine, you are letting your tears fall into my cup. I won't drink that. Give me another."
— Emily Brontë, *Wuthering Heights*

AN ENGLISH PROFESSOR at a western university wrote to me about a picture his wife had painted, showing their bed empty and unmade. Some time after she painted it, she had an affair. The man says that one day, he was alone in the bedroom. He was standing by the bed, and he happened to look up at the painting. At last he real-

56

ized what it meant: it was their bed, which his wife had abandoned. He began to cry.

It is tempting to sweep this kind of story under the rug. It's raw, and it sounds more like a confession than a story about a picture. My correspondent didn't even bother to describe the painting: its quality didn't matter to him, only its subject. The story seems different from the ones I described in the last chapter. After all, Franz, Brigitte, and Kamil may have been suffering from the dubious Stendhal syndrome, but at least they were afflicted by major works of art. Caravaggio, Fra Angelico, and Masaccio are all old masters, and there is good reason to be at least a little emotional when you see them. The English professor's wife's painting is a different matter.

People like the English professor seem to be really hopeless cases, because they are driven to tears by paintings that are entirely worthless on most people's scale of values. Their reactions don't depend on education, high culture, world travel, or art history. All the same, I'm going to try to argue for these people as well.

I think the main problem with the English professor's story is that it sounds too personal. It looks like he cried because his life was a mess, and not because he happened to be looking at a painting. You'd be in the majority if you said his crying was his own business, and had nothing much to do with the painting of the bed. Yet I wonder about that little phrase, "nothing much." There's an entrancing complexity buried in those two words. Did the professor's reaction have *anything* to do with the painting?

Notice how much of the professor's story is *in* the painting. To start, a rumpled bed with no one in it is an unusual subject for a picture. If I saw such a painting, I would wonder why the artist chose to paint an unmade bed. Why not show it neatly made up? Is it a bed for one, or two? And where have the people gone? The painting was almost a stage setting for the end of his marriage.

The professor said he thought the painting was "about 'emptiness.'" That's a fair thing to say about any painting of an unmade bed. Such a picture would have to conjure thoughts of love and loss. When he first described the painting to me, I tried to imagine what I

would have thought if I had seen it. I'm sure I wouldn't cry, and I guess I would probably look more at the way the painting was done. (I imagine it wasn't too skillful, but perhaps it was.) At the same time, I would surely be put in mind of absence and loneliness. In that light, the professor's reaction was only an intense version of something I might have experienced if I had seen the picture.

Another bedroom story. Hannah Pazderka-Robinson, a graduate student in neuroscience, told me a similar story about a picture she owns, of horses "running against a blood-red background." It had hung over her bed for some time. One morning, a month before she broke up with her fiancé, she found herself staring at it, "really studying the thing." Suddenly she started crying, "and couldn't stop for many minutes." She had never really noticed the picture before, and had no particular reason to look at it that day, unless she was drawn to it by some impending sense that the relationship was ending. Even when she wrote me, she couldn't quite put her finger on what the picture meant. At the time, she half-knew she was in love with someone else, and so she might have been struck because the picture made her aware of a "hidden desire for the relationship to end," or even a "fear that it might not end."

We exchanged several letters trying to determine what she was thinking as she looked at the picture. "This honestly baffles me," she concluded at one point, "because I really do love the picture."

Hannah's case seems to have even less to do with pictures than the professor's story, since it looks as if she might have cried over anything that was hanging over her bed. She even told me so herself. "My personal experience is probably peripheral to what's under study," she wrote, "and I fought with myself a bit before sending it." It is tempting to say Hannah was really telling a story about her private life that just happened to hinge on a picture.

But again I can't bring myself to put this story on the trash heap of irrelevant confessions. Both Hannah and the English professor were reacting to pictures, not people, and both were looking closely at the moment they began to cry. Later Hannah reflected on the picture's "blood-red" ground. "That is actually what first attracted me to it,"

she wrote. "As I think of it now, all I can clearly picture is a white horse galloping at dusk across a red desert, with a backdrop of mountains." It must have been a very dramatic scene, and it could well have been inspired by a Romantic painting by Géricault or Delacroix.

Now her fiancé is gone, and she has married. "The picture I now have hanging over our bed is pretty much diametrically opposed," she tells me. "The first picture was all strong colors, movement, and a general feeling of heat, the new one is a picture of mountains, done in watercolor light blues and greys. It is very relaxing, though not nearly as striking. The old picture was pretty 'hot.' It kind of reflected the relationship: tempestuous, passionate, maybe a bit dangerous."

She has not been able to bring herself to look at the old picture since she got married. Only the odd circumstance of our correspondence brought out the fact that the picture had mirrored her relationship in a way so subtle it never quite found words.

These two letters about pictures in bedrooms give me the courage to say that just about any report of crying in front of a painting might really be connected to the picture itself, and not simply to the person's private life. Any picture of horses galloping on a blood-red ground will look tempestuous and even "a bit dangerous." Any picture of an unmade bed will provoke thoughts about loneliness. These people were simply registering things more acutely than others might. And why not? After all, the pictures were in their bedrooms.

Adventures in bad seeing in Paris and Amsterdam. Are there *any* emotional reactions that have more to say about the people who react than the paintings themselves?

Maybe if you cry because you *don't* understand a painting, then it really is your fault. Nuala K., another graduate student, wrote me about a time she visited the Musée d'Orsay in Paris, and had to leave because she was crying so hard. She assures me it wasn't from happiness: "The art, all of it together, especially the wall-sized orientalist paintings, really upset me.... I didn't know what to think about them." She was sobbing because of her inability to figure out a "proper" response. "I hated Paris," she adds, "and for many years, I hated art."

Nuala is not the only person who has cried tears of frustration

because she could not understand paintings. A graduate student at the University of Texas, whom I will call Amy, tells me about a crying jag she had in Amsterdam after going through an exhibit of Rembrandt paintings. They were gloomy pictures, she says, very small and dark. "I felt like Rembrandt had created a tiny, closed world—I felt suffocated when I saw his pictures—they were so intimate that I couldn't fit into them. I felt shut out.... It was like looking into one of those Easter eggs that is hollowed out with a picture painted inside—you can scrunch up to get a glimpse, but all you can ever get is a glimpse." Few of the pictures spoke to her, and she decided Rembrandt had "resigned himself to a dullness of mind." There was no sense of struggle, no transcendent vision, only darkness and discouragement. She ends: "The pictures depressed the hell out of me."

When I first read Amy's and Nuala's letters, I thought I should throw in the towel and admit that some people's tears have less to do with the pictures than with their own states of mind. The Orientalist paintings in the Musée d'Orsay, after all, were once considered unimportant because they appealed *too much* to popular taste. At the time they provoked too *little* anxiety: everyone could see the appeal of a slave market, or a steamy Turkish bath, or a band of soldiers dying in the desert. Nuala seems to have missed that point entirely, mistaking pictures that appeal to many people for pictures that can only be understood by an elite. Even today the Orsay is immensely popular exactly because the pictures are easily accessible: you don't need a Ph.D. to know what it means when a girl in a flimsy robe is displayed in a slave market. (Figure 1 shows the kind of painting that drove Amy to distraction: a patriotic Arab plummets to his death.)

Rembrandt also seems seriously misinterpreted in Amy's letter: many viewers might want to say his canvases are not only inviting, but entrancing. Amy says Rembrandt never struggled, never found any poetry in the dark rooms and somber faces of the people he painted. Most people would probably say that if any artist struggled with darkness, it was Rembrandt. Amy says she missed "transcendence," but for generations of admirers, transcendence has been present in every beam of light in Rembrandt's paintings that comes in a

FIGURE 1: Henri Regnault, *Exécution du Janissaire,* 1870. Museum of Art, Cairo. Alinari / Art Resource, New York.

high window and strikes a dusty bookcase or lights the side of an old man's face. Amy sounds like a student who has somehow managed to get every single question wrong.

But even here I am loath to give up. Notice, for example, how closely the description of Rembrandt's supposed failures matches what most people find in the pictures, but in reverse. Almost everything Amy says is the diametrical opposite of a commonly held idea. She faults Rembrandt for making us "scrunch up" and peer into his canvases: to other people, the effort to see his shadowy scenes is part of the allure. (It means that whatever you discover is that much richer and more intimate.) She says Rembrandt did not struggle with darkness or achieve transcendence: to other people darkness and transcendence are key terms. (Perhaps Rembrandt found them harder to negotiate than Amy thought.) She says the paintings are depressing: other people would praise that quality and call it sobriety, pessimism, or stoicism. In other words, Amy *did* experience a Rembrandt that is close to other people's idea of Rembrandt, but she drew opposite conclusions.

The same goes for Nuala's experience at the Orsay. When she fled the museum in tears she may have been experiencing the same conflicted feelings that many people now experience when they encounter Orientalism. Scholars are still drawn to Orientalist canvases, but at the same time they know Orientalist artists were naive about imperialism and the values of other cultures, and hopelessly old-fashioned about the sexes. It is still hard to look at an Orientalist picture and "know what to think." Painters like Gérome and Alma-Tadema are guilty pleasures: they are sexist and racist, but they're also luxurious and seductive. I have seen people in the Orsay looking at the Orientalist paintings with just that mixture of feelings: they enjoy the faint titillation of half-naked harems and "savage" Arabs. Orientalism is a guilty pleasure, but it's never quite clear just *how* guilty. Does the museum mean to say that the strengths of the paintings outweigh their faults? Are the paintings' politically incorrect subjects supposed to be irrelevant to their quality as fine art? Naturally, the labels in the museum don't give anything away. I suppose most people don't really resolve the dilemma or even think about it much. Amy did, and it drove her out of the museum.

Nuala and Amy reached a threshold of frustration, and then they just out-and-out refused to think about what they were seeing. Their tolerance levels were lower than many people's, and they felt the sting of incomprehension more acutely. Which of us hasn't given up on an artist or a painting, and turned away in frustration? From my point of view, both Rembrandt and Orientalist pictures are interesting because they hold apparently irreconcilable opposites together in strong tension: all the more reason to say that if a person rejects the paradoxes, they are rejecting the *paintings,* and not simply fleeing because of ignorance.

Laugh, and the world laughs with you. Right about now I hear rumblings of discontent from my more academically minded readers. They'll say I have been reading too many letters from weird people. Franz was clearly unbalanced, and not at all a good example of how pictures can be genuinely moving. A person who could cry over a painted dress, as Robin did, might really go to pieces over a real dress. A person who cries in the Turner rooms at the Tate might also cry in the lobby, or at the coat-check. Franz could probably have one of his spells whenever he felt propositioned: there is no predicting such behavior. Hannah and the English professor could have reacted to anything that happened to be hanging over their beds, or anywhere near them. Perhaps I should stick to run-of-the-mill accounts of pictures, or stories well attested in the historical record, and stop trolling in these dubious waters.

I have to admit people cry over the strangest pictures. One of my correspondents wept when she saw prints by the seventeenth-century artist Hendrick Goltzius. (I think of him as a delicate and attenuated draftsman, not an artist who is viscerally powerful.) Others have cried over artists as different as Robert Motherwell, Vieira da Silva, and Joseph Albers. (Albers in particular seems the very model of an intellectual modernist, deeply committed to his work but drained of the desire to provoke such things as tears.)

One person sent me a list of the things that have made her cry, and it's quite a list: "The first time I saw Leonardo's *Last Supper* I was overcome for about twenty minutes. I also cried when I saw

the Sacred Well near the Kailasa Temple in India, and at the hall before the lingam shrine; at the Chapel of the Holy Shroud in Turin, on the stairway up, in the grey chapel, and under the exquisite dome; and looking at the *Portrait of Jayavarman VII* in the Museum in Phnom Phen."

What could possibly be done with such a list?

It isn't looking good for my project when people can weep in front of Goltzius, or the *Portrait of Jayavarman VII*. And that's only the beginning of my problems: an academically minded person might be suspicious of my entire subject. After all, people who cry in front of paintings aren't even looking: their eyes are filled with tears. They could be remembering some stray moment from their childhood, or mulling over a private tragedy, or just feeling the effects of a bad breakfast. No matter what's in their minds, their thoughts are their own. They aren't entertaining the indisputable, public facts about the painting at hand. They aren't reading the catalog, or talking over the picture with their friends.

From an academic standpoint, pictures get their meanings through public consensus. My encounter with a painting is private, but it is informed by whatever is on the public record. When I know what some other people have thought about a picture, then my thinking is guided. I can consider the artist's life, and his or her milieu. I can assess the critics' reactions, and I can consider who has owned the painting since it was painted. In short I can, and should, steep myself in the facts. In comparison, tears are self-indulgent and ignorant.

From an academic perspective it is also important to maintain a relatively calm frame of mind. I need to be sober enough to take in the picture's subject matter, and patient enough to sit down and read a book about what it means. Paintings require study and not gushing emotions. They aren't transparent windows onto other cultures: they need to be interpreted. They say specific things about particular times and places, and those meanings need to be slowly and painstakingly learned. They can't be intuited in a gush of emotion.

What is more, an academic would say, crying isn't even an appropriate reaction to painting. Surely Gauguin didn't want people

bursting into tears when they saw his painting of a green dress. Caravaggio might well have laughed at poor Franz. It could be said that the people I have been quoting are wrong about their own emotions. They feel what they feel, but it is inappropriate, and historically invalid. They are not really *looking* in any responsible way. They are just glimpsing the pictures and immediately breaking down. Weepy people have their problems, and it is probably best to keep them at arm's length—so my skeptical readers might insist.

These are serious, if confused, criticisms, and I'll respond to them throughout the book. The academic study of painting is a tangle of interwoven assumptions. So far I have mentioned, or implied, at least ten assumptions:

1 average reactions are better than extreme ones
2 weepy people are unreliable
3 crying isn't really seeing at all
4 weepy people are self-centered and aren't aware of anything outside themselves
5 if you cry in front of a painting, it's your fault
6 crying is not what most artists expect from their viewers
7 sober reflection is the best kind of response to paintings
8 emotions are likely to be misleading
9 paintings have to be learned just like foreign languages
10 the best way to understand paintings is to read art historical textbooks

I'm going to give each of these complaints a good hearing. For now, I want to address only one of them, which is a kind of root-level misunderstanding.

Is it really true, when all is said and done, that if you cry in front of a painting it is your fault? To my mind, stories like the ones I have been recounting are enough to show that many emotional encounters with paintings are prompted by the pictures themselves, and not the viewers' overactive tear ducts. I've found the argument doesn't quite convince academic audiences, because there's an ingrained belief that crying is private, that it has more to do with inner life than the outer world. But does it?

Imagine you're walking through a large art museum. You stop at a painting of Flemish peasants sitting at a bar and smoking. You notice one of them is about to fall off his stool, and you laugh. Surely that's because the painting itself contains the joke. Or say you're in a doctor's waiting room, thumbing through the medical magazines. You come upon a picture of an operation, and you recoil. You're alarmed, of course, because the picture itself is revolting. It isn't your fault that your stomach tightens a bit, and you get a little shock. I reproduced a number of such images in another book, called *The Object Stares Back,* and I have watched people blanch when they saw those images projected on screen during lectures. In each case, it's the picture that causes those reactions, and I do not fault people for getting a bit sick, or (in the case of the Dutch tavern scenes) laughing out loud.

Some of the best-known paintings in the Western tradition are funny or revolting. The philosopher Richard Wollheim says he finds Matthias Grünewald's Isenheim Altarpiece to be literally unendurable. He has made three trips to Colmar, Germany, to see it, and been repulsed each time. The art historian E. H. Gombrich told me Rembrandt's *Blinding of Samson* in Frankfurt is too violent for him to bear. (In that painting, Samson's toes curl in agony as a ferocious soldier pushes a knife into his eye.) Some modern art is deliberately revolting. The Louisiana Museum of Modern Art in Copenhagen has problems with a sculpture by Ed Kienholtz; in the mid-'90s the museum couldn't keep it on permanent display because people vomited when they saw it. There are also a number of postmodern works that are intrinsically funny. One example among many is Barbara Kruger's photograph of a hand holding a card that says, "I SHOP THEREFORE I AM." In each case it is the artworks that compel people to laugh, or blanch, or vomit.

Although it is a trickier subject, the same could be said about pornography. For those who "consume" it, pornography has an automatic effect. No matter what happens in the viewers' minds, the potential for arousal is in the images. Otherwise, people would use all sorts of images as pornography. (In the documentary film *Crumb,* the cartoon artist Robert Crumb admits to being aroused by pictures of Bugs Bunny. That may sound patently psychotic, but there is a

large market for cartoon pornography. Sometimes the slightest cue is enough to awaken a lascivious eye—and Bugs Bunny has always been a slinky little vamp.)

Sexuality, horror, and humor are in the images. But if they are, then why is crying in the eye of the beholder? Why is it the image that tickles my ribs, or my fancy, but it's my own fault if I cry? If you're walking through a museum, and you have the good luck to be captured by a picture, and if you find yourself crying, then I think it would be a pity to assume it was just fatigue or wayward thoughts from your own past. There is a good chance the painting itself was responsible.

If you think of it, the paintings in our museums are full of pictures that are sad or strange or powerful enough to make us cry. In the old master galleries, there are Crucifixions with Mary and the Magdalen weeping over the dead Jesus, and in the modern art galleries there are paintings of destitute families, and people who are sick or dying (I am thinking of Picasso's early work). Many paintings are also sad in less obvious ways. There are paintings of ruins, deserted landscapes, fading flowers and rotting fruit, people who are alone . . . there is no need to make a list. Any visit to a museum reveals that the preponderance of paintings are clearly about things other than happiness. Pictures that are openly funny, pornographic, or horrifying are in a small minority. Many of the others are out to affect us as strongly as they can.

A weather report on tears. The English professor added an interesting theory (as professors are wont to do) explaining his reaction to the painting of the empty bed. He said the painting gave him a "jolt," and brought him "to the proper experience." It finally forced him to come to his senses by showing him what his wife had been trying to tell him all along. I asked him how he knew he had the *right* interpretation. Could the "jolt" have shocked him into a "wrong experience" and given him the wrong idea about his wife's intentions? He admitted he could have been jolted in the wrong direction: for example, he could have interpreted the painting as an invitation to return to the marriage. His jolt might have cleared things up, or it might have knocked whatever understanding he had achieved right out of him. "Just because one gets the jolt," he said, "doesn't mean one has it right."

True or not (and what interpretation can claim to be absolutely reliable?) the jolt is an interesting moment. The English professor's letter, along with some others, showed me that a picture might be under your nose for years, and then suddenly give you a shock. You might be the wiser for it or you might not, but you'll look at life differently.

The idea of a jolt got me thinking. It was as if he had been hit by lightning: the shock came all of a sudden, out of the blue. It occurred to me there's a parallel to be made between the shifting moods and thoughts that go through a viewer's mind in front of a painting, and the shifting winds and rains of a storm. A powerful picture raises tempestuous thoughts and unpredictable moods, like the variable winds of a thunderstorm. Looking at a strong picture, you can feel buffeted, as the picture pushes your thoughts one way and another.

Weak pictures, too, have their gentle breezes of emotion. Any picture can start the air moving, and the flags flying. An empty, unmade bed is a provocative subject. If it doesn't look peaceful, it will start to condense dark clouds in a viewer's mind. Any picture of white horses running against a blood-red background will raise gusts of uncertainty and unease. A more accomplished painting, say a Rembrandt portrait, may stir up darker thoughts of loneliness, old age, or worse. A truly stark and oppressive picture, like one of Rothko's canvases in the Rothko chapel, condenses a towering raincloud, pitch black and threatening underneath.

For most viewers those mental storms will never get too dark, and rain will never come as tears. Those viewers will leave the museum or the chapel, and the winds will quickly die down and dissipate. But for a few, the clouds will keep gathering as they stand and look, building in strength, buffeting their thoughts, until they are struck by a bolt of lightning—and hurled away from the painting and back into the world.

That is how I think of the "jolt." A sudden shock, or a burst of tears, are part of the much larger and fearsomely complicated meteorology that we experience as seeing. It's universal, this weather system, and it applies in different strengths to any picture. Take Amy's example of a dark Rembrandt portrait, with a face just barely lit by a glancing light. Even a casual observer looking at such a portrait will feel that things are not entirely happy, not perfectly resolved. I don't mean Rembrandt

is dour, and I certainly don't mean he is simply sad. But every well-imagined painting has its currents, its tensions, its uneasy truces of opposing forces. All that is common enough—it is what brings us back to major paintings, and what gives them lasting interest.

Think, then, of your changing reactions as if they were cross-breezes and fluttering gusts of a rising storm. It's the old "pathetic fallacy"—that the storms outside mirror the ones inside—but it is still a good model of the sheer unpredictable complexity of our responses to major paintings. And it helps, I think, to understand what happens when people cry, or are suddenly shocked. Those people are in the middle of very strong storms: they feel the same winds and rain, but at a much higher velocity.

Perhaps crying, or getting jolted, are part of the natural weather system of paintings. If you feel unsteady, and begin to sense the painting pushing or pulling on your thoughts, it is as if the winds are rising. If you begin to cry, it is as if the clouds have finally broken and the rain is pouring down. If you are violently shocked, it is as if you have been struck by lightning. Crying does not happen to everyone, and it is rarer still to be struck by lightning. But rains and winds, thunderclaps and lightning strikes are integral parts of the vast weather system of painting. A tear does not come from nowhere, with no link to the painting's meaning: it comes from the very center of the storm.

This is why I forgive almost any reaction, no matter how far-fetched, personal, inexplicable, embarrassing, or unique. I forgive reactions that don't seem to mean anything, and I even forgive people like Nuala and Amy who cry because they can't see, or they won't see. I regard such stories as a weatherman might: they are the rare storms that can tell us so much about the daily breezes and light clouds that accompany our ordinary looking. To understand a violent thunderstorm, you need to study thunder, lightning, hail, sleet, and even tornadoes. In real life, lightning strikes mostly on hilltops, and on exposed heights. The viewers I have been quoting tend to spend time alone in their thoughts, in the equivalent of the barren places where lightning may strike. They are open to the elements, exposed to whatever storms may come by. Most of us prefer shelter. I can think of many times when I began to feel a strange wind blowing in

from a painting, and I closed the shutters against it by reading the label, or moving on to the next painting.

It is not irrelevant that the pathetic fallacy is largely a Romantic invention, and later in the book I'll look into the connections between crying at paintings and Romanticism. Nor is it irrelevant that the pathetic fallacy had an especially low reputation in the twentieth century. The nineteenth century produced Paul Verlaine's lovely line, "Il pleut dans mon coeur comme il pleut dans la ville" ("It rains in my heart as it rains on the town"), but the twentieth century taught us to mistrust Verlaine's kind of Romanticism. I know what I'm doing is old-fashioned. It belongs, I think, in a genealogy of weather metaphors that begins much further back than the Romantic poets, and continues up to the present. But that's for later. At the moment, the storm metaphor is a way of accepting reactions that seem, at first, to be beyond the pale.

A rainstorm in Boston. I like summer showers that start up with no warning and then vanish before the umbrella is opened. No weatherman predicts storms like those. I also love the enchanted spots that seem to attract rain: the damp lee slopes of some hills on the California coast, or the exposed hill bogs in the west of Ireland. It's as if rain comes from great distances to visit them, when the rest of the world is sunny.

A man wrote me that every time he and his wife go to the Museum of Fine Arts in Boston, she goes to see John Singer Sargent's *Daughters of Edward D. Boit.* She stands there, crying, for about twenty minutes. He says she has never offered him any explanation. When I read that letter, I wondered if there might be a connection to what art historians have said about the painting. According to the art historian David Lubin, the painting's true subject is the absence of Mr. Boit—the lack of a father for the four little girls who stand alone in the big room. The picture certainly has a lot of empty space in it. To the "male artist," Lubin asserts, the girls are "costly aesthetic objects . . . playthings or puppets," things "to be trodden upon," things that are "ultimately blank or empty." They exist there, in the empty box of a room, awaiting their absent father. (The painting was given to the

museum by the four daughters, Mary, Florence, Jane, and Julia, in memory of their father.)

I don't find Lubin's psychoanalytic take entirely convincing; but even so, there may be a quality in the painting that disturbs memories this woman cannot quite recover. I am happy to admit that pictures affect people in entirely personal ways, but it may also be true that Lubin and this woman are both responding—in their very different, equally personal ways—to a disturbing hollowness in the picture. She feels it acutely and cries; he feels it as an historian and theorizes.

The link between Lubin and the woman who cries is the picture, with its four "ornamental" girls and its dark hollow room. It's a large picture, with an unsettling vacuum at its center. Most of the picture surface shows only featureless dark wood paneling. Even light is absent, because the scene is lit from somewhere beyond the frame. The four girls catch the light, but they don't reflect it on their dark surroundings. The seeds of both viewers' discontent, I'd say, are in the painting itself. If you can resist the painting's cold, invisible spaces, you might end up like Lubin and be content with some theory. If you can't resist the vacuum, you might end up like the woman who sees it and simply cries.

The rainstorm theory helps me be more sympathetic to people like the woman who cries, and it shows me how the professional historian and the woman might be linked. The historian is suspiciously calm, like the eerie lull in the eye of a hurricane. The woman is suspiciously upset, as if she is in a storm no one else can sense.

Traveling into the world of the painting. When I think of the mysterious ranges of people's responses to paintings, Robin's comment, "she had no arms, but she was so tall," keeps echoing in my mind. The two things go together, tallness and armlessness: they are parts of her amazement at first encountering the *Victory* on the steps of the Louvre.

I showed Robin's letter to Bertrand Rougé, a French art theorist, and he said it reminded him of the reports of people like shamans who go on spiritual journeys and then come back to report on what they have experienced. I liked Bertrand's idea: as I've said, tears are

like travelers who have returned from distant countries, because they are the evidence that people have felt something strong. If the emotions run high enough, Bertrand says, any viewer might be transported into another world "which imposes its rules even though they are in contradiction with the 'real' world." In the bizarre world of the *Victory,* a sentence like "she had no arms, but she was so tall" would make sense: it would be a normal sentence. In our world, we say, "She had no arms, *and* she was so tall," but in the world of the artwork, they say, "She had no arms, *but* she was so tall." Coming back to our side of things, Robin lost part of the idea of her strange sentence, but she did not forget it completely. Like a child waking from a bad dream, she was speaking half-nonsense, confident that what she said made as much sense as it had in the dream.

Bertrand thinks of the artwork as a bridge that makes it possible to be transported to another side of experience, away from real life. There is truth in this idea. Some people's memories of crying are dreamlike, as if they were somewhere else, "miles away." Other people, who feel things less intensely, can find themselves staring at a painting and not know how long they have been there. Pictures have always been like that for me. They put me in a little trance, and make me forget where I am. Perhaps people who cry travel farther and lose more of themselves. In Bertrand's way of thinking, people who cry in front of paintings are actually taken away: their motionless bodies remain in front of the paintings, but their thoughts are temporarily lost, even to themselves. They are "gone," somewhere inside the world of the artwork. Crying, or shock, is what keeps them there, and when the tears dry up they come back, shaky and unsteady, as if the trip back from the painting led across a narrow bridge suspended high over a gorge.

I'll call this theory the trance theory, or the traveling theory. It is another old one, even older than the pathetic fallacy. It's the idea of possession or trance, and it has its roots in prehistory. It also has antecedents in several earlier centuries of Western art—think of Bernini's *St. Teresa in Ecstasy,* in which the saint is transported into her vision. Later in the book I will try to fit the traveling theory into place in the history of crying. In a subject like this, no matter how dusty a

theory is, it might help, and a very dusty theory might fit the best. I say that because I hope it's true: at least I know there is no hope for a well-behaved, legitimate-sounding theory where things are so wild.

Like storms, traveling helps me see that people who cry are not just enclosed in a world of their own. Even though they are taken away, and even though they come back as amnesiacs, they were not dreaming. Their eyes stay open. People who have cried at paintings are not like shamans, because they keep their eyes always fixed on something everyone else can see. And they are not like Dorothy of Oz, who dreamt she was in Oz but was really knocked unconscious by a door. They have one foot in our world, and the other in the illogical, irrational domain of the artwork. They might say odd things, like Robin did. They might come back quickly and violently, like the English professor, suffering from an excessive enlightenment. However it happens, people who have cried have experienced the painting, responded to it, lived in it for a moment or a minute. When they come back, what they have to say can be both valuable and true.

I love storms and trances because they just won't make sense. They are not predictable, and they certainly aren't rational. Lightning strikes are lovely because they are violent, loud, frightening, and dangerous: the very opposite of nicely behaved philosophy or history. It is entirely fitting that people who survive lightning strikes can have odd symptoms, as if they had brought part of the logic of the "other side" home with them. Some have fixed heart rates that never go up or down; others lose their sense of temperature, so they walk around shirtless in the winter; at least one man lost his sense of smell. I expect strange symptoms from people who have been struck.

The violent, the heartfelt, and the unpredictable are my subjects in this book. Still, in the meteorology of passions most of us keep to the nice sunny days in spring and autumn, where everything is calm and clear and you can see to the horizon. As we live out our safe, diluted passions, it helps to recall there are also gloomy cold nights, stifling fogs, and superhuman winds that can pick us right up off our feet, or strike us with a lightning bolt out of a clear sky.

5

Weeping over bluish leaves

We passed still farther onward, where the ice
Another people ruggedly enswathes,
Not downward turned, but all of them reversed.
Weeping itself there does not let them weep,
And grief that finds a barrier in the eyes
Turns itself inward to increase the anguish
Because the earliest tears a cluster form,
And, in the manner of a crystal visor,
Fill all the cup beneath the eyebrow full.
— Dante, *Inferno*

THE CENTER OF COOLNESS, the most elegant place in Manhattan, is the Frick Collection on East Seventieth Street. In comparison with the brownstones down the block, the Frick looks embalmed, as if it were a royal crypt transported from some French cemetery. When you're inside, the city is hushed and voices are damped to a soft rustle. The Frick has lovely air. To me it has always smelled as if it were scented with the finest particles of disintegrated books, purified by centuries of quiet breathing. I loved the embalmer's smell when I was young, without thinking much about it, and I love it even more now that the place reminds me of a tomb.

The Frick Collection never changes: it always has the same paint-

ings in the same places. When I was a teenager, I used to walk around to see the Vermeers (one in a hallway close by the entrance, and another in a back room), but that was just a way of circling my favorite painting, the only picture that could draw me all the way from my parents' house in upstate New York down into the city: Giovanni Bellini's *Ecstasy of St. Francis* (colorplate 4). Probably from the time my father first took me to see the Frick as a young child, I was mesmerized by Bellini's bluish leaves and waxy stones. My father once told me that when he was younger, he'd gone specially to see the *Ecstasy of St. Francis,* but he didn't say exactly why. I wondered about that, and eventually the painting got its grip on me as well.

Of any picture, this is the one that has brought me closest to tears. I may never have actually wept in front of it—it's been a long time, almost thirty years—but I remember standing there, choked up, with a rush of half-formed thoughts swimming in my head. When I was thirteen or fourteen, the *Ecstasy of St. Francis* was almost too much to look at: I recall thinking I could only take in a few details on each visit. It wasn't a painting, really: it was a dream of what a painting might be. By comparison other pictures were clumsy illustrations where things were, as Beckett put it, ill seen and ill said. Somehow, the *Ecstasy of St. Francis* resembled the way I thought. It had the right texture, it pooled in the right places. When I looked, it was as if words had been swept out of my head and replaced by brushstrokes and colors. The word "magical" doesn't do justice to what I felt, but then again I can hardly remember what I felt: I was attached to the painting in a strange fashion that I have nearly lost the ability to recall.

Why memories should fade. If the *Ecstasy of St. Francis* were hung in some faraway place, I might only have seen it once. My memories of it would have faded, in the natural fashion of things that pass and are forgotten. But it is in the Frick, just where it has always been. Each time I go back, there it is: the same size, the same colors, the same cracks. It seems almost cruel of the Frick not to put it away, and let it dim into some poorly remembered shadow of my childhood, settled in comfortably among the other things I have outgrown. Then, maybe,

I could visit it in my imagination and remember again the pure amazement of those first trips to East Seventieth Street.

In the past, paintings did fade into memory, and people had to cherish their memories or risk forgetting the pictures altogether. Before the invention of airplanes and cars, paintings were substantially harder to see, and before the rise of modern public museums, the majority of paintings were effectively off-limits to most people. We tend not to notice such slow changes in our cultural habits, but they have a far-reaching effect on the ability pictures have to move us. In prerevolutionary China, before there were museums in the Western sense, paintings were largely in the hands of the court or of aristocrats. Aspiring painters sometimes made long and arduous voyages with the hope of persuading owners to show their jealously guarded masterpieces. Some paintings became the objects of almost religious veneration. They were copied, of course, but no one could entirely trust a copy. A painter might only see a rare painting once, for a few minutes, and then it would have to be held in memory for years, and perhaps for an entire lifetime. Painters who wanted to learn the style of some ancient master would be lucky to see two or three of the master's paintings in a lifetime of traveling.

Today everything has changed. We can fly quickly from city to city comparing pictures, or wait for large traveling exhibitions to bring together all of Pollock, or Cézanne, or Picasso. These days reproductions are good enough to serve as passable stand-ins for the originals. If you're on vacation and you see a picture you like, you no longer have to store it up in memory against the near-certainty that you'll never see it again. At the very least, you can buy a book or a postcard to remind you of the original and keep your memory fresh.

Most of us are happy with the new arrangements: within limits, we can see what we want when we want. Yet I wonder if the Chinese customs might not be better than ours. If I had known I would only see Bellini's painting once, I would have looked hard, and tried to memorize it. I might even have made a sketch of it, and labeled all the colors. Later I could have tried to nourish my memory by reading over my notes and trying to call it to mind.

Memories are lovely things because they are unstable. Each time

you recall something it changes a little, like a whispered secret that goes around a room and gradually changes into nonsense. If I hadn't seen the *Ecstasy of St. Francis* again, my memories of it would have slowly altered to fit the changing shape of my life. Who knows?—the painting might have crystallized into an emblem of my childhood. Probably it would have blurred together with memories of other paintings. These days it is hard to let any memory grow old naturally, because it is so easy to get good-quality photographs of paintings. Looking at a photograph refreshes your memory, artificially sustaining it when it might be best to let it recede with time and be gradually lost.

Aren't memories supposed to be things that get dimmer with time? As you grow and get older, most things in life change along with you. My childhood possessions, the ones from the years when I visited the Frick, are long gone. The few that remain are old, broken, and unusable. The people I know are growing older along with me, adding wrinkles imperceptibly year by year. Music and novels aren't like paintings: they age the same way as a person does. I remember tremendous performances of music that can never be recaptured. Each year I remember them a little more poorly, and that is as it should be. I may never find the time to reread *Crime and Punishment* or Milton's *Paradise Lost,* and so my thoughts about them keep changing, getting less accurate, shaping and reshaping themselves each time I recall them. The memories and half-memories of books and music are part of what I am, and I am not sure it makes sense to doggedly reread and reexperience things I encountered long ago.

With pictures, though, that is exactly what happens. A picture can be taken in so quickly, and reproductions of it can be so accurate, that it can be impossible *not* to see it again and again over the years. After a while, the effect is numbing. I have seen the original *Ecstasy of St. Francis* many times, and I've also seen it projected in classrooms, in books, and even on postcards. With more popular paintings, the situation is even worse. Paintings like Munch's *The Scream* and Leonardo's Mona Lisa have been effectively ruined for me. Not only have I forgotten my first encounters with them, which were sometimes intense, but I have almost forgotten that they mean *anything.*

A few years ago I was out walking in the neighborhood of my old elementary school, and I suddenly remembered the amazing twenty-foot-high swingset and the daunting jungle gym with its web of criss-crossing bars. They were very clear in my mind. I even remembered one time I had tried to swing so high I would go completely over the bar. (The swing went up too far, the chains went slack, and I nearly fell off.) Thinking of those things, I walked into the schoolyard, hoping to revisit the place and replenish my memories. The jungle gym turned out to be a simple construction of welded pipes, and the swingset was just over head height. I was disillusioned, but even more than that, I realized the sad little jungle gym had erased my memory of its grand imaginary cousin. Looking at the shiny pipes, worn smooth by generations of hands—including my own—I lost the picture I'd had in memory. The everyday object vanquished its magnificent rival, and I did not think about the playground again until I came to write these lines. It doesn't always pay to study and restudy a thing, because memories are not like building blocks or filing cards that just pile up. A wonderful, magical first encounter can be wholly erased by a thoughtless perfunctory visit.

Each visit I make to the Frick snaps the *Ecstasy of St. Francis* back into focus, correcting the errors of my memory, hauling the picture back in front of me. The painting is like a figure in a feverish dream that seems always to recede and yet remains fixed in place. I can see it, and yet I can't—it's as if my eyes won't stay focused. Some people look forward to returning to a painting they had seen years before. When they see it, they are reassured that some things in life don't change, that the painting will always be there. But for me each visit is an uncomfortable experience, because the picture chafes against my memories. Why not prefer the memory to the real thing?

I imagine what would happen if I kept a diary of my memories of the painting. I would take it with me each time I go to see the painting. Once there, I would note where the diary went wrong, and erase whatever doesn't match the facts. After a number of years, the diary would be blank. Nothing in my memory would be right: the painting and my thoughts about it would go their separate ways.

I don't keep such a diary, and it's probably just as well. When I saw the painting again last winter, after an absence of more than five years, it seemed very far away. It looked inaccessible, a shining blue beetle caught in an amber stone.

Oozy rocks and odd colors. Physically, nothing has budged in the thirty-odd years since I first set eyes on *The Ecstasy of St. Francis.* The painting is still centered on its wall, flanked by its perpetual companions, two portrait paintings. On the left is Titian's picture of a pale young man in a black-speckled ermine coat. He wears a rakish red felt cap that looks as if it had been sewn together from cutting-floor scraps. He seems poetic but vague, and he fingers a shabby glove. On the right is Titian's portrait of his friend Pietro Aretino, a yellow journalist and man-about-town, known as a womanizer and part-time pornographer. It is a flat picture, dully painted, and Pietro has an obtuse expression as if he has just been hit in the face by a frying pan.

Below *The Ecstasy of St. Francis* are two green chairs bordered in green tassels, like the prize antiques in a funeral parlor. A dusty rope hangs in an exhausted curve between them. A huge lamp is cantilevered out over the painting. The bulbs are hidden by a curved metal shade covered in peeling bronze paint. Since there are eight brilliant reflections along the top edge of the painting, alternating incandescent white and cobalt blue, the lamp must house a row of bulbs, four blue and four white. (On my last visit, one of the white bulbs had burned out, leaving a gap between the glares, and imperceptibly tipping the balance of color toward blue.)

The painting itself shows St. Francis, dressed in his monk's robes, looking up into the sky. He is barefoot (his sandals and walking stick are back at his little desk), and he is surrounded by a swirling sea of bluish rocks. They're hypnotic, those rocks. Some look chalky and dry; others ooze like melting jello. Immediately above the saint's head, the cliff face divides and flows around him, as if he were a boulder in a stream. (Bellini may have been thinking of an early legend in which St. Francis escapes the devil by melting into the cliff. According to the story, the rocks parted like wax—a perfect match for the

liquescent stones in the painting.) Toward the top of the painting, an arc of yellowish rocks mimics the saint's pose; even the gatherings of fabric at his waistband are echoed in the tendrils of ivy spreading from a fissure in the rock.

The color is a mystery. Some rocks are safety-glass blue. Others are bottle blue, or the blue of cold wet grass. The blue deepens downward, toward St. Francis's feet. Above his head the cliffs are creamy; perhaps they are reflecting yellowish light from the afternoon sun. As you look down, the cream dims to a fluorescent beige, then darkens into a deep glowing turquoise. It looks as if St. Francis were wading in a chlorinated pool, moving slowly down toward the deep end.

Strangely, there is no green between the yellow and the blue. As any painter knows, that's a trick, since even a dab of blue paint will turn yellow into a bright leafy green. Somehow Bellini avoids that trap, and his candent yellows settle into somnolent blues, without even a hint of green. Some of the blues are stained by browns—there are scatters of fine dirt, and a fuzz of blighted grass—but nothing around the saint is normal, healthy plant green. Just under his right hand is the torn stump of a fig tree. Normally the inner wood and sap would be a tender sap green, but here the ripped surface reflects a wan yellowish light. Even the juniper and orris root in the saint's garden have an odd blackish color.

In the distance things have more ordinary hues. A slate-gray donkey stands in a close-cropped field. The grass under its feet is parched and marred by thistles, but overall the field has the common color of grass. Farther off, a shepherd herds a dozen sheep across a field of tender yellow vegetation. The distant hill is carpeted in dark viridian trees shaped like cotton balls. (The trees have an unfortunate resemblance to the tassels on the chairs in front of the painting. Bellini's green is wonderful and resonant, and the chairs are ersatz. That bothered me even as a teenager.)

How to paint a miracle. Clearly something mysterious is happening. In the distance it is early summer, with an Italian azure sky and a late afternoon sun. The air is clear and sunny. But the foreground is plunged in a mystical night. The sun seems to be shining on the saint,

because it casts strong shadows behind him, and weaker shadows trail from his trellis, his walking stick, and the footrest of his table. Yet just a few feet farther on there are no shadows. The saplings and briars bask in a shadowless haze. The donkey casts almost no shadow, and a big tree behind it is entirely shadowless.

Is the saint looking up at the sun? Possibly; his robe is warmed by an ochre light, and he even has a tiny yellow glint in his eye. A bluish light lingers around his hermit's retreat like a toxic fog. Why doesn't the sunlight penetrate it? And what exactly is St. Francis looking at? His eyes are fixed somewhere up above the upper-left-hand corner of the painting. In the corner itself, the clouds suddenly become sharp-edged and yellowish, and a laurel tree bends in a strange way, as if someone has jumped into it.

When I was young, I thought there must be a true miracle somewhere to the left of those clouds, out beyond the picture frame. I thought the saint is experiencing something so tremendous that Bellini knew that he couldn't paint it. Looking at the picture was like looking at an eclipse by watching its image cast on a sidewalk. I saw the bluish rocks, the saint's astonished and serious face, and the uncanny light, but I wasn't allowed to see what he sees.

Then, sometime when I was in my teens, I read the stories about St. Francis's stigmatization. According to one version, he had been meditating late at night, when a blinding light fell over the landscape. He turned toward the light, and was pierced by the stigmata—five wounds in imitation of Christ's punctured hands and feet and his cut side. Since the painting is called *The Ecstasy of St. Francis,* I looked for the wounds, and found two small ones on the saint's hands.

The painting is meant to show the moment of the stigmatization, but it does so with extraordinary subtlety. It is only nighttime in the front of the picture. (Some historians prefer to say that the entire picture is meant to be a night scene, despite what their eyes show them.) Heaven doesn't open up and spill out angels, and there are no streams of blood from St. Francis's wounds. I imagine most visitors to the Frick see it as a picture of a saint in a landscape, praying. You'd think that if the revelation had taken place at night, and a brilliant yellow light had shone on the saint, everyone in that distant village

would have come running. It *is* a revelation, but it is exceedingly sub-
tle, and only a few creatures take note of it. The donkey's ears are
pricked back and its mouth is slightly open as if it were dully aware
something is happening. Just under St. Francis's right hand, a rabbit
peeks out of its burrow: it is alert but walleyed, and its stare doesn't
reveal what it sees. At the far lower left, in a dark ravine, a small rus-
set-throated bird looks skyward. It might be craning its neck to catch
the water that drips from a stone spout, or it may be trying to see the
miracle overhead. In the far distance, the shepherd turns and looks
our way. And most subtle of all: toward the rear of the flock one ram
is painted very carefully, and it stares right at St. Francis.

Assisi and Ithaca. When I first saw how this worked, I was won over.
Bellini must have been uncomfortable with the idea of a heaven pop-
ulated by people in robes, and he kept the saint's supernatural bleed-
ing to a minimum. He was uneasy, too, with the idea that the night
sky could have been lit up by a miraculous searchlight. The painting
shows how a miracle might look with the volume turned way down.
It takes place in an almost ordinary midafternoon, and produces only
a few spots of blood. There is no angel and no costume melodrama.
Instead, the landscape is the miracle. Because nothing is quite what it
should be, everything is partly sacred. The rocks and trees are nearly
supernatural, so that the sky and the saint can be practically normal.

As I remember it, I was satisfied to have the answer in hand, so I
knew what the painting is really about. Because I am not a Christian,
and since I had no thought of studying art history, I wasn't particu-
larly interested in that end of things—I didn't really care about the
doctrine of the stigmatization, or the idea of a miracle. What I loved
was the diffusion of sacredness, the rapt attention Bellini had paid to
every detail.

The house in Ithaca, New York, where I grew up fronts woods
and fields. I was used to looking at plants, and I recognized many of
the plants and rocks in Bellini's painting. Our eaves were heavy with
grape vines like the ones in the panting, and the woods behind our
house had ivy, maidenhair fern, and briars very like the ones Bellini
painted. I knew the feel of chalky limestone cliffs, and dark wet clefts

in the rock where water drips all year around. I had climbed over rocks like the ones in the painting, and gotten scraped by dead branches that sprang straight out from the vertical rockface. I had wedged my feet into holes like the one Bellini painted, and grabbed onto saplings like the ones he planted at the top of the cliff. Even the saint's retreat looked familiar, because I had explored limestone caves. The damp cave opening, the natural lintel stone above it, and the scrub slope on top were things I knew from boyhood adventures. Bellini had some Italian things in the picture too: we didn't have fig trees, laurels, or medieval castles in upstate New York; but we had donkeys, herons, rabbits, sheep, and places to run and hide like the one St. Francis found.

As a boy, I was entranced by rough slopes, clefts, caves, and thickets because they were overlooked details of landscapes. People wouldn't ordinarily stop to admire them. I loved tracts of dense brush no one could penetrate, slippery slopes no one would visit, knotted vines, and briars glowing red in a thicket of brown twigs. I knew that once you get beyond parks and picture postcards, nature is messy and tangled and full of ordinary things. I suppose I sensed a deep affinity with Bellini, since he had looked at the natural world long enough to realize that plants aren't symmetrical, and that rocks come in shapes beside blocks and balls. The *Ecstasy of St. Francis* showed me things I was ready to recognize: stones that are lumpy, trees that bend into strange curves, birds that crane their necks to the sky, tattered clouds. The beauty of it was that Bellini wasn't just playing or daydreaming, as I had been doing: he was finding evidence of a miracle. If I came across a bluish rock, I might have said it was blue because there was copper in it. Bellini's rocks are blue because they are reflecting a revelation. The little plants at the saint's feet, clinging to slight depressions in the rock, are more than just scraps that nature has thrown down: they are witnesses, bathed in a holy light. The *Ecstasy of St. Francis* is an entire world where every twig and thorn has its measure of holiness. A contemporary of Bellini's said he loved to "wander in his paintings." Certainly that was true for me: I loved every last, lost detail in the painting, and the more lost the better.

I looked especially long at the plants that sprout along the bottom

margin of the painting. (They were easier to see because they were at my eye level.) In front of the saint's feet, for instance, there are four stray plants. Most artists would have painted a corsage of four stems, with leaves all around in a pretty circle. Bellini would never be happy with such a cliché. The left-hand seedling has a straight stem, with one tiny leaf down low, and a crown of leaflets at the top. It isn't possible to tell how many, because he has let them rest on one another in a tangle. The third sapling is a masterpiece: it wavers slightly on its way up, and then splits into two twigs. Three tiny bluish leaves nestle in the fork. Both forks are barren. One shoots out to the side, and the other sprouts an oscillating tendril, and ends in an upward flourish. The wavering stem is an echo of the wavering laurel tree, on a scale so small it would never be noticed. (It is as if the little twig experiences another, smaller miracle of its own.) The painting is replete with these miracles of close observation: each leaf is polished to a dark shine, each stone is enameled. At the far upper right, three tiny tendrils hang down. The longest one, so thin it looks more like a blond hair, has four delicately lobed leaves hanging on bell-shaped stems; it ends in nascent seedbuds so tiny they escape into the surface of the painting.

It was the lostness of the painting that held me, its capacity to lodge my attention on some forgotten detail. Like all great paintings, it changed the way I saw real landscapes, and I started paying even more attention to the tints of rocks and the shapes of clouds. I noticed when a leaf was too tiny to notice, or when a stem deviated as if it were being pushed gently to one side. I watched the broken paths that light follows as it finds its way through foliage to the ground. I would never have said it this way, but the painting was a kind of bible without words: it taught me how to find meaning in the smallest scrap on the forest floor, or the dullest glint from a nameless stone.

The poison well of art history. That was then, and this is now. Now, I feel almost nothing for the picture. I can recapture part of what I once felt, but the intensity is gone, and so is my conviction. Once I was transfixed by a world where every ordinary object glinted in a half-sacred light. Now I can't quite see that: I have tried to remember

what I looked at, and I have gone back and looked again, but it's not a transcendental painting anymore. I can still see that Bellini labored over plants and stones, and sometimes I can almost picture the young man who spent so long in front of the painting almost thirty years ago. But the miracles have drained out of the painting. It's a beautiful picture—but as I write that word, I know how it would have rankled me thirty years ago. I might have said "beautiful" is a pale word, better suited for a museum than a miracle.

I put the blame for this squarely at the feet of art history. Over the years I read more about Bellini, and about the painting, and my attraction to it was one of the reasons I eventually went on to study Renaissance art. Yet each time I learned something new, I lost a little of what I had felt before.

The main disillusionment came with a short book by the art historian Millard Meiss, called *Giovanni Bellini's St. Francis in the Frick Collection*. Meiss sets out to stop people like me, who only want to see rocks and birds. He wants to restore the picture's original historical purpose. He is at pains to demonstrate that the painting is a proper representation of the stigmatization, and that the saint is looking directly at, and receiving his wounds from, the cloudburst at the upper-left corner of the painting. His book has a close-up photograph of the region, and you can see dozens of tiny spikes of light shooting out from a cloud, and streaming in the saint's direction. They're like long yellow needles, lances of sharpened light, and as far as Meiss is concerned they are the source of the revelation: they travel invisibly through the air, becoming impossibly fine and sharp, piercing the saint's feet, his hands, and his side. They cause the tiny droplets of blood that appear on his palms, and a minute puncture on his forward foot.

Meiss is right, I'm sure. He lines up other paintings as witnesses, demonstrating that Bellini had toyed with the idea of painting an *Ecstasy of St. Francis* without the usual seraph in the sky. A few years earlier, Bellini had painted another *Ecstasy of St. Francis* with a tiny angel and cross hidden up in a corner where it would hardly be noticed. In another painting he had hung a translucent angel in a twilit sky like a Japanese paper lantern. It is clear Bellini wanted to do

away with the clumsy machinery that earlier painters used, where the angel floats in the sky as big as life, and lines connect his hands and feet to St. Francis's hands and feet. Even Giotto had followed that obvious machinery: he had taken out his straightedge and drawn lines, tying angel to saint in connect-the-dots fashion. A viewer who has never thought about it before can figure out how the stigmata works by tracing Giotto's lines: the one from the angel's right hand goes to the saint's right hand, and so forth. Bellini wanted his viewers to concentrate on the saint's ecstasy, and not on the technology of miracles, so he evaporated the flying angel and nearly erased the lines. Meiss says, in effect, This is a proper early Renaissance religious painting, and it's not right to evade that by imagining Bellini was saying that nature itself is sacred.

At first I tried to wriggle out of Meiss's solution. I noticed that the shadows at the saint's feet don't come from the yellow clouds, but rather from somewhere off to our left. The saint doesn't look at the clouds, but at a higher spot. And the town in the distance is definitely not a night scene, as it should be if Bellini were literal about his sources.

Art historians have answers for these objections, of course. They say Bellini was just mastering perspective, and so it's to be expected that the shadows are a bit off. Neither should we expect him to pay too much attention to the exact direction of the saint's glance, because he was concentrating on the saint's state of mind. Even the unusually bright night could be explained by inexperience. Bellini made this painting toward the end of the fifteenth century, when few artists had attempted to paint night scenes. Perhaps the town in the painting is Bellini's idea of a natural-looking nocturnal landscape—as Meiss says, no one is abroad except the shepherd, and it certainly looks still and quiet. Hollywood directors have done worse trying to convince us that scenes were filmed at night.

I read Meiss's book sometime when I was still a teenager, and I went back to the painting full of enthusiasm, to see if I could agree that the painting works the way he says it does. As I looked, Meiss's examples came to mind—Bellini's earlier paintings, paintings of St.

Francis by other painters—and I compared them with what I saw. I measured the shadows with my eyes, to see if they might plausibly point up toward that corner. I tried to see the painting as Bellini might have, rather than worrying about the exact colors of day and night. I decided I agreed with Meiss, and I still do. (Though sometimes I also suspect that Bellini painted a small angel *above* the top margin of the picture. That way St. Francis would have been looking directly at it. Unfortunately it's impossible to tell, because the panel has been sawed off at the top and an unknown amount is missing.)

It was fun playing Meiss's game, but it had a side effect that I only began to notice some years later. It blunted my interest in the landscape, and it unfocused my earlier enthusiasm. Meiss says that the painting is more than a landscape because it reflects the saint's ecstasy, and he wants his readers to remember that Bellini wasn't practicing botanical or zoological illustration. Meiss says that, but what he actually does is ignore the landscape in order to spend time looking at *other* paintings of angels and saints. He values the painting enough to write a short book about it, but his way of showing his admiration is to investigate the painting's place in history.

Historical knowledge damps our youthful enthusiasms, and if historians and teachers aren't worried about that, it's because they think historical facts correct youthful enthusiasms. But they don't. What I learned from Meiss and others took my own experience away from me and substituted a different kind of understanding. The one didn't correct the other, it swamped it. My historical knowledge dulled my encounter with the image, deflected my attention onto other things (evidence, angels, texts, miscellaneous facts), and finally extinguished the emotion that I had once felt. History wasn't just correcting my illusions, as we fondly suppose. It was alienating me from my own interest.

Once, the *Ecstasy of St. Francis* was visionary: now, it is about a vision. Once, it held me in thrall: now, it is a picture of someone else held in thrall. There are plenty of things to be said in favor of studying the history of an object you love; historical knowledge can temper personal feelings, and lend them the balance of considered judgments.

The painting depicts a landscape near La Verna in Italy, not Ithaca in upstate New York, and it was made by a person who may never have thought of scaling a cliff or crawling into a cave. It was created at a specific point in the Renaissance, and it owes as much to other paintings as it does to anything Bellini may have actually observed.

History can be a good corrective, and I am an art historian because I find history both valuable and pleasing. Some of what I learned did enrich my experience and showed me new meanings. But in its cumulative effect, historical understanding undermines passion. It smothers strong emotion and puts calm understanding in its place. It puts words to experiences that are powerful because they are *felt* rather than thought, and in doing so it kills them. Learning about this painting's history slowly tore down my original responses and dismantled my memories.

At one time the painting was very personal for me. It meant a great deal, even if I couldn't quite say what. Now I can say exactly what, but I am barred from ever feeling it again.

History is insidious, because once it starts to corrode your sense of a picture, there is no stopping it. Meiss started the process, and then in graduate school I read much more. Each text took something I had felt and transformed it into something I knew. Eventually I read enough to realize that even my love of lonely woods was not mine at all. I had inherited it from nineteenth-century Romantic writers like Ruskin. In upstate New York in the 1960s, I had been unwittingly playing out ideas that had been developed in England and Germany in the nineteenth century. The things I loved about the woods—the thorns, the swamps, the slanting light from the winter sun—were all the stocks-in-trade of Romantic poetry and art criticism. Even the word "woods" as opposed to "forest," or the word "cave" as opposed to "cavern," were proof that I was the unconscious heir of late Romantic ideas—ideas that Bellini could never even have thought. I was trapped, forced to admit that my kind of nature worship was a watered-down descendant of ideas that hadn't even existed until fully three centuries after Bellini's death. There it was in black and white at the beginning of Meiss's book: he says that people

once thought that Bellini's painting was nothing but a glorious sacred landscape, and they didn't want to come to terms with the fact that it might be a specific religious event, rigorously depicted. That was my attitude in a nutshell.

From that moment on, if I thought of my childhood experiences at all, it was to interrogate them, to see if I had outgrown my nineteenth-century feelings about nature. (I haven't: I am still entranced by dark ravines, late autumn sunlight, and other romantic clichés too numerous to mention.) Having read Ruskin, I understand more about the Romanticism that was in the air when I was growing up. Having read Meiss, I can see that Bellini's painting is first and foremost a Christian revelation. But I have come perilously close to forgetting why I was drawn to the painting in the first place.

Historical knowledge stripped me of several illusions, but at a huge cost. I can lecture at length on the *Ecstasy of St. Francis,* but I have lost the ability to be moved by it. It's an insidious process: I remember I was moved, and I have recalled enough to write these pages. I can conjure the past, and testify to my obsession with the picture. I can even remember how I stood there, overwhelmed, unable to move. My eyes might well have been swimming with tears. I can say all that, and so I can almost convince myself that I haven't lost anything. But this is a historian's false comfort: actually, I have lost a tremendous amount. History is the "pale cast of thought," as Shakespeare says. It throws a veil over the world, and after a time, our eyes get accustomed to the weakened light and we come to think that the world looks the same as it always has.

What I have described here has also happened with every other work of art that has moved me; but I regret most what I have learned about *St. Francis in Ecstasy.* The painting is there, but my wonderfully intense, nearly indescribable emotions are long gone. I wish I could turn back the clock and recapture those days when I stood in front of the painting, intoxicated by thoughts I could hardly describe. Now the world has dulled, and filled up with dusty words. Before, the leaves were magic: almost too beautiful to be seen without flinching, and colored an impossibly smooth and chilling blue.

6

The ivory tower of tearlessness

Apollodorus, who had been weeping the whole time, broke out in a loud cry which made cowards of us all. Socrates alone kept calm.

"What is this strange outcry?" he said. "I sent the women away so that they wouldn't offend us in this way, because I have heard that a man should die in peace. Be quiet, and have patience."

When we heard that, we were ashamed, and refrained from tears. He walked about until, as he said, his legs began to fail, and then he lay on his back, according to the directions, and the man who had given him the poison looked now and again at his legs. After a while the man pressed his legs and asked him if he could feel, and he said no; then the man felt his legs, and so upwards, showing us that he was cold and stiff.

— Plato, *Phaedo*

Therefore I say that a man should refrain from excess either of laugher or tears, and should exhort his neighbor to do the same; he should veil his immoderate sorrow or joy, and seek to behave with propriety.

— Plato, *Laws*

I CAN'T CRY OVER the *Ecstasy of St. Francis,* or any other painting. I have joined the ranks of the tearless. Like other art historians, I am

fascinated by the pictures I study, but I don't let them upset my mental balance. It's all right for a picture to be challenging, but I don't think of pictures as dangerous: when I look at an image it doesn't occur to me that it might ruin my composure, or alter the way I think, or change my mind about myself. There is no risk, no harm in looking.

The damping-down of my reactions has been a slow process. In part I grew up and away from the paintings I loved when I was younger. I suppose everyone gets sober as they get older; and I've also grown *toward* books and away from fresh encounters with paintings. These days I tend to prepare myself before I travel to see an important painting: like a diplomat getting ready for a summit meeting, I do some background reading and take some notes. That way I come at the painting well armed with thoughts and problems. Often, it works, and I have a richer experience than I would have without doing research in advance: but there is a small, painful price to be paid every time. Each idea from a book is like a little tranquilizer, making the picture easier to see by taking the rough edges off of experience. Once, it seemed there was nothing between me and the *Ecstasy of St. Francis* but a foot or two of empty air. Now it's like peering between the shelves in a library: somewhere back there, beyond the wall of books, is the painting I am still trying to see.

Studying in advance is an ingrained habit for academics, and because I am an art historian, I may have an especially virulent strain of the disease. Yet the same goes for anyone who learns anything about an image: each fact is a shield against firsthand experience. Anyone who has even glanced at a museum label or opened an art book is incrementally less able to be really affected by what they see. I don't deny that historical knowledge paves new roads to the work, deepens and enriches the work, and helps make sense of unfamiliar paintings. But it also alters the relation between the person and the painting, turning seeing into a struggle. You see what's on the museum label or what the guidebook says, and you are lucky if you see much else. Once your head is filled with all kinds of fascinating bits of information, it gets harder to see anything beyond the labels, the audio tours, and the exhibition catalogs.

In university classes, art historians usually caution their students to try to keep seeing for themselves, and not to be dependent on books. That's a real enough danger, and I think it conceals a more insidious problem: the piles of information smother our capacity to really *feel*. By imperceptible steps, art history gently drains away a painting's sheer wordless visceral force, turning it into an occasion for intellectual debate. What was once an astonishing object, thick with the capacity to mesmerize, becomes a topic for a quiz show, or a one-liner at a party, or the object of a scholar's myopic expertise. I am still very much interested in Bellini's painting. But the picture no longer visits me in my sleep, or haunts my thoughts, or intrudes on my walks in the countryside. It no longer matters to my life, only to my work.

Does learning kill emotion? Most people who study pictures are content to read, and let their reading help them see. For them, learning only deepens the experience of pictures. The more you know, they'll say, the more you get out of a visit to the museum. Without knowledge, you're just guessing, and your guesses are probably both wrong and much simpler than what the artist really had in mind. Any number of historians, sociologists, and philosophers have argued the point. The art historian Erwin Panofsky spoke about the need for "cultural equipment," which makes me imagine going to the museum trundling along overweight suitcases filled with high culture. The sociologist Pierre Bourdieu has written about the need for "cultural competence": without it, he says, the most valuable and important art cannot be understood. (It's not entirely clear what that competence is, because Bourdieu is against academic art history, but also skeptical of unlettered appreciation.) Any number of culture watchdogs, from E. D. Hirsch to Allan Bloom, have agitated for the necessity of knowing before you can see. Culture is complicated, they say, and full of ideas. You might as well try to guess what an electron is, as try to appreciate the Mona Lisa without reading about it first.

There are good arguments on both sides of this debate. Other people—a smaller number—have some things to say in favor of naked, ignorant experience. The philosopher Curt Ducasse has said that

when historians bring their "cultural equipment" to bear, they aren't really seeing what they're looking at anyway: they are appreciating all the ancillary and accidental qualities of the work, like its medium, its dimensions, and the names of the people who commissioned it. Ducasse says scholarly and historical information like the artist's birthdate does not really matter, even though too much learning makes it seem as if it does. I'm not too happy with his argument, because it divides the work's real meaning—which he calls aesthetic— from its added meanings, and I'd hate to separate tears from history. The position I'm taking in this book is closer to two other philosophers, John Dewey and R. G. Collingwood, who have said that no one appreciates any work in full: every response is partial, and any emotion is mixed with its companion thoughts, so why say that one person's experience is off-limits, and another's is legitimate?

These are long debates, like the philosophers' theories of crying. I am going to leave them to one side because they aren't quite asking my question. The division between people who know nothing about pictures and those who know a great deal isn't the same as the division between people who respond emotionally and those who don't. There are overlaps, to be sure, and virtually all academics are in the tearless camp. Learning did kill emotion for me, but I also have letters from people who know a great deal about paintings and still cry.

I'm also avoiding questions raised by Bourdieu, Hirsch, Bloom, and others, because so many people who have joined their debates are chiefly interested in defending and promoting *culture*. They want educated viewers so that the next generation can experience the same sense of culture and history that they feel. In their view culture will be in good shape so long as people can continue to find value in the canon of masterpieces. History is important in their agenda because if everyone just looks, and no one studies, the ongoing conversation about art is suspended. I put this a little baldly, because I want to draw a line between what I am interested in and anything as public or official as culture. I do care that people who stand silently in front of paintings can find something to say to people who stand behind lecterns and talk about paintings, but I have no stake in which

paintings they choose, or how the next generation is educated, or whether our museums remain popular.

Could the two sides talk to one another? The art historian David Lubin, for example, might conceivably have something to say to the woman who cried in front of Sargent's *Daughters of Edward D. Boit*. At least they share the same painting, which appears to be about emptiness of some kind. Yet it's hard to think how the woman's story—if she even has one—could contribute something Lubin might want to add to his next monograph. I never met Millard Meiss, the historian who wrote the monograph on Bellini's *Ecstasy of St. Francis,* even though he was around the Frick back when I started visiting. I suppose it's just as well I never met him. It's hard to imagine Meiss being surprised or really interested in anything I would have had to say.

Can a person who has just cried in front of the Mona Lisa possibly have anything to say to a historian who has studied the painting her whole life? Perhaps it only works the other way around: the person who cries might go to hear the historian lecture, and eventually the weepy person might learn something from the sober one. At least that is the way it would happen if the two people could even understand one another. In my experience people with intense emotional reactions to paintings don't care for the way historians talk, and the feeling is mutual. The gap between what historians write and what my correspondents report looks unbridgeable.

Why I shouldn't have written this book. As part of my research, I called and wrote to a number of nationally and internationally known art historians. I wanted to augment the letters I had solicited in newspapers and on the Internet with the opinions of some of the people who are most knowledgeable about paintings. I asked the historians if they had cried in response to an artwork, and also if they thought there might be a link between the "knowledge" gained by crying and the knowledge—not in quotation marks—acquired by studying. The majority of replies were unambiguous and to the point: crying is not part of the discipline, and has nothing to contribute. The more

famous the art historian, the less likely he or she had ever cried. Based on my somewhat random survey, I would have to say tearlessness is a criterion of good scholarship.

Most of the art historians ruled the question of crying out of court. I was told, for example, that crying is old-fashioned, romantic, and unfitted to twentieth-century art. I was told that serious viewers are right not to cry, and that in any case crying is not what most artists want from the public. I was told that a book on crying has no place in the discipline. "It will close the gates of Harvard to you forever," one historian said—but then he added, "of course, that doesn't mean much anyway." The art historians I spoke to raised most of the points I've been mulling over in these opening chapters: they said that crying is private, irrelevant, incommunicable, misguided, and ignorant. (In so many words, that is: most of my correspondents were very polite.) Some even gave me reasons why I shouldn't be writing this book to begin with: crying, they said, has nothing to contribute to our understanding of pictures. Several people pointed out that if crying *was* somehow relevant, then I shouldn't write the book unless I had cried over a painting.

The historians who helpfully advised me not to continue with my project were certainly annoying, but they're the ones who gave me the impetus to keep going. I decided, perversely I suppose, that I must have hit on the perfect subject for a book: almost no one wanted to talk about it; it was not well defined or widely documented; I may not be qualified to write it; it is unprofessional, embarrassing, "feminine," unreliable, incoherent, private, and largely inexplicable; and it is philosophically dubious and historically outdated. Nothing could have attracted my attention more! Something, I thought, is clearly amiss in what we expect of pictures.

Of all the objections, the one I have the least idea how to answer is the charge that I haven't cried myself. (Or at least, that I can't remember if I've cried.) Perhaps in the end this is like a book of seafaring adventures written by a person who has never been in a boat: accurate but dry. Still, my lack of tears was what kept me curious. It also helped me to be more sympathetic to my weepy correspondents. I

have come close enough to crying to know what paintings are capable of, and it bothered me that my everyday reactions were so weak. It also struck me that if I *had* cried, or if I were the kind of person who cries often, then this book would probably have become too much of a personal memoir. My confused, decadelong encounter with Bellini's painting helped me stand somewhere between the mooniest letters and the most curt and icy skeptics.

There are limits to how much a person can understand emotions he or she has never felt, but at least I've come close. If I had never been overwhelmed by any painting, I don't think I would have tried to write this book. The same goes for readers: if you have been moved by a picture, I hope you can find stories here that will take you even closer. But if, like the people who tried to convince me not to write this book, your interests are intellectual rather than visceral, then let me suggest you have already read too far. Some things can't be taught.

Letters from sober academics. There are many species of tearlessness. Among art historians, it tends to be underwritten by confidence that a lack of emotion is no big loss. One scholar whose work I have long admired wrote me a polite letter, declining to share his experiences. "Dear Mr. Elkins," he says, "Your next project on the Niobe syndrome (art historians moved to tears by what they are seeing) sounds most engaging. . . . For myself, I would rather not participate, even at the risk of confessing to a stony, unfeeling nature." And he signs it, a bit coolly, "with warm regards."

This is typical of several letters, conversations, and phone calls I've had with colleagues. This one is especially circumspect (notice he doesn't quite say he has never cried), but it fits the mold: the historians distance themselves from the subject, and express a brief regret. Indeed, this historian's apology is so perfunctory that it almost looks like he is proud of his "stony, unfeeling nature." Another historian, just as well known, answered me in parentheses, like this: "(the answer is no)." Yet another said she had never thought about the subject before, though she imagined some art historians must have cried. She could almost remember the name of one of them. As we talked, it

became apparent that she had ruled herself out without even thinking. She thought I must have been asking about other people.

Some of these conversations and letters gave me the creeps. People answered me so confidently, and with such emotional distance, that I felt as if I had asked them for the time of day, or tomorrow's weather. It would be one thing if people wondered why they had not cried; but it is quite another when the very notion that they might have cried seemed so alien, so inadmissible, that they automatically assumed I was asking about *other people*. It's the complacency that worries me. If you don't feel strongly, how can you know what's out there, beyond the pale of thought?

The most famous art historian of the second half of the century, Sir Ernst Gombrich, wrote me a long letter all about how other people have cried. (An abbreviated version is in the appendix.) He himself hasn't. "I see that you are going to disprove the passage in Leonardo's *Paragone,*" he writes, citing a passage where Leonardo proposes, "The painter will move to laughter, but not to tears, for tears are a greater disturbance of the emotions than laughter." Gombrich adds that he has never wept in front of a painting, or even laughed, and he tells a little story about his friend, the painter Oskar Kokoschka, who once wept looking at a painting by Hans Memling that showed some bare feet in water. (The story about Kokoschka is wonderful, since he was a large man with big limbs, and the people in his later paintings often have outsized hands and feet. It is lovely to think of him bending over Memling's painting, crying at the delicate naked feet of St. Christopher immersed in water.)

When I got Gombrich's letter, I nearly gave up writing this book: the world's best-known art historian says he's never wept, and he quotes Leonardo, the world's best-known painter, saying that it is *impossible* to make people weep over paintings. What more is there is say after that? How could anyone cry unless they're a bit off in the head?

Luckily the rest of Gombrich's letter shows how. The example of Leonardo is particularly telling. Crying wasn't something Leonardo valued, and he shared that perspective with many artists of his time

and place. It is not accidental, I think, that Gombrich was trained as a specialist in Italian Renaissance art (as I was). Historians of any stripe pick up the values of the period they study, and many are attracted to certain periods by affinities they feel. In relation to what came before and after, the Italian Renaissance is a locus of dry intellection. Relatively speaking—these are treacherous generalizations, but they have their truth—in other times and places, crying was both valued and expected. Even Gombrich's friend Kokoschka cried at least once. So even though Leonardo is the West's preeminent painter, he doesn't stand for the centuries that followed him; and even though Gombrich is the best-known living art historian, his education is not irrelevant to his judgment.

Gombrich says that even though he wrote an entire book on caricature, he hardly smiled, let alone laughed. I would certainly agree it is possible to write a book on caricature without laughing, or a book on crying without weeping—after all, I'm trying to do that myself. But Gombrich's assertion makes me wonder if something might be missing from such a book. That is the big question, as far as I am concerned. What would Gombrich have written differently if he had laughed, even once, while he was writing about caricature? What would other historians have written differently if they had cried, even once?

Needless to say, my profession is not entirely unemotional, even if it is nearly tearless. Some art historians habitually form strong attachments to the pictures they study. Given the emotional climate of the times, strong dry-eyed reactions are easier to admit than weepy ones, and a number of people have told me they have been moved *virtually* to tears by pictures. I don't want to say too much about those letters, because I want to insist on the criterion of actual tears. (As I've said, if I were to let it go I am afraid almost every person who loves paintings would line up to tell me they had been deeply moved at one time or another.) Yet it is also clear that there are many kinds of extremely forceful, personal encounters that do not result in tears: the lightning bolt, for example, and others I'll be mentioning later. The philosopher Richard Wollheim told me he has shuddered at artworks, but never cried. Over the years I have seen several historians and critics get

worked up over artworks, stomping around, gesticulating, overcome with happiness or fascination. One of my teachers, Barbara Stafford, has a wonderful infectious enthusiasm for whatever she sees. Historians like her—a happy minority—are clearly transported by works of art: something in the pictures takes hold of them, and (as Plato would have said) they catch fire. I know a number of very passionate, engaged, enthusiastic art historians, who are deeply attached to paintings, and I am not begrudging that kind of half-wild response—but I would still want to know what it means to say you're *very* attached, or *very* enthusiastic, even though you have never cried.

In all, I talked to or wrote almost thirty art historians. When the letters were all in, I had seven people who said they'd cried at paintings, and only two who were willing to go on the record. Eleven of the thirty said they habitually feel very strongly about art, even though they don't cry. (They were all very shy. One historian wrote saying he hadn't cried, he didn't think emotional reactions were a good idea, and I could not use his name.)

At a rough guess, I would bet that 1 percent of my profession have been moved to tears by an artwork, and another 10 percent let themselves get emotional. The remainder are professionals, in the pejorative sense of that word.

Ascetics. I've been talking about art historians and other academics, but what I'm saying goes as well for anyone whose attachment to pictures is mainly intellectual. I'll hazard another guess, based on my unscientific survey of people in all walks of life, that the majority of such people are content not to feel very much, and that many actually distrust strong emotions. They try not to let themselves be manipulated, and they look askance at people who get carried away. For them the eyes are intellectual organs, made for scrutinizing the world, and the mind's business is to keep control of the passions. Nietzsche wrote some brilliant pages on that kind of person, whom he called "ascetics." For them, the object of appreciating art is indeed to feel something, but feelings have to be managed so they do not get out of hand. Asceticism has its good points: it fosters critical distance and provides the coolness that is essential to any considered

evaluation. But ascetics forget that in addition to seeing, the eye is also an organ that cries; and in addition to thinking, the mind is also an organ that slumps into a miasma of confusion, or burns up in a storm of incomprehensible passions.

Ascetics are fundamentalists of the passions: they don't want to feel, and they have rigid reasons why feeling would be bad for them. Mark Twain was one of them, at least when he visited Milan. Ascetics are related to a more interesting group, whom I'll call wistful ascetics: people who have not cried, but who are taken by the idea of crying and maybe even want to cry.

Robert Rosenblum, an art historian, wrote me a very straightforward catalog of his reactions to paintings. After "some soul-searching," he says, "I must end up confessing that, unlike Diderot's, my own lachrymal ducts have never responded to a work of art." (My letter to him had mentioned the eighteenth-century critic Denis Diderot, whose passionate art criticism was a tonic for the age.) "On the other hand," he adds, "if you're interested in physiology, I have truly gasped (jaw dropped, breath caught, etc.) from the sensation of what I guess we might still call Beauty, or some other kind of magic in art." He lists a few works of art that took him aback, and then he notes—a little sadly, but only a little—that he never felt that way the second or the third time. "In each case, it was a response to my first view of the work. By the time of the second, I was already invulnerable. I suspect we art historians, in particular, wear too much armor; but thank you for suggesting that we might shed some of it."

What a telling phrase, "I was already invulnerable." Certainly that is what history did for me in regard to the *Ecstasy of St. Francis*. It's as if the discipline provides intellectual armor for viewing paintings in safety and comfort. There's something funny but pathetic about the image—scholars tromping around museums in heavy suits of armor, peering through the slots of their visors, anxious about doing battle with little teardrops.

Rosenblum isn't afraid of crying, and he doesn't disdain it. From there it's one step to becoming a wistful ascetic, like the nameless person who wrote "I wish I could cry" in the Rothko chapel visitor's

book. A few art historians who wrote me did express unhappiness about the fact that they have never cried. One was openly envious of people who can react openly to pictures. Another wrote to say that crying in front of a painting might be "one of the best things a person can do," because it could "save you from having to see a doctor or psychiatrist." That correspondent also said people should "open their souls or their minds when they see a picture," and stop holding back. "If you *listen* to the words people *say* when they look at paintings, it's mostly things like ... 'Oh, how wonderful!' ... or else they are just discussing the details of the picture, or trying to find out what the symbols mean, or other technical stuff. But if you can see the picture just for what it is, without restraining yourself, you might be overwhelmed by its beauty, which breaks all the resistance, and tears down all the walls between the object and the observer—even 'inner walls.' In that case ... the painter and the observer grow into one another. They are united, like Siamese twins."

Sadly, she can't bring herself to cry. "One thing I hope for myself," she concludes, "is that I will cry, just once, seeing some special painting. I just cannot. When I visit galleries and museums, I feel bothered by the crowds around me. I hate to have to share all the beautiful paintings with other people. It's hard to feel close and intimate with the paintings when there are so many people around." Once she had "dry tears" looking at Vermeer's *Milkmaid*. That is a funny phrase, "dry tears," and I am not sure what it means. It sounds different from what I felt in front of Bellini's painting, or from the gasps that Rosenblum recalls. My intense and confused reaction to Bellini, Rosenblum's gasps, and this woman's dry tears all share a common trait: they are responses that could lead to tears, like resting places on the way to full crying. This woman's letter is especially sad because she wants so much to cry: she loves paintings, she believes in crying, and she does cry at sunrises and sunsets; but she can't find a way to subtract the distractions long enough to let the paintings do their work.

I won't be surprised if I get a letter from her someday, telling me how she had finally cried at a painting. For her, it is only a matter of finding the right place. For me, and I suspect for Rosenblum, it is not

sounds that have to be subtracted, but knowledge. To cry at *The Ecstasy of St. Francis* I would have to forget what I've learned, and I can't see how that will ever happen. Perhaps in the haze of old age, when none of this matters anymore, I will be able to remember why I was once so deeply affected. But by then I will be someone else, and the stories of history will be far away.

A cynical theory of the discipline. The woman who had "dry tears" is still hopeful, but most of the people I have talked to are not. Instead the problem for them—as it is for me—is to figure out what it means to be so far from tears. I exchanged letters for a while with another historian who feels as I do, that it would be a lucky thing indeed if she were ever to actually cry at a painting. "Art historians are embarrassed to admit that they *have* cried before paintings," she says. "My dissertation advisor eons ago confided to me that he had cried when first seeing the Breughel collection in Vienna, because he saw them in the still bombed-out museum. The entire scene really overpowered him. He told me this as we were discussing why it was art historians never 'went public' about the preference for 'quality.' Now, why don't we? Is it because art historians were mostly men operating in a suspiciously 'feminine' field, and they had to look tough? Art history, as a very 'soft' area of study, was trying to look more 'objective' and therefore more scientific; could it be that saying, 'I like this work to the point of tears' made us sound too much like critics? Are we just prigs?"

Especially in American culture, people don't like to admit crying, and academics are only that much more reserved, and less likely to confess anything personal. Art history is definitely "feminine" in all sorts of ways: it is not a hard science, and it attracts a high proportion of women students. Certainly male art historians have occasionally been at pains to lend it a masculine legitimacy. Even more important, though, art historians do not want to be confused with critics. (That would make them even softer, even more undisciplined.) Weeping sounds too subjective, too unreliable, and therefore too much like art criticism.

In the United States, art history has traditionally been a "soft" discipline, supposedly one of the easiest academic fields—and that alone would be enough to account for what my correspondent was describing. There are other factors as well, which are even harder to admit. I suspect, for instance, that not all art historians have very deep feelings in general, in life. They are often interested mostly in texts and languages, and the trappings of the trade—going to conferences, teaching, getting better jobs. Needless to say, it is not easy to say such things diplomatically. But the evidence is there, in the field itself: art historians are trained to be dispassionate and to avoid judgments of quality. That being so, the field may also attract people who already feel relatively little.

Seven out of the thirty historians I talked to admitted to crying in front of paintings, but several thousand saw my questionnaire and didn't answer at all. The response rate among academics, as a sociologist would say, was unusually low. The overwhelming majority don't cry, never have, and don't wish they could. How can I explain that fact, unless I say that many people who become academics fail to feel anything very strongly? Academia is well stocked with philosophers who know about such things as empathetic reactions, theories of crying and catharsis, and "lacrymogenic experiences" (as one especially serious correspondent put it). There is no lack of people content with their "stony, unfeeling natures." Absence of strong emotion becomes the norm, and I think many academics end up living their lives pretty much without it.

Inevitably art historians produce students who think crying is more or less out of the question, an embarrassment, an irrelevancy, something for neophytes, a breach of decorum, a sign of immaturity. In that respect, art historians are ascetics in Nietzsche's sense. They don't feel much, and that makes them suspicious of people who do: that's my cynical theory of the discipline.

How to understand hedgerows. I don't mean to say that *all* historical learning is poison. In some circumstances, even a tiny drop of historical fact is dangerous, even if it is dissolved in an ocean of tears.

(The Shroud of Turin must have been ruined for some people when the blood turned out to be red paint.) In other cases, reading and looking can go hand in hand. There is no formula. I lost myself in Bellini's painting, and history ruined it for me afterward. Other times I have read about pictures in advance, and then managed to forget some of that learning when I saw the actual painting. History can be a panacea, a poison, or a placebo. Most often it turns out to be a fatal poison.

In all cases, it helps to not be afraid of feeling something personal, something no one else could understand. That's the bottom line in any encounter between a viewer and an image. Another art historian who wrote me, Martin Hesselbein, takes an uncompromising stand on this issue. He says art should be "an intimate meeting," and he tests each new artwork before he is willing to study it, to see if it can have a strong enough effect on him. "Inevitably this viewpoint has consequences," he writes. "I apply it to all styles and all periods, in order to come to terms with a piece of art, to measure my relation to it. What doesn't measure up I consider an exercise." He describes one such occasion, when he was in the basement of the Worcester Art Museum in Massachusetts, looking at a Persian watercolor. "The painting described a weeping man in plain lines; I couldn't read the accompanying Farsi text, but to me the painting was about love, about love at an age when one ought to be wise. Considering his beard and belly this man must have been over fifty years old and could barely stand upright. It seemed that someone was pushing him over. Obviously the scene matched my own state of mind and loosened up memories of so short a time ago."

Martin acknowledges that he responds to pictures for personal reasons. (He says he tends to respond especially to lonely scenes.) Of course that doesn't make for good scholarship. But it does not prevent him from using his emotional reaction as a criterion for each new artwork he encounters. Each of us has a particular shape to our imagination, a certain mix of ideas and memories that makes us respond. I remember enough of my early childhood to know why I am drawn to woods and cliffs, and I also know that I am partly pro-

jecting that matrix of memories onto Bellini. But only partly. Some of it is already there, in the painting (or if you prefer, in the painting as it has been traditionally understood). So I agree with Martin: a strong response can be a criterion for separating meaningful art from the chaff of "exercises," provided the viewer recognizes what's private and what's not.

Even after many years, I am still drawn to pictures of places that seem isolated or rarely visited, to objects that would be overlooked, and to shapes and colors that would normally go unnoticed. The saint in Bellini's painting still catches my eye, standing alone at the foot of his cliff, looking out over the nearly deserted landscape. I know that the actual cliffs still exist in Italy, and I know that the cliffs around Ithaca are still there. I know the differences between them, and so I also know their similarities. That knowledge is what helps lead me from my most immediate reactions back to history.

The same old memories of upstate New York also prompt me to feel a special affinity for some paintings by the nineteenth-century artist Ralph Edward Blakelock, known mostly for his eccentric paintings of Indians. What moves me are some odd little paintings he made of hedgerows. He painted the thin trees and straggling bushes that grow in thin strips between farmers' fields. In America, farmers who don't have space to spare keep the distance between their fields as a minimum: a few bushes for a windbreak, and a narrow path we used to call a "corn road." These attenuated strips of forest are ubiquitous, and mile after mile of them pass by unremarked on any drive through the country. No one pays attention to them. Unlike the thicker hedges and walls that divide fields in parts of Europe, farmers don't tend the thin bushes Blakelock painted. They offer no good hiding places for children, they aren't much shelter for animals, and they are not scenic enough to attract hikers. No one just stands and *watches* them, and sees how they mean nothing to anyone, day after day, year after year—no one, that is, except Blakelock. He does not try for any special effects: there are no twilight scenes, no lowering clouds, no birds singing or farmers passing by. His paintings are small and intensely observed: the paint builds up slowly as he keeps

looking, until it is becomes an enamel bas-relief, recording every withered branch and half-grown shrub.

There is something immensely moving about Blakelock's patient, loving attention to things that are utterly forgotten. To my eye his paintings are stained with melancholy, and they put me into a kind of involuntary trance. I have the same kinds of reactions, but milder, looking at some paintings by Blakelock's fellow landscape painter George Inness, who also loved waste land, scrub woods, swamps, and back country. Naturally my thoughts aren't just my own, and it was not entirely a surprise to get letters from people who also love turn-of-the-century American paintings. Mary Ann Caws, a professor of English, French, and comparative literature at the Graduate School of the City University of New York, tells me the marshes of Martin Johnson Heade have made her cry, and so have Inness's paintings of early morning. Marshes, deserted spaces, hedgerows—they're all abandoned places, lavished with unaccustomed attention, and they are strong attractors for my eyes.

I have thought about why Inness and Blakelock have this effect on me, and how inappropriate it is that they are linked to my childhood, and to Bellini's painting done three centuries before. I know my appreciation of landscape comes from the nineteenth century, and specifically from English writers like Ruskin and Arnold, and German Romantics like Fichte, Schelling, and Novalis. The sources for my affection for hedgerows also include turn-of-the-century aestheticism, strains of earlier Jewish mysticism, seventeenth-century ideas about landscape, and even further, all the way to second-century Gnosticism. There is material there for another book, one I doubt is worth writing.

I know all about the dubious pedigree of my ideas, and I can name a whole collection of old-fashioned notions that formed my imagination as a child. The key is to *know.* As long as I can see what makes up my imagination, I can keep an eye on how it mingles with historical ideas, insinuating itself into the facts of history, posing as part of the picture, camouflaging itself as historical truth. Each of us has an intellectual genealogy like this, waiting to be discovered, and it leads each of us to love certain images and avoid others.

The moral is: trust what attracts you. You do not have to doubt your gut feeling and turn immediately to the guidebook or the label on the wall. Academics read so many texts they have nearly lost the ability to make contact with pictures, and they are taught that their untutored reactions are unreliable and irrelevant. But they aren't. On the contrary: unchecked responses are the only way to experience pictures as something more than wall ornaments.

In most cases, history kills. Luckily it kills slowly, over many years. During the long interval between the first poison pill and the death of all feeling, history can give a great deal of pleasure. Just as smokers love their cigarettes, I love the facts and findings of history. The story I told in the last chapter, about the *Ecstasy of St. Francis,* paints history as a pure disaster. That isn't entirely true, because the historical material makes the story richer and more fully human. Meiss's book, the story of the stigmata, Bellini's other paintings, the landscape of Italy: all that adds immeasurably to my sense of the painting. I do miss those first encounters with the painting, but I would almost miss the history more, if I had to give it up. Art history continues to deepen my experience of images, and I keep buying, reading, and writing books of art history, even though I know I am slowly corroding my ability to address paintings with full emotions and an open heart.

Like a drug, history takes me out of myself, saves me from myself. It shelters me from the raw unpredictable encounter with artworks: it's safe, it's calm, and it's entertaining. It's very pleasureful. It has all the traits of a deadly drug.

History is an addiction, and there is no cure.

7

False tears over a dead bird

He most not flote upon his watry bear
Unwept, and welter to the parching wind,
Without the meed of som melodious tear.
— Milton, *Lycidas*

Why ay! — These tears look well! sorrow's the mode,
And every one at Court must wear it now —
With all my heart, I'll not be out of Fashion.
— Colley Cibber, *Richard III* (1700)

HERE IS A PAINTING no one could cry over. Or so you might think (colorplate 3).

It shows a young girl mourning her dead white canary. Apparently she has been crying—her cheek is glistening, and her eye is puffed red. Now she has stopped, and dried her tears.

To some extent, it is a familiar scene. Many children lose pets they adore. I can still remember finding our family's pet parakeet dead in its cage one morning. I looked at it for a minute, thinking it might suddenly spring up and start flying around, and then I opened the cage and took it out gingerly, and held it in my hands. This girl must have done the same, and I can imagine how she cupped the little bird in her hands and began to cry.

The scene is familiar enough, but this painting goes too far. The girl is treating her bird as if it were an ancient hero laid out on a bier. She has concocted an animal version of a classical soldier's death, something out of Homer or Racine. She has very poetically draped the bird's cage with ivy, and artfully arranged its dead body so that the head droops pitifully over the edge. (It makes the bird look like an opera singer who has just been stabbed.) Even the girl's gesture is theatrical, the kind of histrionic pose children tend to pick up from their parents.

She does seem to be suffering, but her sadness is modeled on melodrama. Perhaps she has been reading too many romantic poems. (If she were a contemporary girl, we would say she had been reading her older sister's Mills and Boon paperbacks or Harlequin romances.) It's easy to picture the solemn ceremony that will follow: she will dress in full mourning, and take the dead bird out to some poetic, solitary place under a weeping willow. She will bury it with solemn pomp, and then she'll linger on as the moon rises, and sing plaintive songs to the poor bird's departed spirit.

The painting is funny that way—like a bad poet's idea of how children suffer, or like a spoiled child's notion of genuine grief. None of it is quite believable: if a child actually behaved like this girl, we might say she was play-acting, doing everything for effect. The painting is also oddly, inappropriately sexual. She is overattractive for her age, like a preteen fashion model, or like the rouged porcelain dolls that are sold in *TV Guide*. Her dress is low-cut, and in a fashionable disarray. Her cheeks and temples make her look older than she is, and her arm is a plump teenager's. Is she six, or sixteen?

The whole ensemble makes me a little queasy. It is too sentimental and too literary, and it's slyly sexual. It is precious, cloying, effusively sentimental, and weirdly artificial. Even its colors are childish and oversweet, with the bluish myrtle, the pink flowers tucked in her bosom, and her ripe strawberry cheeks. This is more than just a picture of sadness: there's something wrong with it.

The artist, Jean-Baptiste Greuze, made several paintings like this one, showing little girls and dead birds, and many others depicting

tearful scenes of farewell or reconciliation. He painted deathbed dramas with survivors wailing, and touching reunions where the onlookers are all in tears. Always the sentiment is strong and pure, and the moral virtues are as obvious as they are naive. This painting was one of his most popular. It was widely admired, and copied several times. (The original is in Scotland, but there are copies in the Wadsworth Athenaeum in Connecticut, and at the University of Missouri at Columbia.) In the next two centuries Greuze's not-so-innocent little girl gave rise to a whole stable of ignoble descendants: in addition to the dolls, she is also the mother of the watery-eyed tramps on sale in Montparnasse, and those Japanese animé figures with lubricated crystal balls for eyes. She is even indirectly, but demonstrably, responsible for the American custom of dressing up little girls as adult fashion models.

I don't know anyone who has cried over this painting, though I do not doubt that people have wept over their porcelain dolls and their fashion-model children. But in the eighteenth century, when this was painted, people were deeply moved. At the time, it seemed to be wonderfully pure and true to a child's heart. It had real innocence. People said it had genuine affect—real emotional force—and true sentiment. We wouldn't use the same words today. What they called affect, we might call affectation. What they called sentiment, we would call sentimentality. What they thought was sweet, we would say is saccharine. To them, this painting was pure loveliness; to us, I'd say, it has unpleasant undertones of perversion.

Greuze's smarmy fan clubs. The art historian and novelist Anita Brookner, who has written an excellent book on Greuze, admits up front that her subject belongs to "a vein of feeling that has now become extinct." "Few people like or admire Greuze," she writes on the first page of her introduction, and she calls him a "not very lovable painter." In the conclusion she says (daringly for a scholar in 1972) that the Greuze girls are always "on the verge of orgasm."

Brookner's sober, feminist assessment went against the grain of a particularly nauseating kind of admiration that Greuze had begun

to attract around the end of the nineteenth century. A book called *Greuze and His Models,* printed in 1912, is a good example; it begins with a paean to the girl herself. The section is headed "The Greuze Girl":

> All the world knows her, and no one who has seen her can ever forget the sweet sting of her beauty. Her eyes are like the fishpools of Heshbon, and many a man has died happy for the kiss of a mouth such as hers. The noonday sunlight seems to have got entangled in her hair, and young men dream o' nights of her warm and palpitating throat. And, if with innocent effrontery, she delights in showing to best advantage her dimpled arms, her firm and delicate hands and all the fresh graces of her rounded form, it is because her child's heart—the wide and troubled eyes confess it—has suddenly been thrilled and a little frightened by the eternal, delightful and foolish craving for something to love; and so, she lavishes the treasures of her heart on the pet lamb she holds in her arms, or the doves she fondly presses to her heart. She has reached that moment when the child, suddenly, miraculously, blossoms into womanhood, and, knowing nothing of love, dreams the livelong day of nothing else.
>
> Greuze painted these charming girls as though he loved them, and, to tell the truth, we should think none the less of him if he did. We can imagine him shouting with enthusiasm over the charms of his model; and, after each sitting, humbly kissing her hand at the door, with an "Adieu, my beautiful child!"

If the people who police child pornography were more vigilant, they would try to ban books like this as well: this is about as close to pederasty as it was possible to get in 1912. The author goes on, heaping abuse at people who think the Greuze girl is "a brazen hussy" who poses knowingly for the painter, and praising the French talent for overlooking such possibilities (she might, after all, be an experienced girl, but what's the difference if your heart remains pure?). The French aren't that awful, after all. Perhaps we Americans shouldn't "eye their

yellow-backed books with suspicion," but rather follow them when they try to show us what really seductive innocence can be.

Greuze and His Models is a bit extreme, but it captures the sweet-and-sour feelings people still have about Greuze. It's either Brookner, with her cold dismissal of girls "on the verge of orgasm," or it's *Greuze and His Models,* a smarmy reverie about the joys of prepubescence. Greuze is sort of ruined for the twentieth century: he looks sweet but unsavory. A few historians, including Brookner, have worked to salvage what they can, but it is not an easy task.

Diderot's weepy salacious story. Things were different back when the painting was new. Then it attracted all sorts of viewers, not just the weepy, the creepy, and the dubious. It even caught the eye of one of the most respectable people of the entire eighteenth century: the philosopher, engineer, novelist, poet, editor, and art critic Denis Diderot. Because Diderot is so important to eighteenth-century art, and because he loved this painting so much, Greuze's *Young Woman Who Weeps over Her Dead Bird* is the central example, the high-water mark, of an age that was especially prone to emotional outbursts in front of paintings.

Diderot wrote impassioned art criticism, and he came perilously close to weeping over several pictures that he critiqued. (Whether he actually wept or not is an interesting, but unresolvable, question; he doesn't quite say.) Yet he was not a naive critic—far from it. He knew the painting was overwrought, and if the word "saccharine" had been in use back then, he would have used it. He realized the model might not be of age; for him it lent the painting a kind of tender spiciness. Early on in his rhapsodic account, he pretends to wonder how old she is. She has the head of a fifteen- or sixteen-year-old, he says, but the arm and hand of an eighteen- or nineteen-year-old. It may be that she is supposed to be about twelve, so she may be underage, of age, or overage; it's hard to tell.

Diderot starts out almost deliriously: "What a pretty elegy! What a pretty poem!" he writes, and you can almost imagine him jumping up and down in front of the painting. "Oh, what a beautiful hand!

What a beautiful hand! What a beautiful arm!" In fact the painting is so wonderful that he says it makes him want to talk to it:

> When one first perceives this painting, one says: Delicious! If one pauses before it or comes back to it, one cries out: Delicious! Delicious! Soon one is surprised to find oneself conversing with this child and consoling her. This is so true, that I'll recount some of the remarks I've made to her on different occasions.

He goes on to invent a whole scenario: it seems that the girl couldn't see her boyfriend, because her mother was always around. One morning her mother left the house, and she immediately called her boyfriend over. (At that point Diderot says the girl in the picture started crying, while she was telling him this story.) The boyfriend knelt down in front of her and began weeping, so that (as Diderot says, speaking to the girl) "you felt the warmth of the tears falling from his eyes and running the length of your arm." The boyfriend promised to be faithful, and gave her the bird as a present. Then he left before her mother returned.

In the next few days, the girl cried incessantly, so much that she entirely forgot her present. The bird starved to death. Diderot says the girl asked him, "What if the bird's death is an omen? What if my lover will never return to me?" and Diderot says he comforted her: "What an idea! Have no fear, it's not like that, it couldn't be like that ... "

Diderot is an excellent writer, and he knows that even his most patient readers will be tapping their feet impatiently while he spins out his preposterous story. So he interrupts his little fiction, pretending that we are his friends and he has just noticed that we are giggling. (Apparently *we* have been standing with him the whole time, while he has been talking to the painting. With Diderot, you never know just how involved things can get.) Diderot says to one of us: "Why my friend, you're laughing at me; you're making fun of a serious person who amuses himself by consoling a painted child for having lost her bird, for having lost what you will?"

Well, all right, we might say, maybe losing a pet is serious for a little girl, and maybe Diderot was right to try to show some sympathy. It is indisputably brilliant writing, blurring the painting together with a made-up story about the girl, a made-up dialogue *with* the girl, and a made-up conversation with *us,* no less. Of course we can forgive it if it's all in fun. But wait a minute: what does he mean by that last phrase—"for having lost what you will"? She has lost her bird, and perhaps also her boyfriend—has she lost anything else? Well, you shouldn't have to ask, he hints, but since you insist, it is her virginity.

Diderot's enthusiasm is infectious, and even though he is playing around, he is deeply sympathetic with his imaginary "painted child." The little invented drama about the boyfriend is Diderot's expert way of drawing out the most shameful and moving secret under the guise of a little harmless sport. It's all wonderfully managed, with a light touch and a bit of self-deprecating humor. He insists that the painting could not possibly be about a dead bird: "This child is crying about something else, I tell you." Never mind that Greuze probably meant the painting to be about the girl's first awareness of death (he based it on a poem by Catullus, which is about death). From the moment Diderot's commentary began to circulate, this was a painting about hidden subjects—love, loss, and deflowering.

No one has ever written criticism like Diderot. How could he possibly get away with pretending to talk to the girl in the picture, and *inventing* a whole drama about her lost virginity? Is that any way for a serious philosopher to behave? Let's say, for the sake of argument, that we believe his story: we're convinced Greuze meant there to be a boyfriend, and that he intended us to guess she has lost her virginity. In that case, this is a rhapsodically beautiful painting that hides a sad secret behind a fairly silly facade. It deserves our tears—we should cry from sympathy, and also from admiration and even from sheer delight at the painter's audacious invention. But even if we choose to believe Diderot's story, how much can we care? And how much can we *feel?* Anita Brookner might say we can care a great deal, but we cannot feel anything. She is certainly right that this vein of feeling has become extinct. For a modern viewer, Diderot's outrageous story has

to be just that: a little diversion, a quirk in the writing of a great philosopher. Greuze's painting cannot be anything but maudlin and pathetic. It is *intended* to be an absorbing, entrancing portrait, and we can easily see that we are supposed to be absorbed. But are we? I don't think so: the painting just doesn't work anymore.

How we've lost the eighteenth century. At first glance it is no great loss that we can no longer take Greuze seriously. After all, if you want cloying sentimentality, you can get it from romantic potboilers and Hallmark card shops. But there is a fair amount at stake here, because Greuze is only a sign of his period. Giving him up means giving up many other painters who believed that tears were noble, fine, and appropriate, and that great art should move people. The late eighteenth century was an especially emotional time in painting, and Greuze was part of a revival of earlier sentimental painting, including the soapy-eyed Spanish painter Murillo (like Greuze, an extraordinarily talented artist), the fluffy and pious Guido Reni, and the ecstatic sensualist Correggio. If we give up on paintings like *Young Woman Who Weeps over Her Dead Bird,* we would also have to give up a large portion of the eighteenth century and its predecessors, as well as some of its most interesting writers, including Diderot himself.

The eighteenth-century painters who have pride of place in our books of art history were the ones who declined to stir up people's emotions. Today people admire Chardin's tactful reserve, and they enjoy the sensual decorations of Boucher and Fragonard. Greuze is different—he is a bit unpleasant, and not at all reserved. Diderot recognized the problem, though he put it more gently; he says that Greuze and Chardin both speak "quite well about their art, Chardin with discretion and objectivity, Greuze with warmth and enthusiasm." Diderot could admire both painters, something we can't do. Somehow, the eighteenth century is broken, and a big chunk of it is missing.

The problem only gets worse the longer we consider it. If we give up Greuze, I think we also have to consider giving up Jacques-Louis David, the heroic painter of the French Revolution. His *Oath of the Horatii* in the Louvre is one of the crucial paintings of the eighteenth

FIGURE 2: Jacques-Louis David, *The Oath of the Horatii*, 1784. Paris, Louvre. Photo Lauros-Giraudon.

century, but it also asks its viewers to feel a deep emotion that I doubt we can still accommodate (figure 2).

The painting shows three brothers swearing to die in battle for their country. They clash their swords together as a sign of resolve. On the right, their mother and two of their sisters collapse in despair. One sobs, another faints. At first glance this might seem designed expressly to stir tears, but the circumstances of the painting suggest more was at stake. It was commissioned by Louis XVI's minister of arts in order to help improve the public's sense of morality, and it was intended as a sober reminder of the importance of patriotism. Eighteenth-century viewers who found themselves crying at the idea of three men leaving their family and swearing to die would be misunderstanding the painting. *The Oath of the Horatii* is out to teach a harsh lesson in civics: loyalty to one's country comes before

everything else. The original story, written by the Roman historian Livy, goes on to tell how two of the brothers died in battle, but not before they managed to kill all three of their adversaries, and how the single surviving brother then returned home and killed his own sister for grieving over one of the enemy dead. Knowing that, viewers would realize their tears were self-centered. Really, the painting is about the *idea* of patriotism, and the family drama is only an occasion to make an abstract point about civic loyalty. I imagine the painting's original viewers were very strongly affected. Perhaps some cried at first, thinking of the soldiers going off to die, but then they would have realized that David (and Livy) had a higher lesson in mind. They would have dried their tears of sympathy and steeled themselves to accept the higher ideal of nationalism. The painting doesn't say: War is horrible, it destroys families. It says: The country is worth more than any individual in it.

In our own time, people still wrestle with the subject that David painted. Anyone who has lost a friend or relative in a war, or come close to losing someone, will have weighed the same issues that David conjures. Those are the right viewers for David's painting. Perhaps some veterans, or veterans' families, have cried looking at *The Oath of the Horatii*. If so, I have not heard from them. The problem here is the same as it is with Greuze's juvenile fantasy: people who see the painting are supposed to be moved, but these days they are not. It is my guess that no one who is professionally involved with *The Oath of the Horatii* (I mean artists, historians, curators, and museum trustees) has ever been deeply moved by it. For us it is a story about patriotism, not a lesson in patriotism: and it's a dry story at that. We have become jaded about our government, and too divorced from ancient history to take such a lesson to heart. Hence we regard the picture very coldly, as if we were doctors performing a postmortem to find the cause of its death. Art historians write about what happened when the picture was shown, and how people judged it. The historians are interested in it as a sign of its times, and as a painting that responded to other paintings and codified the Neo-classical revival. *The Oath of the Horatii* is in every textbook, and it is

probably on every teacher's list of the most important paintings of all time. Everyone understands it, but no one takes it as it was meant. No one gasps, no one flinches at the frightening oath. The painting has lost virtually all of its affective power: it is stark, but not overwhelmingly so, and it is passionate, but in a theatrical way that fails to convince. In short it is as dead as *Young Woman Who Weeps over Her Dead Bird.*

And the same, sadly, can be said of many of the paintings done in David's generation and just after. When you visit Paris, go to the Louvre and find *The Oath of the Horatii:* it hangs in a huge room, the Grande Galerie, along with dozens of other paintings by David, his school, and his followers. Just down the hall is another room just as large devoted to Romantic paintings by artists in the generations after David. With a guidebook, you can follow all the stories these paintings have to tell, and there is no lack of drama. There is a painting of a nude man, bathed in eerie moonlight: he has been seduced by the moon, and she is ravishing him in the form of moist greenish light. There is an enormous painting of a deluge, like the biblical flood: a man tries to rescue his family, and they all cling frantically to him as he clutches a breaking twig. There are even larger canvases of military battles, with babies trying to suckle at their dead mothers' breasts. One painting shows the pathetic but noble victims of the plague, dying in an Egyptian hospital. Another depicts a despotic emperor who has ordered his slaves to kill one another and destroy his entire kingdom; he watches impassively as everyone around him dies. A man stabs a horse, and another stabs a naked woman. In other paintings men cannibalize each other; a drowned woman floats down a river; a man sits in anguish as his sons are brought in dead; people languish on their deathbeds while their families weep. In one small painting, two little boys hear a footstep in the hall: it is their executioner, come to take them away and kill them.

Of course it's a travesty to describe these paintings as I am doing. Some of these pictures are among the most powerfully imagined and executed of the entire Western tradition. Many are compelling, and a few are overwhelming. They are important and fascinating for any

number of reasons, and no one who cares about painting can afford to ignore them. But at the same time, absolutely no one shivers or weeps or really believes anything in them.

The eighteenth-century vogue for crying. "Move me, astonish me, unnerve me, make me tremble, weep, shudder, rage, then delight my eyes afterwards, if you care to": that was Diderot's rallying call.

His was a time when successful artworks were expected to raise all sorts of extreme reactions. The Abbé Du Bos, an arbiter of taste for the mid-eighteenth century, claimed that "the primary object of poetry and painting is to play on the emotions; poems and pictures are only good if they move and involve us." To him, the *only* essential thing about a work is that it possess emotional power. "A work which moves us a great deal," he concludes, "must be excellent from every point of view."

These days we think otherwise. A good deal of modernist painting has to do with the act of painting itself, and the painter's engagement with painting. Modern and postmodern paintings can be principally about painting, and that is not a subject calculated to draw tears. Late-twentieth-century painting can be ironic, circumspect, involuted, densely intellectual, deliberately opaque, and even rascally or snide. There are a few paintings and painters who "move us a great deal," from *Guernica* to Rothko, but for the most part Du Bos is nearly our antipode.

It's true that Diderot and Du Bos were very emotional people, and I would like to believe that two centuries later we have come to a more balanced idea of the effects that pictures might have. Once when I was giving a lecture on the subject of this book, someone asked if I were intending to revive Du Bos's outmoded eighteenth-century emotionalism. Perhaps, she said, I was hoping to get people to give up their bookish ways and revert to Du Bos's gushy habits. I told her I didn't think that would make sense, because so many twentieth-century pictures were made in the wake of a reaction against the very ideas of sentiment and sentimentality. People like Du Bos really can't help much when it comes to Mondrian or Warhol.

Likewise, some of the older pictures I admire are very dry—Piero della Francesca's, for instance. Du Bos and Diderot have had their day, but—and this is where my doubt, and my interest, come creeping back—they knew what it was like to feel something in front of Greuze or David. I think that we've lost that, and that we should be concerned. I told the woman I'd be happy to revive Du Bos if it could help us reestablish contact with Greuze, but I wouldn't think of promoting eighteenth-century theories as a panacea for all paintings.

The Enlightenment was a revival of emotional reactions to artworks. Crying had faded from view in the Renaissance, and it began again sometime in the late seventeenth century, in France. The first reports are about women crying when they read novels. Eventually crying spread like an epidemic through western Europe, infecting readers from England to Italy. In October 1728, Mademoiselle Aïssé wrote to a friend about her experience reading a fairly poor novel called *Memoirs of a Retired Gentleman*. "It is not worth much," she admits, "but despite this one spends the hundred and eighty pages dissolved in tears." Notice that Mlle. Aïssé doesn't say she cried once or twice, but more or less continuously. Some Enlightenment writers were virtuosi at unremitting bathos. Baculard d'Arnaud wrote rum stories that captivated his readers, making them shed "floods of tears." Better novels elicited whole rainbows of tears, from red anger to violet passion. One reader cried tears of "admiration, regret, and desire" over Rousseau's *La Nouvelle Héloïse*.

I can scarcely comprehend these multiple cryings: what could it mean, I wonder, to cry because I *admired* a novel? Could I ever cry because I *regretted* what a fictional character had chosen to do? Sheila Bayne, a scholar of French crying, says seventeenth- and eighteenth-century people cried "intellectual tears" over such things as virtue, philosophy, equality, generosity, and gratitude. I have tried to imagine what it could mean to cry over the abstract *idea* of philosophy. I can't fathom it: as the contemporary philosopher Jacques Derrida says, there is no such thing as a philosophic truth that should be expressed with an exclamation mark. Contemporary philosophy just isn't weepy.

The eighteenth century thought otherwise, and people cried for all sorts of reasons that we have forgotten today. All we are left with in the twentieth century is blockish, simpleminded crying. We cry when something is sad, as if crying could come only from sadness. Back in the eighteenth century readers cried because Rousseau's characters were simple, because they were pure, and because they were happy. They wept delighted tears, jubilant tears, gentle tears, and rapturous tears. Some readers could not bear to finish Rousseau's novel *La Nouvelle Héloïse* because their crying became too intense. Tears rained, sprinkled, and poured; they flowed in rivers and torrents; they fell in sheets. People suffocated in tears; they were "torn apart," harrowed by hot tears until they had to stop reading.

Soon the weeping spread from novels to theater, and from theater to daily life. The historian Anne Vincent-Buffault, who collected most of the examples I have just quoted, says weeping was a common expression of sentiment. Lovers bathed their letters with tears, dampening the paper. "Friends embrace weeping," she writes, "and spectators open their hearts with delight." In literary salons, people told stories that moved their audiences to tears. Even the great philosopher Voltaire cried at sad stories.

These people were sentimental and effusive, but they weren't uncritical. Some evenings the collected company sobbed together, but that never prevented them from exercising their judgment. A work that elicited tears—especially the tears of a beautiful young woman, or a grand old man such as Voltaire—might still have its faults. Sobbing was not approbation, and it did not mean the work was worth buying, or even worth rereading. Tears were just part of the full response that any sensitive person should feel. Friends and lovers exchanged tears, and Vincent-Buffault tells how tears mingled and mixed, were given away and shared, elicited, paid, and bought: there were "tributes of tears," "debts of tears," and a whole liquid economy of love and friendship. The same ideas infused the experience of artworks. A work of art was not an object, as we somewhat callously put it, but a new friendship, a new affection. Two centuries later, we know this but have forgotten how to initiate intimacy with objects.

Surely there is wisdom in the Enlightenment attitude: after all, what better seal on the closeness between a person and a novel, or a picture, than tears of happiness or recognition?

For eighteenth-century readers, tears transformed experience, making it increasingly intense. Diderot once watched a friend reading a novel by Richardson:

> At this point he seized the notebooks, withdrew into a corner and read. I watched him: first I saw tears running down his face, he interrupted himself, he sobbed; suddenly he got up, he wandered aimlessly, he cried out as though he were devastated, he reproached the Harlowe family in the most bitter way.

Diderot himself knew this mood well. In such a frenzy of sentiment, a reader is cleansed of the distance that separates him from a work: irony and cynicism wash away, and the baptism of tears makes him pure and innocent. It would be a calamity *not* to be moved to tears by a beautiful story, because it would betray a crassness, a brutishness, that might possibly be beyond redemption. From that point of view, there's no such thing as an excessively emotional reaction. As the biographer and historian Fred Kaplan says, "an access to feeling could not be an excess of feeling."

How to tame a tear. Yet for many people the flood of tears was well under control. The sentimental public wanted tears of a certain sort, a kind of sugar-coated pill of sadness. Diderot chided them on their weak-kneed taste, and said they should want genuine pain and despair as the Greeks had. But the eighteenth-century taste was for less harmful pleasures. An evening at the theater, or a night spent with a book, were expected to yield a measurable quotient of weeping, a few teaspoonfuls of tears and a handkerchief somewhere between damp and sodden. As playwrights and authors knew, it was no simple task to measure out tears the way the public wanted. It was necessary, at the least, to manage all the props with exquisite care: the sets had to be grand, but not overwhelming or distracting; the characters slightly

pathetic; the evil hard but not harsh. Speeches had to be timed just right. A very short speech might have an unpredictable effect: some listeners would hear almost nothing, and others would catch a stray word and suddenly burst out crying. Long speeches might be prone to the opposite problem: anything lyrical in them could be swept aside by the excess of words. To coax just those few tears that the readers and spectators wanted, a speech would have to be a perfect middle length.

Nowadays the people who know those Enlightenment rules for generating just the right number of tears write potboilers for supermarket paperback stands. First-time authors for some publishing houses are given recipes for optimizing lachrymal output: take thirty pages between love scenes, have at least four torrid encounters but no more than six, and so forth. If you know your public, titillation and fearfulness can be managed quite accurately and deliberately.

Given this ability to control emotions, it is no accident that the eighteenth century is also the beginning of the theory of acting. Diderot and Voltaire both speculated on whether actresses should cry outright, or feign their emotions. Some crying might elicit pity, or even disgust. Crying had to be *projected,* sent out to the audience and not just released. The "gift of tears" was a theatrical term, which means, according to the standard French dictionary Littré, "to weep in such a way as to cause others to weep."

It may sound cynical to anyone who loves crying, but the eighteenth century showed that tears can be domesticated. In the hands of the right artist, and with the complicity of the viewer, tears can be parceled as exactly as measures of sugar and salt. (As John Barrymore did when he cried exactly three tears.) Stendhal, who often cried, was a connoisseur of theatrical crying; in his letters and his book *On Love,* he meditates on the tears his various sweethearts produced for his delectation. He mistrusted the "tear-pump," and he claims women used their eyes almost always for effect. What he wanted was the precious blue rose of the world of tears: the unwanted tear, the one that fell despite all attempts at containing it. Only that tear would tell him he was truly loved.

In all these ways, the decades at the end of the eighteenth century were enraptured with emotions. They cherished tears, and wrote theories defending their importance. They conjured tears, expected tears, measured tears, mistrusted and pursued and loved and stage-managed tears. Greuze was part of that world. His *Young Woman Who Weeps over Her Dead Bird* is both heartfelt—there is not a scrap of evidence that Greuze could laugh at his own creations—and also stage-managed to perfection. I suppose a very refined little girl, growing up in Paris in the 1780s, well versed on melodramas and opera and well able to conjure emotions, might really have behaved like Greuze's girl. Basically, though, she is a fiction, a character designed by the artist to show us that he believed real loss felt by an innocent heart is the saddest affliction. It is an utterly sincere painting, and at the same time it is utterly contrived, designed to give a little tug on our heartstrings. The ideal viewer of such a painting will certainly admire the artist's skill (and Greuze is superlatively skilled, beyond most other artists in his generation) and see how the painting is put together out of allusions to tragedy, theater, portraiture, and opera. But the ideal viewer will not let that stand in the way of real appreciation: such a viewer should certainly feel a pang, and ideally also shed a tear.

The ice-cold rhetoric of tears. These days we resist Greuze's brand of coercion. We do not want to feel manipulated, and we resent being tricked by a little girl's false tears. Greuze's eighteenth century, it seems, is very far away. We fancy ourselves more honest and sober, and less naive. We say Greuze is maudlin, and David histrionic. We say the paintings in the Grande Galerie of the Louvre are melodramatic, theatrical, and over-the-top: by which we mean that we see their tricks, and we aren't going to fall for them.

To me this is a desperate situation. There isn't much hope that any painting can keep its force into the indefinite future, because people's reactions change as cultures come and go. But Greuze and David aren't that far away from us (barely two hundred years), and already their paintings are only the brittlest shells of what they used to

be. We regard them with all the condescension of scholarship: not because we are too mature to be swayed by histrionics and melo-drama (the movies prove otherwise!), but because we have stopped believing that a painting's value depends on its power to affect us. I find that very sad and largely inexplicable. How did we become so callous, so full of airy sophistication and false refinement? How did we lose the desire to cry openly?

I am tempted to say I know exactly why I am not moved by Greuze. He has a straightforward, go-for-the-jugular sense of drama, and in common with other twentieth-century viewers I strenuously resist being told when I am permitted to feel emotion. Greuze believed with the utmost naiveté that some people are naturally good and others evil, and that the two are opposed, just as selfishness is to charity, or prudence to impetuousness. He categorized people as Noble or Selfish, Prodigal or Improvident, Callous or Compassionate. A whole machinery of human types is at work in his paintings, coor-dinated by the engine of Human Nature. I distrust it all. Like most people from the mid-nineteenth century onward, I do not think human nature works that way. People are more complex, and people who appear Selfish one moment may be Noble the next. For me Pure Goodness is Pure Illusion. Since I am not a moral philosopher, I haven't thought much about it, but it strikes me that there must be as many kinds of goodness as there are reasons to want to appear good. I can imagine a person who is genuinely good and also has ulterior motives: goodness does not seem all that cut and dried. For me, Greuze's characters are caricatures.

Greuze is also utterly confident that he knows what makes a good family. He knows how fathers, wives, sons, and daughters should behave, and he thinks that those behaviors are simple enough so they can be depicted in paintings. But isn't being a father or mother something that has to be worked at over a period of years? Can an image or two really set us on the right road, and help us through all of life's uncategorized troubles? Then in the midst of this bullish simplicity Greuze has the gall to tell us what an adolescent girl should feel when she is confronted with the loss of her virginity (or

for that matter her dead bird): the picture tells us how she should weep over her fall, and how she can take heart in the measure of delicate purity that still clings to her. It's clear that she will find a virtuous husband in the end: after all, Greuze and Diderot are obviously attracted to her, despite her condition.

I could go on. There are all kinds of reasons to find Greuze silly and sentimental, and any one of them would be enough to bring me up short. But I wonder if they are the reasons I do not cry. They sound suspiciously like rationalizations. Maybe it would be more honest just to say I wasn't moved by Greuze, and that made me set about explaining myself by comparing his ethics to mine. No, ethics is not the reason that Greuze has lost his hypnotic power. I doubt the painting would have moved me even if I believed just what he did about underage girls. Wherever ethical ideas are processed in the brain, it must be pretty far from the mysterious center that regulates crying. (You can't cry when you know you should, and you cry when you wish you wouldn't.) Besides, who doesn't cry over sentimental things? People have cried over *Dick and Jane* books and Walt Disney movies, and that's proof enough that no excess of mawkishness is enough to prevent tears if they are coming anyway. There must be some other reason why Greuze is so powerless to move us. The answer, I think, lies in our fear of crying.

It is amazing how icy people have become in just two centuries. Even Vincent-Buffault, who loves Enlightenment emotionalism, is a bit cold when she tries to say why the eighteenth-century novels make her smile instead of cry. The figures of speech that provoked such outpourings, she says, make up an outdated "rhetoric of tears" that has been abandoned. Once that "rhetoric" must have been "readable," but now it can't move us any more than hieroglyphics. Greuze's little girl is a stack of symbols for grief: the reddened cheek, the ivy garland, the little bird with its head thrown back, the dress in disarray. Such symbols of grief and excessive joy, Vincent-Buffault says, "indicate that the codes of emotional communication were part of the literature of the eighteenth century." I also smile when I read about a heroine's tear-stained handkerchief glimpsed between her clenched fingers, or the purity of a single teardrop trembling on a

rosy cheek. But it is not a happy smile. I do not expect to lose myself in eighteenth-century novels, but I envy the capacious responses of the eighteenth-century readers. Art historians who study the eighteenth- and nineteenth-century paintings in the Grande Galerie know how the painters elicited emotion, and how the early viewers responded. Like Vincent-Buffault, they are familiar with the "codes of emotional communication." They may be deeply sympathetic with the painters' aims and achievements. Yet that knowledge is dry-eyed and well controlled, as different from the sodden and sincere paintings as a desert from a swamp.

Vincent-Buffault's phrases—"codes of emotional communication," "rhetoric of tears"—are emotionally detached. I am not as sure as she is that we know more, or know better, than Diderot or Greuze. Do we really want to say that the sensitive and versatile tears of the eighteenth-century writers and artists are things best left to the past? Can we really believe that their cataclysms of emotion were naive, and that we know better? They were of their time, no doubt about it. But how can anyone look at their behavior and their artworks and be sure we do not live in an impoverished world? The emotional temperature of our responses to pictures is plummeting toward absolute zero. How coldly can we look and still claim that we are looking?

In the eighteenth century, the inability to cry was worse than a social defect. It was a sign of illness. Such a person was thought to be afflicted, possibly melancholic, or even an imbecile. "Sombre melancholy withers the heart," wrote Louis Sébastien Mercier in 1784. For a melancholic person, he said, there are "no more tears, no more laughter, no more emotion; the hours of life are slow and cruel." Such a person "can neither live nor die." By that standard, today's historians and scholars are ill: they have been given a full range of passions, but they have traded most of them away in favor of a superior intellectual purchase. Where people like Greuze *felt* passions, today's historians *know* passions. They are expert anatomists of emotion, archaeologists of commitment.

Ordinary museumgoers are in the same boat. If you look at a painting like David's *Oath of the Horatii* and see the masterful orchestration of a theme of civic allegiance, then you are right—you will

pass the art history exam. You are also right if you say the painting's the pinnacle of a newly emerging sense of neoclassicism. And you are right if you explain it as the sign of David's thoughts about France, and French patriotism. You are even right if you see in it a kind of emerging homophilia, where men are strong and beautiful and women are ancillary and weak.

Yet in another way you are wrong, because you are in danger of confusing that knowledge with the full, intended response to the painting. David's painting can still be a masterpiece in the textbooks, but really only there. It will always be a landmark in the history of painting, and it remains essential viewing for many painters and all art historians. But what is it aside from that? It has been declawed and defanged, and chained up inside old rhetorics and disused codes of emotional communication. It used to be about our reactions, and now it is only about what other people thought.

Crying has lost its everyday flavor. People shy away from it because tears seem self-indulgent, feminine, and weak. At least women are allowed to cry: when men cry at all, it is supposed to be over a horrendous tragedy or some hidden, irreparable despair. We no longer know how to cry moderate tears. The point of *sensibilité,* to use the Enlightenment word, was to be sensible about experience: not to be wild and risk insanity, and also not to be brutish and mechanical. Tears were wept with judgment, with decorum, with tempered passion.

Two centuries later, part of us has shriveled. We are stoked with irony, banked with lucidity, but the fires have gone out. It is as if the culture itself has aged: as Diderot said, the older a person becomes, the drier and colder they get. I wonder if that is what happened after the eighteenth century. Maybe we just grow up. Maybe our emotions lost their youthful elasticity, like joints stiffened in old age. Maybe when Diderot wrote, modern culture was young, and now we're all suffering from emotional arthritis.

Were eighteenth-century viewers childish when they said sobbing can be a form of insight into a work, or that uncontrolled weeping might be a reasonable reaction to a novel? I do not think it is prudent

to reason that way, comforting as it may sound. The eighteenth-century writers, philosophers, and painters were altogether intelligent people, and there was nothing childish about their wholehearted embrace of wholeheartedness. What is childish is the modern regimen of sobriety. We are on a strict diet of ironic detachment: we permit ourselves slim rations of pleasure, but genuine transport is strictly forbidden.

It is little wonder that we can't see Greuze anymore. He wants us to look with our guard down: he asks us to think about the little girl and sigh for her lost innocence. But we are adults: we've put on our serious clothes, and we're not about to fall for that.

8

Crying because time passes

Stage plays also captivated me, with their sights full of the images of my own miseries: fuel for my own fire. Now, why does a man like to be made sad by viewing doleful and tragic scenes, which he himself could not by any means endure? ... What is this wretched madness? ... For what could be more wretched than the wretch who has no pity upon himself, who sheds tears over Dido, dead for the love of Aeneas, but who sheds no tears at his own death in not loving thee, O God, light of my heart, bread of the inner mouth of my soul, O power that links together my mind with my inmost thoughts? ... For my own condition I shed no tears, though I wept for Dido, who "sought out the sword's point," while I myself was seeking the lowest rung of thy creation, having forsaken thee— earth sinking back again to earth. And, if I had been forbidden to read these poems, I would have grieved that I was not allowed to read what grieved me. This sort of madness is considered more honorable and more fruitful learning than the beginner's course in which I learned to read and write.

— St. Augustine, *Confessions*

Tarzan nodded. Monsieur Flaubert gave the signal. He and D'Arnot stepped back a few paces to be out of the line of fire as the men paced slowly apart. Six! Seven! Eight! There were tears in D'Arnot's eyes. He loved Tarzan very much. Nine! Another

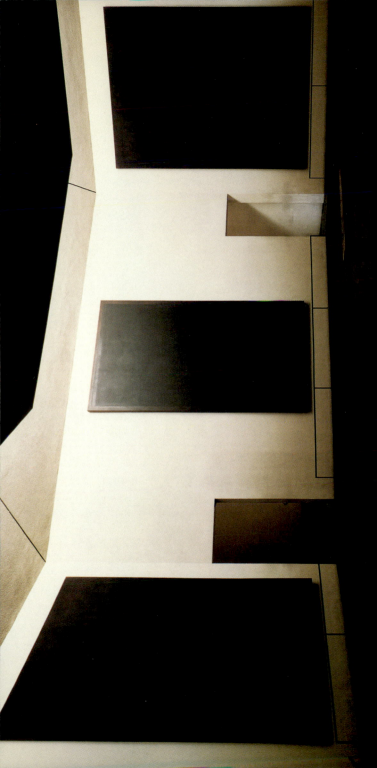

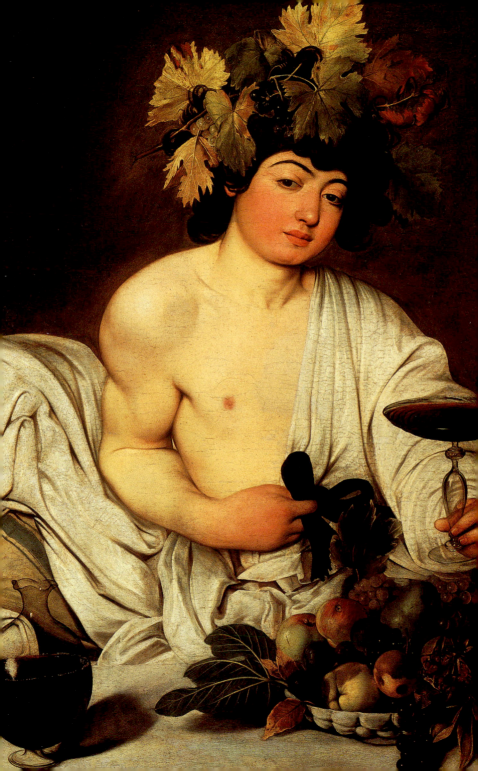

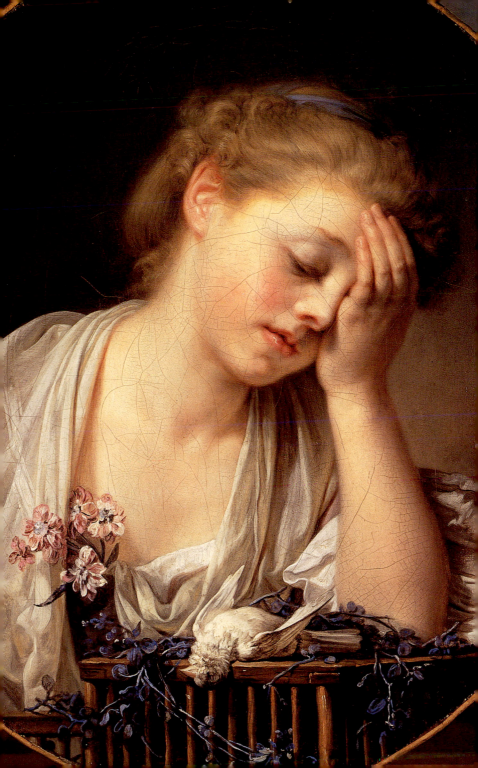

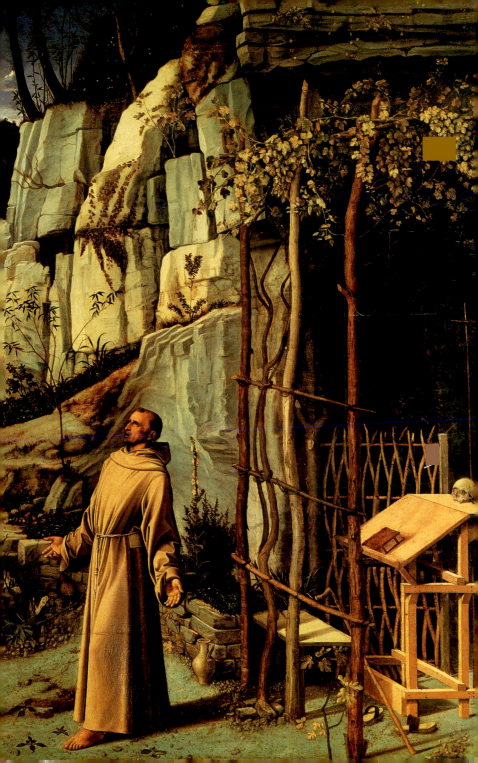

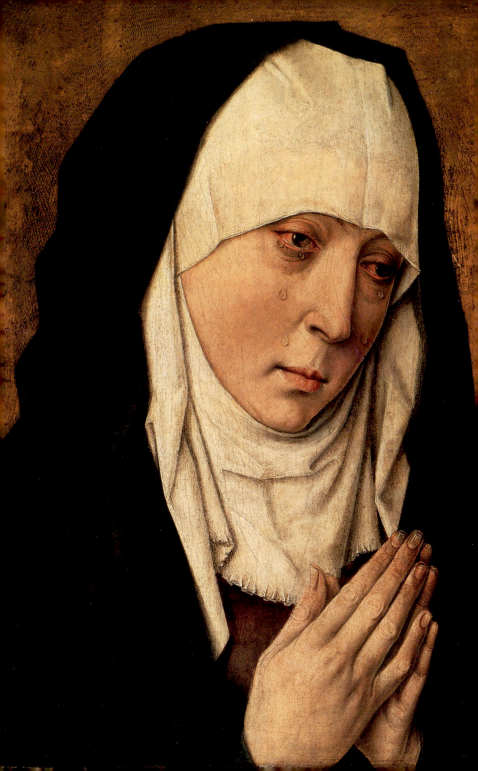

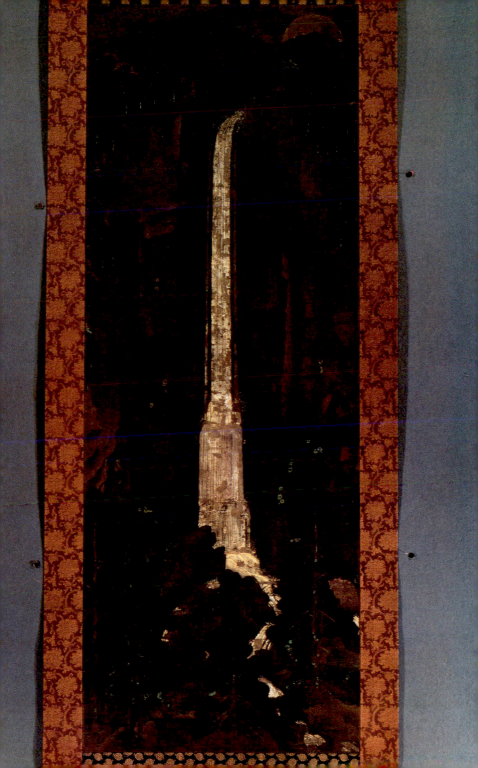

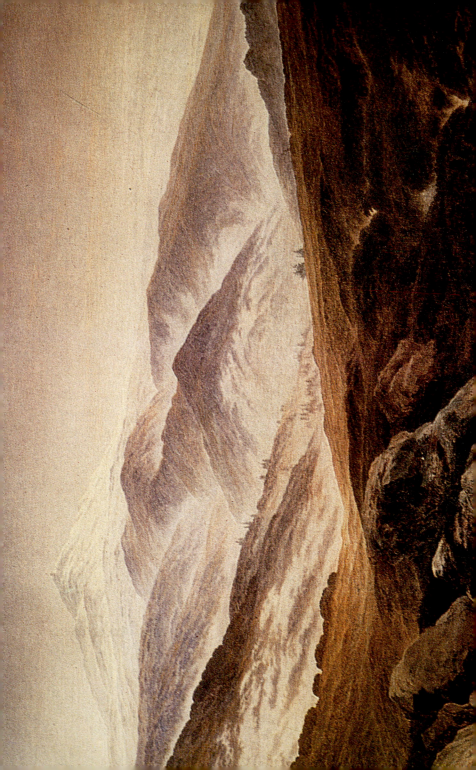

pace, and the poor lieutenant gave the signal he so hated to give. To him it sounded the doom of his best friend.

— Edgar Rice Burroughs, *The Return of Tarzan*

CAN ANYTHING BE SALVAGED from Greuze's awful painting? Is there any shred of realistic reporting, any scrap of believable emotion, that might help me be just a little sympathetic to what he was trying to do?

There is one thing, though I have to overlook most of what's going on in the picture in order to get at it. It's the simple passage of time, the way that time goes on even after we die. That sadness is deeper and more general than a little girl's loss of her pet, and Greuze's painting captures it. The young girl sits there, disconsolate but still breathing and moving. That particle of real tragedy doesn't save the painting (after all, it's just a canary), but it is a remnant I can admire. If I try hard, I can subtract away Greuze's overblown notions of love and innocence, and even his attraction to underage girls who have recently been deflowered. What is left is a painting about loss and the inexorable ongoing movement of time, which carries us forward whether we want it to or not. At least in that respect the painting is economical and direct.

It appears from my survey that time is one of the principal reasons people cry at paintings. Some are struck when they return to a museum they hadn't visited for years and see the same pictures hanging from the same walls. That made several of my correspondents think of their own lives, and how they are ebbing away. One person said he realized the painting he was looking at would still be there long after he had died. Now there's a depressing thought, or, if you prefer, a genuinely sad one.

Another person told me he cried when he looked at a painting and saw how beautiful, how peaceful and balanced, a life can be. He thought of the mess he had made of his own life, and he realized the painting was impossibly perfect and timeless, like a ship in a bottle. The contrast, he said, was too harsh to bear.

Several people told me how they had come to love some painting, visiting it over and over, imbuing the painting with personal thoughts, thinking of it intermittently or continuously for years—and then, abruptly, they realized the picture had never really spoken to them. It had been dead and silent all along, and they had been projecting their thoughts onto it. For people who want to love paintings, that can be a bitter realization.

Another person cried looking at a painting that captured an optimistic moment, because he knew that what happened after the painting was done was a tragedy. Paintings done by young artists often look forward into the future with confidence; paintings done by older artists can betray the bitterness of ending a life frustrated and unknown. In a museum, chances are that every painting you see is by someone who is now dead, and so you're seeing a snapshot of his or her life—a moment when the artist had certain hopes and did not yet know how things would turn out. Pictures capture that kind of universal disappointment with pitiless precision.

Yet other people cry for things they have lost, because they see them again in pictures. Photographs, which aren't my subject in this book, are especially pitiless. They can show us people who died and hold them up for us as long as we can stand to look. (The main reason I haven't written about photographs is that people who cry looking at photos almost always cry for just one reason: they know the person or the place. Photographs have a kind of naked truth—they seem to be hard-wired to the world—and they elicit a narrow range of very personal reactions.) Paintings seem to have a little more distance, and it can be wonderful to see a painting of a person who is no longer living, although it can also be dispiriting and bitter. The history of painting is replete with paintings about loss—cultures that have vanished, places that have changed, people who died long ago. There are innumerable trivial examples as well: paintings of overripe fruit, withered flowers, dried crusts of bread, grimacing skulls, long tapered candle flames, tattered old books. There are so many examples that it can seem as if the whole history of Western painting is fixated on the passage of time.

In the winter of 1984–85, the Legion of Honor in San Francisco

held an exhibition called "Venice: The American View, 1860–1920." It included scenes of Venice painted by John Marin, Maxfield Parrish, Maurice Prendergast, and John Singer Sargent. The historian Margaretta Lovell, who curated the exhibit and wrote the accompanying catalog, told me a woman wrote her afterward saying that she had gone three times and each time left in tears. "I think that was an appropriate response," Lovell says, "because the exhibit was all about loss." The galleries were hung with banners bearing quotations from writers such as Henry James and Edmund Gosse, extolling Venice and the almost unbearable delight it could produce. Looking at the elegant, liquid watercolors by Sargent and reading the rapturous testimonials on the banners, a viewer could easily be led toward thoughts of loss. "Of course I didn't design the exhibit to make people cry," Lovell told me, "but I did intend it to capture that moment when people realized Venice was disappearing." Indeed Venice was a dreamy utopia for late-nineteenth and early-twentieth-century tourists, and if the paintings Lovell showed have any power to move us it is because they speak about the joys that the artists knew were quickly vanishing. The woman who cried in Lovell's exhibit was remembering a lost time—hers, or Venice's, or a combination of the two.

There is something peculiar about the way pictures break into our sense of time, collapsing the even movement of the clock, making time pass roughly or grind to a static halt. In everyday life the forward motion of time, the slow incremental walk toward the end of our lives, is an unbearably light burden—we scarcely notice it. Time flows quietly and does not cause us any pain. Some part of us knows that every day lived is another day taken away: but most people, I think, are reconciled to that completely ordinary fact. It hurts when time suddenly leaps forward, as it does when someone we know dies or when we find ourselves unexpectedly older. And it hurts when time suddenly halts, as it does when we encounter someone we have not seen for years. Visual art, I think, has a particular capacity to pick out those moments. A painting on the theme of time can be like a hand that reaches out and suddenly stops the clock, or pushes the hour hand forward, or spins it back around the dial.

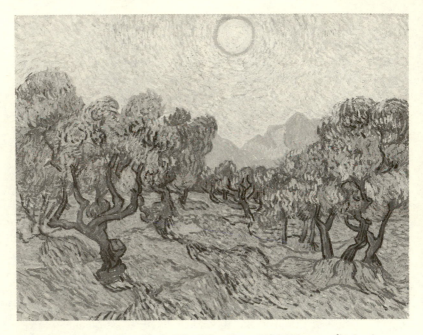

FIGURE 3: Vincent Van Gogh, *The Olive Trees,* 1887. Minneapolis, Institute of Arts.

•

When time is out of joint. A painting can also be like a broken clock, pointing forever to 13 o'clock. Its time is never ours, and we can never read what time it is in the painting.

I got several letters from a novelist named Warren Keith Wright, who told me how he was once moved by a painting, and how he continued to visit it for nearly fifteen years, without ever quite knowing why it had affected him so much. It was Van Gogh's *Olive Trees* in the Minneapolis Institute of Arts (figure 3). At one point he thought he might not be able to visit the painting again for some time, so he spent a specially long time looking at it. As he stood there, he thought about the anguish Van Gogh had suffered at the time, and "about the several friends I had discussed the painting with. . . . Though I did not know that circumstances would prevent my seeing *Olive Trees* face to face again, I found I had to wipe tears from my face." He left, still not knowing why the painting moved him so.

In the end, Warren solved the mystery using a time-tested writer's trick: he let one of his fictional characters work it out. Only then did he realize it had to do with the painting's jarring presentation of time. The painting was out of synch with itself, set to an impossible hour.

In his novel, Warren has a female character who becomes obsessed with the painting. One day, as she floats in a canoe down the St. Croix River in Minnesota, it suddenly becomes clear what was wrong with the picture. In her words, "It portrays two distinct times at once,—predicts its own future, reverts to its past. Note that high above the cool lavender mountains, the blazing late-afternoon sun stands due west; but the actual light source casts tree-shadows that slant in from the left, the southwest, off the canvas, from autumn ... —Moral light, thrown from a differing angle, a different source: where daylight would fall, later on in the year, once this tangible season was history."

Even though Warren loved the painting enough to go see it fifteen or sixteen times, he didn't realize what was drawing him until he had his fictional character think it out. And he is right: time is definitely out of joint in *Olive Trees*. The painting gives me a funny feeling, and I can easily understand how it could have a lasting effect on someone who had not quite identified the contradiction. (The museum catalog just says it's an "error" on Van Gogh's part.) Writing is a strange business, and I like to think that Warren needed his character—a woman, paddling a canoe through a landscape in Minnesota, while she thought of a landscape in France—to help him see it. I hope the painting hasn't been ruined for him now that he has "solved" it.

Frozen time. One enigmatic entry in the Rothko chapel visitors' books reads, in its entirety: "This is where it stops. Depthless. Time Out." From the handwriting I guess that the writer is a man, but there is no way to learn more about him (or her). I can scarcely imagine what he meant: the blank canvases stopped him short, and somehow stopped time too. Time became, in his lovely word, "depthless."

I received a letter from a Dutch woman named Mardien Abeling that is extremely eloquent on "depthless" time. She tells how she visited Florence in 1967 and saw Michelangelo's Medici Chapel. When she saw it again seventeen years later she realized that it was

completely unchanged, and that it must have looked just the same centuries ago when Michelangelo abandoned it. Suddenly, it was as if time had stopped moving. The sensation was oddly intimate. "I remember the stillness in there," she wrote. "I remember that I felt very much 'at home.'" She cried, and when her husband asked her why, she could say only, "It is so beautiful": but what she meant, as she explained in the letter, was that she had experienced "what life *in reality* is all about. Time stands still, or does not exist." She felt "a certain stillness," and at the same moment "a feeling of being touched, of great happiness. Being home."

Somehow artwork that had never changed, that would never change, made her think about how her own life had been changing. "To me it seems that this is the real purpose of art: to attract you to your very self by breaking certain barriers (isn't crying just a melting of the heart?), by way of a certain harmony. To unite you with who you really are."

At first, Mardien felt how Michelangelo's chapel exists outside of time, in some charmed region where nothing changes. That's a fairly common thought, but Mardien's experience is more carefully described than others I've read. Time itself, she thought, was nearly canceled: when nothing changes, even time "stands still," or ceases to make sense. And then she somehow felt this timelessness as a message directed at her. That is a less common thought, and a more dangerous one. She felt "at home" in the vacuum, in harmony with her "very self." I've never experienced what Mardien did, and I can't be entirely sure what she means. But I can see how suspended time could bring her thoughts back to herself.

"Art is a matter of the *heart, not* of the head," Mardien concludes. "Only if you take it by heart, only if you are involved completely, can you say that you know anything about it. You can write pages and pages without really knowing, or saying, anything. A real artist, like Michelangelo, or Mozart, or Beckmann, *knows.*"

For Mardien, the art put an end to the movement of time, like a wrench thrown into a gearbox. The result was a moving stillness and harmony. For others, art can provoke a harsh contrast between the viewer's life and the painting's "life." A nationally known psychoana-

lyst wrote me about such an encounter. (He wants to remain anonymous, though I am not sure why: after all, it's an important personal experience, and psychoanalysts are supposed to be open about such things!) He says that in 1971, "during a time of considerable personal stress and sadness," he was in a museum and stopped in front of a painting by Bonnard. "It was the view he often painted, of a spectator looking out through a window. Suddenly I found myself crying, rather overwhelmed by intense sadness. Later on, collected, I thought about the experience, and even though I am a psychoanalyst, the best I could come up with (and I'm comfortable with my interpretation) is that the utter serenity and harmony of the painting so shockingly contrasted with my own inner turmoil that it became a devastating experience."

In this letter it is as if the painting were in a different universe of time, and the analyst cried because he realized the impossibility of crossing over. Bonnard painted kitchens and living rooms that open onto iridescently beautiful gardens: they look like the kind of gardens you might dream about but never actually experience. It is no wonder that the psychoanalyst found the painting provocative. I have sometimes wondered how Bonnard himself could bear to look up from his impossibly lovely canvases to the actual gardens he saw and the real rooms in which he lived.

I'd like to say the psychoanalyst's experience is the mirror opposite of Mardien's. His letter is about being cut off, and hers is about crossing over. For one, the barrier between life and art was hopelessly high: for the other, it unexpectedly dissolved. Both of them make me think again of Bertrand Rougé's "traveling theory," the one about the bridge: a picture exists, he says, in another world, and we can suddenly find ourselves carried through into it. Crying might happen at any time, either when we come back across the bridge amazed and dazzled at what we've found, or when we find ourselves still standing in the museum, unable to cross over.

The painting's broken clockwork. I have been building from simpler to more complicated examples, to show how intricately time can move in paintings, how easily it can fall out of joint. The art historian Stephen Bann, who teaches at the University of Bristol, told me a

story about an experience he had in the Musée des Augustins in Toulouse. His account is significantly more complex than Mardien's, Warren's, or the anonymous psychoanalyst's.

Stephen was in a small room, admiring a portrait of the painter Antoine-Jean Gros. In the picture, Gros is young and full of confidence, wearing—as Stephen says—a jaunty hat. At that point in his life, fame was imminent. The room with the portrait is a small one, in a modern annex to the museum; the adjacent room is much larger and older, and has Gros's painting *Hercules and Diomedes,* painted for a salon forty-five years later. Stephen describes it as an "immense and distressing picture." At the time, a critic said, "Gros is a dead man." The idea was that Gros's early works were consecrated—they were classics—and that he had somehow lived on past them. Then, as Stephen writes, "his body was found floating in the Seine near Meudon, a few weeks after the Salon opened."

Stephen did not cry in front of the huge *Hercules and Diomedes,* but in the smaller room, looking at the portrait of Gros as a young man. "My tears in front of the small portrait," he writes, "could be explained by the sudden *lack of proportion* between the small and the large painting—between the early promise and the gloomy ending: between the low, confined space of the new gallery, and the Salon-type proportions of the large gallery." In a way that early portrait was of a dead man—his works would die, and then he would—and Stephen's reaction also had to do with the disproportion, the sudden drop in pressure from a life too large to fit in a small portrait, to a life too small to fill a large canvas.

It may be that each of us is drawn to special stories about time, though they circle around the painting's stillness. For some, it is unbearable to see works remain year after year, while their lives ebb away. For Mardien, it was overwhelming to be pulled out of the normal flow of her life into an artwork's petrified quiet. Van Gogh's painting pulled Warren out of normal time over and over, for almost twenty years, until he solved its paradoxical time. The anonymous psychoanalyst was shocked when a painting showed him how turbulent his own time was and how calm and serene time can be in a picture. Greuze's painting conjures a transient moment, shortly after the

FIGURE 4: Jean Auguste Dominique Ingres, *Virgil Reading the Aeneid to Augustus.* c. 1819. Musées Royaux d'Art et d'Histoire, Brussels, Belgium. Photo Giraudon / Art Resource, New York.

bird has died and before the girl has buried it, when everything is quiet and nothing moves. The girl's stillness equals the bird's stillness: that's an equation that must have moved Greuze.

Stephen's story is detailed, as a historian's might be, and it may also signal a shape of time peculiar to him. He has written an exhibition catalog for a show in the Toulouse museum; a centerpiece of the show was Ingres's *Virgil Reading the Aeneid to Augustus* (figure 4). The painting is about a similar fold in time: the Emperor Augustus had chosen his son-in-law Marcellus to succeed him, but Marcellus had died. The poet reads to the emperor about the death

of his son-in-law, but the poem is set in the distant past, in the underworld. A crowd of shades—ghosts or spirits—gathers. One approaches, and is told, "You will be Marcellus"—meaning, "You are the nameless shade who will become Marcellus, the emperor's chosen heir," and implying the sequel—"but you will die before you take the throne." Every time Ingres's painting is seen, the words "You will be Marcellus" echo back and forth through history: they are addressed to the shade waiting to be born and already destined to die, they are spoken by the poet reading the poem and proclaiming the death after the fact, and they are read by the viewer looking at the painting and reliving the moment. Inges's painting has an analogous temporal shape to the story in the Toulouse museum: they both turn on brief joyous moments that look forward, from a distant past, into a tragic and gloomy future. The still points can't be held or recaptured.

These stories could go on, swelling into an encyclopedia. They don't add up to a single theory of time in painting, because each picture pulls at our sense of time in its own particular way. If there is a common thread, it may be that paintings show us a single moment, even though they remain fixed for centuries. The ephemeral instant and unending duration are forced very close together, and that is one of painting's special strengths—one of the properties that sets it apart from other forms of art. The instant, the very definition of change, is pressed flat like a dried leaf in a collector's book and made to remain in place indefinitely.

Crying at novels and films. When I've given lectures on the subject of this book, people have often told me I should really be writing about movies and novels. That's where most people cry, they say. (Others add operas and the symphony.) The people who make those suggestions often add that films, concerts, operas, and novels make us cry because they take place through time. You can take in a picture in the blink of an eye: but movies and music take time to do their work, and that is what creates suspense, builds tension, and provokes that crucial pitch of emotion. If people are to cry, they tell me, they need the

opportunity to wonder what will happen next, and to reflect on what has passed. It is the story, they say, that carries us along and finally brings us to tears. In orchestral music there is another kind of story, an abstract one that is told in the piece's tonal architecture. Operas are doubly moving because they have melodramatic stories that take place through time, and also a tonal architecture (or at least they did, before Schönberg). No matter what the medium—so I've been told—if the work is to stand a good chance of being genuinely moving, there has to be a thread to follow through time. Otherwise everything happens at once, and it is over before you've had the chance to be ensnared.

I have heard this theory in many forms, and I can't quite believe it. I hope the stories I've been telling show that paintings are also experienced through time. It took me ten years or so to gradually lose sight of Bellini's *Ecstasy of St. Francis,* and it took Warren nearly twenty to see Van Gogh's *Olive Trees.* If you see a picture in the blink of an eye, then you've missed it. It takes ten or fifteen minutes just to inventory the plants and animals in the *Ecstasy of St. Francis.* David's *Oath of the Horatii* is the same. The story isn't there all at once: the women have already slumped down in response to something they have already seen and heard, and the most important events are still to come. Greuze's painting is much simpler, but there are still deductions to be made about what happened before, and what will happen next. I'd say it would take at least thirty minutes in the Rothko chapel for the paintings to build up their emotional force. When people say that movies and novels are "time-based" arts, they may be revealing that they spend relatively little time in front of pictures. Pictures may *appear* to be single moments, but I don't know any picture that really is.

Time is involved in the meaning of any artwork, and I think it is especially poignant in painting. So if most people cry at novels and films—and I don't deny that—then there must be other reasons.

One that occurs to me right away is that we're protected by silence in the movies and at the opera. It is ferociously difficult to concentrate in the bustle of an art museum. Then there's the distraction of other people. If the museum is even a little crowded, someone is apt to come up beside you and start looking at the same picture as

you are. In some countries, people don't give each other much "personal space," and you may find people elbowing you out of the way or standing right in front of you. In some European countries it's a custom for people to begin discreetly leaning over, inch by inch, until they entirely block your view. That kind of interruption is fatal to any serious concentration. Museums also have bright lights. If they had darkened rooms, it would be significantly easier to pay attention to the paintings, instead of the guards and the other visitors.

Noise, crowds, bright lights: it's a recipe for tearlessness. If museums were to put just one painting in each room, and if they let only a few people in at a time, then, I bet, many people would cry. The National Gallery in London does that for one picture, a huge drawing by Leonardo. It is a beautiful and stirring experience to see that drawing: You sit or stand, and let your eyes adjust to the lowered light; the drawing begins to softly glow in the darkness. It is quiet, because no one tries to talk in darkness, and the picture is all that remains to see or to think about. Who wouldn't be moved in such a setting? What painting wouldn't gain in intensity and emotional power if it were put in such a room? Many times I have been transfixed by minor paintings when they are in small rooms, alone, in half darkness, and out of the way of other people. The National Gallery's room is reminiscent of a small chapel, and the picture there has the advantage of being a masterpiece. I bet people would be deeply moved even by something as corny as *American Gothic,* if it were put in the National Gallery's dark room.

It makes some sense to say that people cry over things that take place through time, but it isn't a watertight theory. I've already mentioned some cases of instant tears (the English professor's "lightning bolt") in chapter 3, and I'll introduce more later. There's also the question of what *kind* of narratives provoke tears, because many stories don't. If anyone has cried after deciphering the elaborate stories in Giotto's Arena chapel, I haven't heard. (I can imagine crying at the impression of the place, but not at the cumulative effect of the dozens of episodes.) The same goes for the Sistine ceiling, Piero della Francesca's cycle in Arezzo, and even the stained glass in Ste. Chapelle.

Likewise people don't cry at just any music, as they would if all

that mattered was that the work progressed through time. They cry chiefly at Romantic music. People are moved by Mahler, Tchaikovsky, Rachmaninoff, and Brahms, and sometimes Beethoven, Schumann, Schubert, and Chopin. It's usually the old warhorses, and it's hardly ever classical, Renaissance, or modern music. Similarly, Romantic operas make people cry—works by Massenet, Verdi, Puccini, Wagner, and Gounod—but not Baroque operas or modern ones. I know some people cry at Monteverdi, Handel, and Josquin des Prez, but who cries at Schönberg, Webern, Nancarrow, Carter, or Stockhausen? And who cries at early-music concerts? There are the brilliant exceptions: a musicologist told me he cries at the *St. Matthew Passion,* even though he knows the work inside out. But that's the kind of exception that proves the rule. The music that elicits tears is mainly Romantic to begin with.

The same could be said of romantic novels, whether they were written at the end of the eighteenth century or the twentieth. People don't cry over fiction that is clearly modernist or postmodernist— Joyce, Kafka, Borges, Calvino, Pessoa; nor do they cry at modern and postmodern films—Gance, Robbe-Grillet, Bresson, Buñuel, Deren. People weep at romantic novels, especially when they're not exactly the best literature. Harlequin romances are romantic, both in the sense that they are stories about love, and in the sense that they belong in a genealogy that goes back to Romanticism.

It would be possible to go around and around about what makes a work modern or postmodern, but the overwhelming majority of successful, mass-market movies and novels draw on ideas, symbols, narrative shapes, purposes, and even notions of sentiment and psychology that were originally set out by the early-nineteenth-century Romantics. Fiction and filmmaking are arguably more closely indebted to Romanticism than much of twentieth-century painting. So perhaps (just perhaps; this is an especially broad generalization) another reason fewer people cry at paintings than over novels, films, and orchestral music is that most popular novels, films, and orchestral music are still Romantic. Twentieth-century painting belongs more with modern classical music than with Brahms, more with the late Joyce than with the Brontës. Romantic thoughts are the ones

that make us cry when we're reading sentimental novels, when we're out at the opera or the symphony, and especially when we're watching Hollywood movies.

It's not that movies are time arts, it's that they are Romantic time arts. We are very much a culture of the movies, and as the Hollywood executives know, we can be counted on to cry at all sorts of movies, from *Dark Victory* to *Terms of Endearment,* from *Miracle on 34th Street* to *Fried Green Tomatoes.* We even cry when we know the movie is silly. I'll put in my own story here. I was amazed and embarrassed (it's still embarrassing to tell it) when I cried at the movie *Terms of Endearment.* After all, art historians are like special-effects experts in Hollywood, who are never scared by monsters: we know how visual art works, and we are accustomed to analyzing how art produces its effects. I tend to watch movies like a technician, looking to see how the scenes are edited to increase the tension. I notice how the camera moves in slowly for a close-up, riveting the viewer's attention; I hear all the sounds that are dubbed in after the shoot (nearly everything is dubbed in Hollywood movies, from faked street noises to faked footsteps); I take note of the weird bluish lights that Hollywood has taught us to perceive as ordinary nighttime illumination. Very often, and often to my annoyance, I see the little black ellipses in the upper-right corners of the frames that signal the projectionist to change reels. Sometimes they are so obtrusive that I am aware of what number reel it is. If I'm sitting too close to the front of the theater, I notice the little perforations in the movie screen that keep it settled, and occasionally I've even seen through the holes and noticed parts of the film projected on the back wall of the theater. I am hardly ever absorbed or entranced by a movie, and I spend much of my time at the theater figuring out how the movie was put together.

None of those technical interests stopped me from crying at *Terms of Endearment.* As I watched the last few minutes, where a mother who is dying says good-bye to her children, I was also listening to the orchestral soundtrack, and noticing how the camera drew closer and closer to the deathbed. I wasn't absorbed in the drama, I never mistook what I saw on the screen for a real-life drama, and I did not forget that my theater seat was half broken so that the seat inclined

uncomfortably to one side. I was even aware that the film was slightly off-focus, and that it had the usual running scratches. I knew how the story was going, and I recognized many of the devices from Romantic novels and even from paintings. Greuze himself painted scenes with crying children at their parents' deathbeds, and he had even painted stoical little children who refuse to cry but are secretly the most moved, like the one in *Terms of Endearment*. Yet the whole grinding, creaking machinery of romantic storytelling got the better of me, and I started crying anyway. It's the romantic devices that we fall for.

Even the most acute cultural critics allow themselves to be carried away by movies in ways they would never allow in art galleries or museums. David Carrier, a philosopher at the Carnegie Mellon University in Pittsburgh, told me he probably hasn't cried over a painting, but (like Gombrich and like most of us) he has cried at movies. "I am terribly sentimental," he adds, "and I have cried before even rather silly films—the one about the Jamaican bobsled team, for example, much to my daughter's amazement." It's amazing that even a hopelessly clichéd, underacted, overplayed, underfunded, overwritten movie like *Cool Runnings* might yank a tear from a few viewers. Hollywood movies are romantic, and like Pavlov's dogs we respond to them even when we don't want to.

Any theory that links crying to the passage of time has to come to terms with these exceptions and perplexities. I'm going to sidestep the equation of tears and time arts because it has too many problems. I'm content at the moment to say that paintings are time arts, and that their ways of capturing time are very specific.

The angel's cry. Unlike opera, theater, novels, poems, movies, and orchestral music, pictures give us what appears to be one instant of time, dilated and fixed until it lasts far longer than a lifetime. If there is something peculiar to tears shed in front of paintings, it should be related to that distinctive distortion of time.

Unfortunately there's little to go on in the literature. Only a few books describe crying and art, and they lump together all kinds of media. Arthur Koestler's huge *Act of Creation* has a short chapter called "The Logic of the Moist Eye," all about crying in general. He

doesn't seem to care whether people cried at the movies or over spilled milk. A strange book by Marghanita Laski called *Ecstasy, A Study of Some Secular and Religious Experiences* reports on a survey of some six hundred people who responded to a questionnaire about ecstatic experiences. She wonders if she should classify tears and other ecstatic phenomena according to what provoked them, and she decides "the most illuminating nomenclature" is one that arranges ecstasies "according to the nature of the experience"—language ecstasies, Adamic and time ecstasies, desolation ecstasies, drug ecstasies. She's not interested in finding out if ecstasies experienced in front of paintings differ from those felt at concerts, or in childbirth, or in religious revelation. Tom Lutz, an English professor, has a book on crying, but again he isn't concerned with differences between art and life, or among different arts.

The only book I know that zeroes in on individual arts is Michel Poizat's wonderful study called *The Angel's Cry,* about people who cry at the Paris opera. Poizat says opera lovers cry because they dimly sense that singing is an attempt to escape from words. Language is like a prison house, he thinks, and the singing voice is like a dove trapped inside: the voice wants to float free, without having to mean anything. In every great aria, Poizat observes, there is a moment when the voice—especially a woman's voice, especially a soprano—begins to do amazing things, warbling and trilling, flying up to impossibly high pitches, falling through cascades of arpeggios and grace notes. The words that are sung are under incredible tension: a single syllable can be pulled and stretched so that it seems to go on forever. At some point the listener will lose track of the words altogether, and it is then—especially when a single note is held for an impossibly long time, until finally there is a break just before the end, when the singer gasps silently for breath—that Poizat says people start to cry. Listeners sense that the singer's voice had almost broken free of language, and at the same time they know that the voice can never break out of language. After the soprano catches her breath and sings the tonic note, the opera goes on in ordinary human language. Poizat thinks only angels can sing and still not make sense; if human singers could actually move outside of language the result would be a wild scream-

ing, something dangerously close to insanity. According to Poizat, all true opera lovers feel this, even if it's unconscious, and all true opera lovers cry. Ordinary pole-faced opera fans do not understand that when the coloratura sings, it's not a human voice they are hearing, but "the angel's cry."

I don't know if Poizat's theory is true—I suspect people at operas cry at other times, and for other reasons—but it is an entrancing idea. For me the best part is that if it is true, it is true only for opera. It would not apply to novels, movies, or paintings. Poizat has done for opera what I am after for painting. I want to know if pictures move viewers differently than movies or music. Maybe it's to do with the stillness, the "depthlessness" of pictures, their uncanny ability to show us everything in a glance, and then keep it there in front of us forever. Maybe. At least it's clear that paintings' disjointed sense of time produces wonderfully intricate symptoms in viewers.

"Pictures" in other arts. That's as far as I want to go with my theory about paintings and temporality, because there are so many exceptions. Proust, Joyce, and other novelists have played with frozen moments and instantaneous revelations, and there was an entire movement in Western poetry called imagism, where static visual images were a central goal. Photographs give us instants more instantaneous than painting: after all, a painting really records the hours or weeks that it took to paint it. There are movies that present instants in time: the French film *La jetée,* for example, supposedly takes place in a single moment. Some compositions, such as Carter's *First String Quartet,* also emulate the collapsed time that paintings do so well.

My favorite example of pictorial effects in writing occurs in one of the most moving poets I know, the Chinese writer Mei Yao Ch'en. He had a tragic life: he lost an infant child, then his wife, and finally his son. His poetry is haunted by the successive deaths. He wrote bitter poems about the loss of his children, but the longer he lived the more it was the memory of his wife that bore down on every thought:

> Since we were first married
> Seventeen years have past.

Suddenly I looked up and she was gone.
She said she would never leave me.
My temples are turning white.
What have I to grow old for now?
At death we will be together in the tomb.
Now I am still alive,
And my tears flow without end.

I hadn't read Mei Yao Ch'en for a decade or more, and my copy of the poems had been lying on its side, gathering dust on a shelf in my parents' house. When I took it down to read again for this book, I was moved again without thinking I would be.

The best of his poems paint pictures of his daily life. The strongest of all, I think, is this one:

In broad daylight I dream I
Am with her. At night I dream
She is still at my side. She
Carries her kit of colored
Threads. I see her image bent
Over her bag of silks. She
Mends and alters my clothes and
Worries for fear I might look
Worn and ragged. Dead, she watches
Over my life. Her constant
Memory draws me towards death.

I still feel a stab when I read Mei Yao Ch'en, partly because I know what is coming.

The picture, the unmoving object kept in steady view, is what drives the poems. "I see her image bent / Over her bag of silks." I read the lines, I see the images, and I know how the poet saw it. It is static—"I see her image" every morning, or each time I read the poem—like a picture. Something about pictures is at work here.

Horace's old phrase *ut pictura poesis* ("as is painting, so is poetry") has been quoted and discussed for nearly two millennia, and I am not

about to sail into those well-charted waters. I want only to acknowledge that paintings can't produce a species of tears that is utterly unknown to other arts. There are overlaps, because many arts use the idea of a picture. (That's also the reason I am not examining sculpture, video, or photography in this book. It's enough to try to see what is peculiar to painting, without having to draw boundary lines between the arts.)

An odd relation to time in paintings can certainly drive people to tears. It is the principal reason that people have given me when I pressed for explanations. The cases are confused and entangled, and I've done my best not to paper that over. There is no Linnaeus of crying, no hope of tidying things up. That's as it should be. If crying could be cleanly subdivided it wouldn't be an extreme experience, but a domesticated one.

Alongside time there are two other causes of tears that people often mention, and which are supported by the historical sources. Both of these causes surfaced right away, in the first chapter on Rothko, and I have been half explaining them all along. I've been slow to talk about them because they have to do with a subject that may seem overindulgent even by the standards of this book: they have to do with religion.

I had a couple of reasons to put off talking about religion until halfway through the book. First, I figured a book on crying at paintings is moony enough, and if readers saw the word "religion" on page 1, they would close the book. (I probably would.) Second, I know that many people in the arts find religion an anathema. It is one of the great excluded topics in twentieth-century art history. And third, I was afraid it might look as if I were saying strong paintings are basically religious. That is not so, and we are lucky it isn't, because the connection between the deep experience of painting and the deep experience of religion is not as far-fetched, or as trivial, or as mystical as many twentieth-century writers might hope. In the chapters that follow, I'm going to try to show that some of the most intense encounters with paintings have been essentially religious, even when religion was the farthest thing from the viewers' minds.

9

Weeping, watching the Madonna weep

Tears ... are marks of devotion, not merely products of grief.
Christ wept for what affected us, not for Himself, because God
does not shed tears. Christ wept because of the nature of what
took place: He wept when He was crucified; He wept when He
died; and He Wept again when He was buried.
— St. Ambrose, *Two Books on the Death of His Brother Satyrus*
(d. 17 October 379 A.D.)

Think of St. Paul's tears when he was in prison: for three years,
night and day, he did not stop weeping.

What fountain can you compare to those tears? The one in
Paradise, that waters the entire earth? But this font of tears
watered souls, not earth. If some artist were to show us St. Paul
bathed in tears and groaning, wouldn't that be far better to see
than a choir of countless singers, all gaily crowned? ...

With these tears the Church is watered; with these tears
souls are planted; with these tears any fire, no matter how fero-
cious, is quenched. ... Christ said, "Blessed are they who
mourn, and blessed are they that weep, for they shall laugh."
Nothing is sweeter than these tears; they are sweeter than any
laughter. ...

So tears are not painful. In fact, tears that flow from pious
sorrow are better than tears from worldly pleasures and disas-
ters. ... For where is a pious tear not useful? In prayers? In

exhortations? We give tears an ill name, by not using them the
way they were given us to be used.
— St. John Chrysostom, *Homilies on the
Epistle of St. Paul to the Colossians*

THIS IS SUCH A DRY century that it helps to remember that people
have cried in front of paintings ever since there were paintings. Even
when the documents are lacking, the evidence is clear. In ancient
Greece, people felt "pity and terror" at tragedies, as Aristotle says
tersely. The players on stage pretended to cry, and the audiences
answered with real tears. It is possible that people began crying at
pictures, including reliefs on gravestones and possibly even paintings
on vases, around 500 B.C. Hedwig Kenner, who has made a special
study of Greek crying, says that new gestures of despair and grief
appeared on vases and grave stelae just at the same time that tragedy
and large-scale wall paintings were getting under way—right around
500 B.C. That is when we begin to find pictures of people crying on
their own, rather than in groups as they do in Greek tragedy. In the
theater, phalanxes of wailing women enacted ritual grief, but the new
solitary figures were stricken in an inward-turning way.

Each gesture is different, because each person is a suffering indi-
vidual. One lets her eyes fall to the ground. Another covers her faces
with her robe. On one vase a woman raises her arms stiffly, clutching
at her cloak. Another stands, her chin pressing down onto a cupped
hand, her other hand holding tight to the elbow. Clearly these are
attempts to compress grief, to stop from shuddering.

On a carved relief, disconsolate mourners stand on either side of a
tomb. One is stony-faced and empty-handed. She stares away into
space. The other clutches herself to stop from shaking as she weeps.
There is nothing else to see: just the tomb, and the two forms of sad-
ness. They are intensely imagined, and they must have brought some
viewers to tears.

Those are promising beginnings for a culture of painted tears.

Unfortunately so much Greek painting has been lost that the story largely ends there.

Tears of compunction. When Christianity took hold, weeping became commonplace. The flood really begins in the Bible, where a psalmist declares: "Every night I will wash my bed: I will water my couch with my tears." (The passage was quoted many times. St. Ambrose mentions it in the same passage as the one that opens this chapter.) Another psalmist says, "My tears have been my bread day and night," as if it were possible to live on the salt in teardrops. The prophets wept for their country ("For the mountains I will take up weeping"), and the country itself wept in return ("The earth shall mourn and the heavens lament from above").

Beginning with Antony Abbott in the fourth century, crying became an officially recognized form of worship. People were urged to weep with the joy and sorrow of God. After all, Antony wrote, the saints weep and sigh for us in heaven, even as they face God; how much more should we cry for our own salvation. The doctrine of compunction, as it came to be called, was an essential part of prayer. Tears of compunction were not selfish tears, and they didn't stem from anything personal; they were considered a gift from God.

Gregory the Great said compunction "pierces the distended mind with the punishment of penance": a wonderful phrase, meaning, I think, that God punctures a devoted servant so that His joy can escape. If you are a compunctive worshiper, your tears are not your own: they always belonged to God, and the only way to show Him that you love Him is to let Him release His tears so that they can go back to Him. God listens to tears, because He recognizes them. "We must know," writes St. Benedict of Nursia in the sixth century, "that God regards our purity of heart and tears of compunction, not our many words."

Reading this literature, I feel myself being carried off in a deluge of different kinds of tears. Compunctive tears are a bittersweet flood, mingling joy and grief, desire, repentance, penance, devotion, love, and hope. A worshiper might be praying, and be seized by guilt for

some sin he had committed. He would start to cry, begging forgiveness; but then, remembering not to cry for himself, his tears would turn to a sweeter flavor, and he would think of himself as crying for all mankind; and then later, still weeping, he might recall Gregory the Great, and try to let God coax the tears from him. It would be as if the tears were flowing from the cross, into the worshiper's body, out again through his eyes, and back to God. The many tears in the medieval texts merge together in my mind like bright alpine rivulets converging into muddy streams, all joining and pouring into a great swollen river of weeping. The early medieval texts give ample evidence that people knew whole oceans of tears and that they tried continuously to distill their crying into the purest compunctive teardrops.

The word "compunction" comes from a Latin word, which is in turn related to *pungo,* "to prick, sting, bite, grieve, or annoy," and *punctum,* "a small point, spot, prick, or sting." That is why compunctive tears puncture the worshiper, and why the body is imagined as a reservoir of dammed-up tears. With these images of piercing and pricking, it makes perfect sense that paintings of the crucified Christ were a focus for compunctive worship. In medieval crucifixions, the impaled Jesus, his hands and feet pierced through, his side cut, his head bleeding, his skin pricked, looked down at the worshiper with unlimited forgiveness.

People like St. Francis answered one such image with tears. Thomas of Celano, a fourteenth-century follower of St. Francis, tells how a painted crucifixion spoke to the saint, and from that moment on "he could never keep himself from weeping."

It is an amazing thing to say. Never mind for the moment whether you believe in Christian miracles, or even if you're a Christian: it is clear that Thomas thought it was entirely reasonable that a *painting* had changed St. Francis's life.

Intimate devotional images. Late medieval and early Renaissance paintings often had crying figures, inspiring compunctive worship. Thirteenth-century paintings in particular are full of weeping. Jesus cries, his disciples cry (especially John the Evangelist, who felt the

divine tragedy most inwardly), and the angels cry when they see Jesus crucified or laid on the ground. Then there was Mary, typically prostrate near the foot of the cross, "her face flowing with tears," and Mary Magdalen, gripping the cross itself and wailing up at the crucified Christ. The Virgin took the pose first used by Greek painters, where one hand grips the opposite elbow, and the other steadies the head. In late medieval sculpture, it became popular to decorate tombs with "weepers," figures who stand and cry open-eyed, or shut their eyes and wring their hands with unexpressed grief.

Toward the end of the Middle Ages, in the fourteenth century, a new kind of painting came into being that was specifically intended to produce an intense emotional experience. Instead of showing Christ or the Virgin in full-length poses, the new pictures brought them forward and depicted them in half-length, from the waist up. That way the holy figures were nearer the beholder: as one art historian says, they worked with "the immediacy of a quiet conversation."

The painters experimented with "close-ups" of commonly painted stories. Instead of painting the whole scene of the flagellation, with Jesus bound to a column, being whipped by Roman soldiers with Pontius Pilate looking on, they would paint Jesus alone, his wounds bleeding, looking straight out of the picture at us. Instead of painting the way to Calvary, with the parade of Roman soldiers and onlookers, they would paint Jesus sitting down, just before he was put up on the cross. Instead of painting Jesus and all twelve disciples at the Last Supper, they would paint just Jesus and his most devoted disciple, John the Evangelist. The new painters chose such moments so that viewers would concentrate on the most intimate, heartfelt emotions.

The new painters made double portraits, connected by a hinge. On one side they put Jesus as the man of sorrows with his scourge and crown of thorns, and on the other the Virgin, weeping. The double pictures opened like books, so viewers could stand them up on a table or a home altar. Mary would seem to be looking across the hinge at Jesus. I can imagine sitting with such a double portrait open in front of me: it would be as if I had joined a quiet group of mourners, sitting in a close circle. If I spoke, it would be in a whisper. I

would be in intimate conversation, hemmed in by the suffering Savior and the stricken Madonna.

There are even pictures that isolate Christ's wounds—whole pages in prayer books filled with bright red ellipses of paint, representing the slit in Christ's side, or the holes in his hands or feet. Some of those images are weirdly sexual—they are soft and red, and they look more like vaginas than wounds. Modern scholars have written on the unconscious sexuality of such images, but fundamentally they were meant to concentrate a viewer's attention, to make worship more intimate, to put before the mind's eye only what the heart could understand.

The closely cropped half-length portraits, sometimes called "devotional images" (in German, *Andachtsbilder*) must have moved many people to tears. There was a new doctrine in the air, enjoining worshipers to do more than just sympathize with Jesus or Mary: the aim of prayer was to identify with them bodily, to try to think of yourself *as* Jesus, or as the Mother of God. You would look at such an image steadily, sometimes for hours or days on end, burrowing deeper and deeper into the mind of the Savior or the Virgin. Finally you would come to feel what they had felt, and you would see the world, at least in some small part, through their eyes. At that point their tears would be your tears—as compunctive doctrine had always said they were.

A devotional image in Chicago. Dieric Bouts's *Weeping Madonna* is one of those images (colorplate 5). Like some other *Andachtsbilder,* it was very popular, and Bouts had his workshop do several versions. The one I know best is in the Art Institute in Chicago, across the street from where I work. Another, painted shortly afterward, is in the Metropolitan Museum in New York. They are small paintings, the size that would have fit well on a shelf. Both were once hinged to companion paintings of Jesus.

Bouts's painting in Chicago is gorgeous, one of the finest of its kind. The Virgin Mary sits in a room, alone. Her cloak is lopsided, pulled up carelessly over her head. She is not shaking or wailing, as she is in other paintings: instead she is praying quietly. She faces in

Jesus's direction but doesn't look at him. Her hands are pressed together gently and firmly, the fingers of one hand resting in the depressions between the fingers of the other. Her little fingers are held apart from the others, and slightly bent. The pads of the fingers push a little against one another. They're interesting hands: careless and yet tense, spontaneous but fixed in place.

Her face has the same informal deliberation. Her lips are closed, but her teeth are not clenched. The corner of her mouth has that slight indentation that is an infallible sign of tension—the gentlest echo of the deep groove that forms when the mouth opens in grief. Her mouth is set, but not too hard. The slight unmistakable set of the mouth and fingers is a wonderful touch: it stands for her fragile composure, her resolution.

Her hands and her mouth are enough to tell the story, but the painting is really about her eyes. They are masterpieces of modulated expression. Her left eye (the one farther from us) is extremely sad; it turns away from us, and away from Jesus, into the dark folds of her veil. The nearer eye, if you look at it alone, seems to look back at you with an unsettling abstracted glance. Together, her two eyes give us a face that is just barely focused on its object. We are meant to know that Jesus is dead, and the Madonna's thoughts are turning inward. Her eyes have almost lost their grip on what they see. They only stay focused because of her continuing effort. In the moments before the one depicted in the painting, she must have been wild-eyed and crying hard. Now the initial burst of passion has ebbed, and her tears have dwindled to a steady succession of drops. Her eyelids are puffed from crying, and both eyes are red. The capillaries in her corneas are swollen, coloring her eyes a deep pink.

Tears are dripping slowly down her cheeks. The left eye has two drops, and a third down on the cheek. The near eye is overflowing with tears—you can see the brim, lucent on the lower lid. One tear has formed toward the back of the eye, and another is just dropping from the front. Two tears have fallen ahead of them: one on her cheek, and another that is about to swerve and run into her mouth.

The sadness of this is the way her grief is measured out. She cried out loud only when Jesus was put on the cross, and then brought down and buried. But in Bouts's version she will never stop crying, as long as she lives. For years, she will have the same half-absent look, the same taut expression. Her tears now are everyday tears. The Crucifixion could have happened years ago, for all we know: this is a painting about a state of mind, a permanent low-level mourning. What she feels is consonant with the doctrine of presentiment as it is depicted in other Renaissance paintings: the Madonna knew what would happen before Jesus was grown, and she still has that knowledge. It is a kind of eternal sadness, which will not be dulled by time. She remains in her room, weeping. Her slightly unfocused eye will always see the death of her son.

It is terribly hard to get close to these ideas, and I understand scholars who can only say things like "An essential feature in the various forms of *Andachtsbilder* is the significance of the visual presentation for the stimulation of an empathic response." That sounds rather clinical, but what else is there to say? These are private matters, certainly beyond the dry methods of scholarship, beyond the scope of most viewers in the twentieth century, and possibly even beyond the reach of words. The only reason I learned to love Bouts's picture is that a student of mine named Rasa once copied it. She set up her easel right in front of the painting, and despite the distracting crowds she kept coming back, week after week, slowly perfecting her copy. She helped me to see the picture in minute detail.

We studied the uneven textures of the Madonna's middle-aged skin, the faint shine of her unpolished nails, and we even looked at the dirt lodged beneath them. We discussed the mistake Bouts made in the length of her first three fingers (at first they were not long enough, and so he stretched them a little, making a row of double fingertips). Rasa visited the museum once or twice a week for fifteen weeks, and at the end of that time we both had a sense that we knew the figure in the painting. Toward the beginning, Rasa's copy was a blurred version of the original, with a brilliant gold leaf background.

As the weeks went she gave the skin color and depth, and clothed the naked head in its heavy bluish-black cape and starched white veils. Toward the end she painted the little wrinkles on the back of the Madonna's hand and around her eyes, and put the tiny folds in her clothing. She glazed the gold leaf with soot-colored pigment to simulate the effects of five centuries of tarnish. And finally, as the last touch—the essential moment, when the picture came to life—she painted in the tears. They are round, full tears, carefully measured out, each one lit by a little reflection from a small window.

During those weeks the Madonna's sadness became real to both of us, and by the end we were far from the art historian's interest in the "stimulation of an empathic response": we didn't need to know about empathy because we simply *felt* the Madonna's emotions. At least for me, the feeling was sour, salty, and heavy, as if I were steeped in the brine of the Madonna's grief.

Devotional images require devotion: that is the bottom line. Without the patience to live with such a painting, it remains silent. And what is art history in this respect, if not a typically impatient academic pursuit? Its practitioners are constantly fluttering from one image to the next, anxious for intellectual nourishment. The flood of tears that swept over central and western European painting in the fourteenth and fifteenth centuries will probably always be a desert for people who move too fast. These are slow paintings, suffused with dull, slow-acting passions.

Rasa finished her painting several years ago, and I still visit the original whenever I go through that part of the museum. The face and its sorrow have no specific age, and the painting seems to grow older along with me. Each time I see it, it seems more resolute. Someday, when the painting sinks deeply enough into the way I think, I may well cry.

A note on the sober Renaissance. Bouts painted his *Weeping Madonna* at the end of the reign of late medieval tears. The custom of painting *Andachtsbilder* was dying out; they were gradually being replaced by other kinds of images, and by a new kind of secular painting.

Renaissance artists had very different thoughts about painting and crying. In the early fifteenth century Leon Battista Alberti, arch-humanist and polymath, worried about how to make sure people in paintings don't look like they are laughing when they are supposed to be crying. Alberti was out of sympathy with the pictures he critiqued. He was thinking of some fourteenth-century paintings where the Virgin grasps her dead son with an expression that looks suspiciously like a giggle. In some of those paintings the "laugh" was probably intended to be that pathetic smile that can creep over your face if you try too hard not to cry. The fourteenth-century artists were not entirely naive: surely they knew that an opened, upturned mouth would look very much like a happy smile. The point is, they did not care. They knew that people who suffer terribly sometimes get that funny expression. No one but a Renaissance humanist or a pedantic scholar would bother to point out that the expression also looks like laughter.

As in everything he did, Alberti was in touch with his times. His concern about reliable, unambiguous expressions became a central issue in the education of artists. By the end of the seventeenth century, people had already written books on it, and in the eighteenth century it became the "science" of physiognomics. An artist could tell exactly how to paint an emotion by looking it up in a book. Suffering, even the grief of Mary, would just be listed under the heading "suffering," in alphabetical order between "sanctimonious" and "supercilious." How bloodless—how impious—that would have seemed to a medieval painter intent on capturing the Madonna's plaintive "smile."

In comparison with what went before, most High Renaissance art is dry-eyed. In the years from Alberti to the young Michelangelo (say, 1430 to 1510), central Italian artists were caught up in great ideas: the theory of visual art, painting's status among the other arts, the geometry of the visible world, the concept of drawing. It was heady stuff, and it meant artists tended to be as interested in demonstrating their skill or their intellectual acumen as in moving their viewers.

Later in the Renaissance, the Counter-Reformation broke down some of the humanist resolve, and created something of a crisis

among artists such as Michelangelo who had been brought up disdaining art that pandered to the emotions. Late in his life, sitting with his friend Vittoria Colonna, Michelangelo made a withering remark about Flemish people who cry over paintings. It is one of the few times any Renaissance text mentions crying in front of paintings.

> And smiling [Vittoria] said, "I wish to know, since we are on the subject, what Flemish painting may be and whom it pleases, for it seems to me more devout than that in the Italian manner."
>
> "Flemish painting," slowly answered the painter, "will, generally speaking, Signora, please the devout better than any painting of Italy, which will never cause him to shed a tear, whereas that of Flanders will cause him to shed many; and that not through the vigour and goodness of the painting but owing to the goodness of the devout person. It will appeal to women, especially to the very old and the very young, and also to monks and nuns and to certain noblemen who have no sense of true harmony."

He then goes on at length about the superiority of Italian painting. Art historians cite this passage as a slam against Flemish art, and certainly it is that. But it is also more complicated. After all, Michelangelo was addressing a woman who was famous for her piety, and he says right up front that Flemish art pleases devout people. Vittoria Colonna had a special place in Michelangelo's life in these years: she was his intimate companion in spiritual matters. Their shared sense of spirituality involved a great deal of private devotion. They read texts that hardly mention church services, enjoining worshipers to spend time simply thinking about the "dread figure" on the cross. Michelangelo drew pictures of the Crucifixion for Vittoria to use as objects of meditation—to use, essentially, as *Andachtsbilder*. She reports looking at one of them for hours at a time. Some of Michelangelo's own drawings, ones he did not give her, are oddly stained, and one art historian has suggested they are pocked with Michelangelo's own tears. That may or may not be true—a chemical analysis could resolve the question someday—but it is in tune with the spiritual climate of the drawings.

So Michelangelo's answer is both more and less than a put-down. He does say, "There is no clime or country lit by sun or moon outside the kingdom of Italy where one can paint well," but he also knows that those whose lives center on devotion and prayer—as both his and Vittoria's did in this period—will be brought to tears more readily by Flemish pictures. He was in a bind, and well aware of it: he had an intense desire to produce truly devout work, and an equally strong ambition to make great art, and he knew that the two had begun to seem incompatible.

Devout people, including Michelangelo, may have been crying at religious images throughout the sixteenth century, but Michelangelo also means it when he says people will not cry over "true painting." He did not live long enough for us to be sure which side he would have come down on, but his late works certainly tend away from the humanist achievements of his youth and back toward the realm of pious, compunctive tears.

The Italian Renaissance, the beginning of so many things, might also be defined as the resumption of tearlessness. Even though it seems distant now, the Renaissance is the place where painting was defined as an art. Before the Renaissance, paintings were objects that had religious uses: even an early Renaissance painting like Bouts's is first and foremost an object to accommodate prayer, and only secondarily a work by the famous master Dieric Bouts. With the inception of the Renaissance, it became possible to conceive paintings as *artworks:* things done at least in part for the glory of the painter and the furtherance of the art of painting.

It goes without saying that many people must have cried at images in the Renaissance, and I don't mean to make a black-and-white border here between medieval piety and Renaissance artistry. Yet when it comes to the largest, most fundamental changes in the ways we use and comprehend paintings, the Renaissance revival of artist's skills, artist's biographies, and artist's careers is decisive. It has many ramifications, many more than I could fit in this book. For the history of tears it has a single, crucial consequence: when you emphasize the skill of a painting, you necessarily lose a little of the capacity to be directly moved by it. If you concentrate on the artist's genius, you

unfocus your emotional response. Every adjustment in the direction of art is a minute shift away from the apparently unmediated and intimate response that a painting like Bouts's can elicit. Historians resist generalities like this, and for good reason. I am pushing this one a little because it seems to me that there are times when it is good not to forget the deepest shapes of culture, the ones that lie so deeply buried that they seem to have become the very landscape we walk around in. Like the half-buried giant at the beginning of Joyce's *Finnegans Wake,* or the giant that makes the landscape in William Carlos Williams's *Paterson,* the question of the beginnings of our awareness of painting as an art is right under our feet.

So when I say that the Renaissance was the resumption of tearlessness, I mean on the largest scale, with allowance for a myriad of exceptions. But I also mean it: the paintings in the Renaissance rooms of most museums still elicit our admiration and our awe more than our tears. The artists' skills are preeminent and inescapable. Every picture is in some measure a proclamation of its maker's genius and the sophistication of the theories he mastered. Even if you aren't moved by a medieval or early Renaissance painting like Bouts's, it is uncomfortably clear that what matters is only piety and emotion.

The history of crying in a nutshell. We owe the Renaissance more than we often admit. It gave us not only the art of painting, but the very idea that painting could be an art. It bought all kinds of new interests for painting, sometimes at the expense of medieval values. Prayer and piety were muffled or made inaccessible, and in their places we got art theory, painting schools, historians of painting, and even textbooks and courses to study. Paintings, in the plural, became radically more compelling, while painting, in the singular, changed and lost some of what it had once been.

The shift from the fifteenth-century *Andachtsbilder* like Bouts's to the sixteenth-century showpieces of skill is the first large-scale alteration in Western thought about painting and emotion. (I'm not counting Greek painting, because not enough has survived.) The second is the seventeenth- and eighteenth-century return of emotions, as in Greuze's painting. The third, which I'll come to in chapter 11, is

nineteenth-century Romanticism. And the fourth, the one we are living in now, is the twentieth-century retreat into stoic intellectualism. In the broadest possible terms, that is the vacillating history of pictures and tears in the West.

It is also the story of our current disillusion. A huge cultural change, like a tidal wave, has brought us to this affectively neutral place and marooned us here. From our dry desert island we look out at the ocean with suspicion. The fact that I'm writing this book in the middle (or near the end?) of an era of sobriety makes it, I know, fundamentally eccentric. The emotionless air of the twentieth century has come to seem entirely natural: we're inside it, we breathe it, we take it as the normal condition of life. That is why it helps to look back to the fifteenth century, or the eighteenth, or the nineteenth. It may well be that our imagination can't find its way back to those periods—that is a question I am leaving open, right to the end of the book—but at least it helps to know they existed. We can't know what went on in a worshiper's mind in Assisi in 1250, or Bruges in 1450, or Florence in 1550. (Those are roughly the coordinates of St. Francis, Bouts, and Michelangelo.) But we can be sure there were people back then who would have thought it was fundamentally eccentric, naive, or misguided to look at a painting and feel nothing.

Portrait of a scholarly culture. The twentieth century bears comparison with the sixteenth century, its great dry predecessor. From cubism to neoexpressionism, from fauvism to minimalism, twentieth-century movements didn't ask for the kinds of extreme reactions I have been considering. Instead, twentieth-century painting is very much concerned with itself as an art: it is intellectual, meaning that it is intended to raise all sorts of issues that don't have to do with brute emotions. Visual artists are focused on what they are doing, weaving a myriad of threads connecting their painting to philosophy, history, criticism, politics, gender studies, and psychoanalysis. Some of the best recent work is intensely self-aware, self-interpreting. Twentieth-century painting, in short, knows itself and its project, its potential and its limitations. The better it gets at all of that, the further it is from the kind of emotional force I'm chronicling here.

At least that is one way of putting it. There is also plenty of evidence that the twentieth century has found ways to experience powerful emotions together with self-reflexive awareness of the history of painting. No one who has cried looking at the *Guernica* could have been oblivious of the fact that it's a highly stylized painting. At the least, that shows crying and the word "cubism" are not wholly incompatible. A number of the people who reacted to the Rothko chapel were very thoughtful about what they felt. I wouldn't rule it out of court (though I'd have to see the evidence) that people could have been driven to tears by the fierce ideology of Malevich or El Lissitzky, or by the pummeling rhetoric of the futurists. Tears, in sum, can be mingled with many kinds of cold intellectual concerns.

It's not that the twentieth century is cool and standoffish. There is work that aims to shock viewers, and plenty that aims to dismay, insult, enrage, repulse, and disorient. Some paintings are intended to be intensely annoying (some of Warhol's were), and who is to say an intense annoyance can't be as powerful as an intense affection? It wouldn't be difficult to make a case that twentieth-century painting is full of strong emotions. People have laughed at paintings, sneered at them, and been sickened by them. In Nazi Germany paintings were burned. Protesters and psychopaths have slashed paintings with knives, thrown acid at them, cut them up, and even shot them. Given all that, is it still possible to say that the twentieth century is dry-eyed?

Despite everything, I think it is. A good, easy piece of evidence is the textbooks that describe the century's painting for students and scholars. Nearly without exception, those books take a sober and controlled tone. They are not concerned with recording the artists' emotions, and they would count it inappropriate to get a reader too worked up. (The exceptions are best-sellers, like Simon Schama's *Rembrandt's Eyes*.)

Twentieth-century textbooks are preoccupied with intellectual issues. There are books on painting and gender relations, on artists' patrons, on artists' theories, and on painters' responses to contemporary politics. Many books on twentieth-century painting are driven by specific theories: psychoanalysis, semiotics, feminism, deconstruc-

tion. Books for undergraduate students are just as dry. They tend to present twentieth-century painting as a succession of styles and manifestos, or as a parade of gossip. Naturally there is a tremendous variety in all these books, but not one twentieth-century book on art that I know comes close to Diderot's ecstatic, ridiculous, and hilarious little fiction about Greuze's painting. In comparison, we are terribly parsimonious with our emotions, circumspect and intellectual and timorous. In Diderot's eyes (and many other names from the past could be put in here), we would look frail and prissy.

Dieric Bouts's painting is seen by hundreds of people each day. In the years I have been visiting the museum, and in the months when I have worked there every day, I have only seen a handful of people really standing still and *looking* at the painting. They're attracted because the painting is in a Plexiglas case on a plywood pedestal, so it is obviously an object of special value. (Or because it is often reproduced on museum postcards and maps.) They glance at the label, and then they give the painting a quick inspection. It is obviously well painted, and sometimes that merits a comment. But in my experience, the great majority of visitors don't linger more than a half-minute. The picture is largely a curiosity, a lovely little image from a forgotten century. (The room it's in is catercorner to a much larger room with paintings by Monet, Gauguin, and Van Gogh.) Art historians have also given it short shrift because it isn't one of Bouts's most important paintings. It is a superlative example of its kind of painting, the *Andachtsbild,* but it isn't unique. Rather it is a sign of its times, a work intended for the "stimulation of an empathic response."

The painting is sealed off from us, encased in its Plexiglas box like an extinct animal preserved in a zoological museum. It's a relic, severed from its original life and from our imagination. Two great dry deserts stretch between us and the *Weeping Madonna:* the original Sahara of the Renaissance, and our own desert of modernism and postmodernism. The painting is right there in front of us, and yet it is unimaginably far away.

10

Crying at God

Consider that St. Paul was bold in the face of fire, hard as adamant, firm and unshaken, riveted in the fear of God, and absolutely inflexible. "Who," he asked, "shall separate us from the love of Christ? Will we be separated by tribulation, or anguish, or persecution, or famine, or nakedness, or danger, or the sword?"

But the man who was brave in the face of all those things, who laughed in scorn at the hard gates of death, who broke everything that opposed him: this same man, when he saw someone he loved in tears, was crushed. He did not even conceal his feelings, but said straight away, "What are you doing, weeping and breaking my heart?"

What do you think of that? Does a tear have the power to crush a soul as hard as his? "Yes," Paul says, "because I can hold out against everything but love. Love prevails, love subdues me."

That is the mind of God. An abyss of water did not drown Paul, but he was crumpled by a few tears.

— St. John Chrysostom

Pray humbly to the Lord, therefore, so that He may give you the spirit of contrition; and say, with the Prophet, "Feed me, Lord, with the bread of mourning and give me to drink tears in full measure." Wherever you are, wherever you go, you are miserable unless you turn to God.

— Thomas à Kempis, quoting Psalm 79

ON THE THIRD SUNDAY in Lent, in the year 1380, St. Catherine stood in a courtyard outside the old St. Peter's church in Rome. She was looking up at a high wall above the cloister, at a giant mosaic showing a boat on a stormy sea. It was Giotto's famous picture, known to every artist for its breathtaking realism. It was so famous that it had a nickname: the Navicella, or Little Boat.

In the picture, the boat looked as if it might be swamped at any moment. Its sail was stretched to bursting by the wind. Jesus's apostles were all in the boat, huddled together in fear. On the right side of the picture, Jesus was walking across the water toward the ship. The apostles had just sighted Him, and He had called to Peter, asking him to step down out of the boat, into the sea, and walk out to meet Him. As it says in the Gospel according to Matthew, Peter saw that the wind was blustery, he became afraid, and he started to sink. He cried out to Jesus,

"Save me!"

Jesus reached out, caught him, and said, "O thou of little faith, wherefore didst thou doubt?"

Together they walked across the stormy waves to the ship, and when they climbed in, the wind died down.

Giotto had chosen to show the moment when Peter was on the point of sinking. He was in up to his knees, reaching up toward Jesus, begging to be saved. Angels were flying through the air, crying and singing. The other apostles were cringing in fear, seeing Peter sink and Jesus float on the churning waves. One apostle was wringing his hands; several others could hardly bear to look.

For St. Catherine the meaning was clear: You will sink if you do not accept Jesus as your savior. But who would jump out of a boat into a stormy sea? How much faith can a person have? As she stood there, St. Catherine suddenly felt the whole weight of the boat on her own shoulders, and she collapsed to the ground. From that moment until the end of her life, she was paralyzed from the waist down.

Pictures that make people bleed. This story is like the one of St. Francis weeping for years after he saw a painted crucifixion. Scholars

tend to doubt these testimonials, but then again we've drifted a long way from St. Catherine's kind of faith. I wouldn't want to doubt that she was paralyzed by a picture. At the least, the story is wonderfully apt, and illustrates truths about piety and worship. Like the story of St. Francis's tears, it shows the power that pictures once had.

The image St. Catherine saw still exists, although it has been restored so many times that it is only a lingering echo of what it was when she stood under it in 1380. St. Catherine was probably familiar with Giotto's exceptional, almost mythical status. His works were thought to be more astonishing, more directly real, than any other artist's, and it is entirely fitting that if any picture could have the power to break St. Catherine's body, it would be one of Giotto's. The picture is all about weight: the sinking St. Peter and the floating Jesus, and the sheer mass of the stone and glass mosaic mounted high over St. Catherine's head. Yet it wasn't only the picture's mass that crushed her, or even Giotto's unparalleled skill: it was the force of faith that Giotto had made visible.

St. Catherine cried often, and her letters are full of tears. Many of them were shed over images, or while she was remembering images. She had also been looking at a painting five years earlier, on the first of April 1375, when she felt the heavenly pain of the stigmata. Her hands, her feet, and her side were all pierced as she knelt in front of the painting. In this case, the picture she saw still survives intact: it is a crucifixion in the Casa della Santa in Siena. It is amazing to think, looking at it now, that this image once had the power to pierce a viewer's heart, and even to draw blood. It is a typical archaic-looking fourteenth-century crucifixion, with a flat, formulaic Christ. His arms are stretched limply like wires from a telephone pole. Yet for St. Catherine it was a revelation and the instrument of a miracle from God.

I think St. Catherine is the first person on record to receive the stigmata while looking at a painting. Her reaction was modeled on St. Francis's stigmatization, which happened in 1224—and ever since St. Catherine's time, devout worshipers have experienced spontaneous bleeding in front of images. A sensationalist book, *The Bleeding Mind,* provides skeptics with photographs of stigmata on people's

hands and feet. The evidence is ambiguous, and even the early saints did not always claim to have bled from their hands and feet when they received the stigmata. (Some said they bled afterward.) It may not be medically possible to bleed spontaneously from the palms by the sheer force of belief, but it is not unheard of to bleed from the eyes. Hysterical bleeding, as it is sometimes called, has been observed in people who looked at images of the Savior crying. To be sure, most people merely weep: but there are a handful of documented cases of bleeding. It's entirely possible that the painting in the Casa della Santa made St. Catherine bleed, just as it's possible that Giotto's mosaic paralyzed her. Whether or not either encounter actually happened, they need to be taken seriously for what they have to say about the beliefs of the time.

How can we possibly find our way back to St. Catherine's piety? How can we experience anything even remotely like the burning intensity with which she looked at pictures? At the least, we would have to be pious. Then it would be necessary to overlook the painting's quality, stop thinking about its stiffness or its skill, stop wondering how much it's worth, or who owned it last. It would be necessary to stop seeing pictures as artworks. I think it's too late for all that. We've been crushed by the weight of history's myriad minute facts, and St. Catherine's piety has slipped away. If I were to study the Casa della Santa crucifixion, I could learn to admire and even love it: but I am forever barred from feeling the pinprick of emotion. The picture is never going to make my flesh crawl, or reach out with invisible needles and puncture my skin—the very thought of it is ridiculous. Looking at it now, the most I sense is the kind of cloudy reverence anyone feels for something so ancient.

Being punched by a painting. Once upon a time, in late medieval Italy, pictures could make people cry—not just once, but for years. They could hurt people, and make them bleed. Pictures were capable of healing, blessing, and even transfiguring the people who saw them. Viewers were wounded and even paralyzed: they were, in effect, assaulted by paintings. We may be a long way from St. Catherine's

open-hearted piety, but I don't think the trail has gone completely cold. As in the case of Greuze's silly painting, an idea can still be salvaged from St. Catherine's experiences.

As I did before, I take my cue from the letters I've gotten. Some of them were written by people who were literally floored by paintings: they collapsed onto chairs, or fell to the floor. The feeling of having the wind knocked out of you by a picture may be the distant echo, many times diminished by the long passage of time and dulled by the changing culture, of St. Catherine's crushing experience looking at the *Navicella*.

In chapter 4, I told a story of the English professor who wrote to me describing a "jolt" he got from a painting. It was like a shock or a lightning bolt—something almost physical. I have several letters from people who really did feel physical pushes and jolts. They say they felt as if they were hit, shoved, or punched by certain pictures. "I can remember specific instances of feeling punched," one woman writes. The feeling was especially strong when she first saw "the big Pollock" at the Museum of Modern Art. "I walked into that big room, through the back door, I guess, as the painting was hung to confront the viewer head-on and I didn't even see it until I got across the room and turned around and POW! I had to sit down on the floor, pow. Everything I had ever written, that I had been taught, etc., was wrongheaded, and that painting was the absolute evidence of it—all I had to do was look at it to see that. I was overwhelmed."

The woman, whose name is Elithea, adds the last sentence because it is important to her that I know she did not cry. It was a "sit-down-quick kind of overcome," as she later said of an encounter she had with Van Gogh's *Starry Night*. At first she didn't even recognize Pollock's painting—"it was such a shock of non-recognition"—and then it hit her. Elithea uses the word "overwhelmed," but not everyone who is overwhelmed collapses on the spot. I'd rather say she was punched, because it fits with the "POW!"—or else I'd say she was thunderstruck, since that fits so well with lightning bolts and deluges of tears.

The nineteenth-century critic John Ruskin was also thunderstruck, the first time he went to Italy without his parents. He was literally floored by his favorite Venetian painter, Tintoretto. Writing to his

father, he says a friend of his was all "crumbled up"—by which he means weepy and weak—but that he felt exhilarated, even after he was struck to the floor by the sheer power of the paintings. Sometimes Ruskin talks as if the paintings made him drunk. Titian's *Assumption,* he says, is a "very sufficient staggerer," and on September 24, 1845, he writes: "Dearest father, I have had a draught of pictures today enough to drown me. I never was so utterly crushed to the earth before any human intellect as I was today, by Tintoret.... He took it so utterly out of me today that I could do nothing but lie on a bench & laugh."

It's also very sexual, this encounter: sexual, drunken, and comical. Ruskin "drinks" Tintoretto, and then collapses, and in the end it's funny how weak he is. There is definitely something sexual about being thunderstruck: the paintings fill you up, or take it out of you. They knock you down, they ambush you, they overwhelm you. Is it irrelevant that St. Catherine's letters are full of sexual hopes and fears? Let me be yours, she writes, or Take me away from myself, or Let me give myself to you. According to Jeffrey Kottler, a professor of counseling at the University of Nevada and author of a book on crying, "people cry not during arousal, but during release." Michel Poizat says the same in his book on opera: people cry when they sense the release—the moment when the soprano has no more breath left, when she can't keep the single syllable going for even a second more. The "sit-down-quick kind of overcome" has something sexual about it, and something comic as well.

St. Catherine's collapse and Elithea's collapse have to be cousins. They're worlds apart, of course, but they are both the results of physical assaults. Ruskin, too: he was flailing, drinking, laughing, and staggering because Tintoretto assaulted him. St. Catherine's paralysis is an astonishing and tragic experience, and Elithea's and Ruskin's are its weak-kneed and comical modern echoes: but they're all collapses, and they belong together.

The history of being thunderstruck. The common ancestor of all these thunderstruck people is not some ancient art critic, but the patriarch Abraham, who "falls on his face" when he talks to God in

Genesis 17:3, and again, laughing like Ruskin, in Genesis 17:17: "Then Abraham fell on his face, and laughed, and said in his heart, shall a child be born unto him who is one hundred years old?" There is a lot of this kind of prostration in the Old Testament: Job and Moses fall to the ground; whole crowds fall in the Book of Leviticus; and in the Book of Numbers, even an animal falls on its face. In that story, the stubborn and impious Balaam is riding on an ass when an angel bars his way. The ass has a pure and simple soul, and so it sees the angel and falls down; Balaam can't make out anything, and he starts whipping the animal. At last God opens Balaam's eyes, and he sees the angel standing in the road. Balaam bows his head and "falls on his face."

In the Middle Ages, writers applied those episodes to holy images. There is a letter from Eusebius, a fourth-century bishop, to Constantine's sister; she had asked him for a portrait of Jesus, and he tells her that such a thing would be impossible because the resurrected Christ was more than human—"his face shone like the sun and his garments like light." How could any "dead colors and inanimate pictures" show what he was like? Even his "superhuman disciples" could not bear to behold him, and they "fell on their faces, thus admitting they could not withstand the sight." He talks her out of the notion of wanting a picture that could have such a powerful effect.

Being punched by an image means succumbing to a sudden unexpected weakness: the limbs give out, and the body collapses. There are no tears, and people like Ruskin may even think it's comical to find themselves flopping helplessly about like the disemboweled straw man in *The Wizard of Oz*. There are also slow, sleepy falls: James Breslin, Rothko's biographer, reports feeling the need to sit, and even to sleep, in front of Rothko's paintings, even though he was not tired. The Old Testament does not bother with the physiological details of falling on one's face. In the dozen or so passages in which people fall we are never told if their legs buckle or if they just crumple to the ground.

It seems to me there's a long line of descent from the Bible's matter-of-fact prostrations, through St. Catherine's paralysis, and up

to Ruskin's, Breslin's, and Elithea's harmless collapses. The line can even be continued to embrace all sorts of weak-kneed responses. Once I spent part of an afternoon looking at Jan Van Eyck's *Arnolfini Wedding Portrait* in the National Gallery, London. The painting is exceedingly demanding, full of things that are hard to see and spaces that are hard to imagine. After a half hour looking, I was suddenly deeply tired, and I had go to sit down in another room. People who spend time looking will recognize what I am describing: hard looking is actually very draining. The sudden exhaustion reminds me of the way that concert pianists sometimes start to sweat after only a few minutes at the piano. It's not because they're nervous, or because the concert hall is warm. With the exception of some large-scale pieces, piano playing doesn't require any great physical exertion. Pianists sweat (and I've experienced it myself) because of the quality of attention they bring to bear on what they're doing. I wasn't tired or hungry the day I visited the *Arnolfini Wedding Portrait*; the painting exhausted me because it was difficult to see.

I wouldn't mind adding even weaker examples to the list, such as the bit of claustrophobia I felt in front of one of Rothko's paintings, which I described in the opening chapter. (It was almost nothing: I just felt a little lightheaded, and I stumbled backward.)

All these mild experiences are the anemic distant cousins of St. Catherine's crushing experience in front of Giotto's *Navicella*. They share the surprise, the sense of weight or pressure, the sudden strike of wordless force, the shortness of breath, the fall. They are all of a piece, all from a single meteorological system. I felt the last little breezes of the storm, and St. Catherine was right in the middle of the lightning field.

Trying not to mention God. Two chapters back, I promised to spend the last chapters of this book on religious ideas. Now it's time to make good on the promise. I've been sketching in a history that begins with some powerful religious examples and ends with reactions so faint they wouldn't even register on St. Catherine's scale. They share some physiological similarities—the punch, the collapse,

and so on. By itself, that is not enough to claim that Elithea's "POW!" or Ruskin's giggles are somehow fundamentally religious.

Yet I am drawn to a curious feature that is common to all such experiences: they are responses to the painting's sheer unexpected overwhelming presence. In each case the picture is suddenly *there,* exerting a real force on the viewer, knocking the wind out of him, or shoving him down.

For St. Catherine, St. Francis, Thomas of Celano, and Eusebius, that presence was God. God was what Vittoria Colonna was looking for in Michelangelo's Crucifixion drawings. Fifteenth-century worshipers who cried in front of Bouts's *Weeping Madonna* were crying at God. Now God has receded, and people don't talk openly about religious meaning when it comes to fine art. Luckily we still have the entrancing word "presence" to try to name the fullness, immediacy, pure existence, and urgent mystery that used to be called "God." Sudden, unexpected, out-of-control *presence* is one of the main reasons people cry in front of paintings, and the best meaning I can put to it, the one that explains it most fully, is to say it's a religious feeling. Even my very weak reactions to the paintings by Van Eyck and Rothko were responses to sudden plenitude, to unexpected density.

"Presence" makes it possible to avoid naming God when I talk about experiences like mine, Elithea's, or Ruskin's. Back in chapter 2, I quoted part of a letter from Robin Parks, the one with the line "she had no arms, but she was so tall." Robin goes on to tell about a concert of Bach suites for solo cello at which she cried "so hard I had to leave." "It was in a weird little Methodist church and there were only about fifteen of us in the audience, the cellist alone on the stage. It was midday. I cried because (I guess) I was overcome with love. It was impossible for me to shake the sensation (mental, physical) that J. S. Bach was in the room with me, and I loved him." She says the examples of times she cried have "something to do with loneliness ... a kind of craving for the company of beauty. Others, I suppose, might say God. But this feels too simple a response."

Elithea, who is a graduate student in philosophy, thought at first that God wasn't the right word for what had floored her in front of

the Pollock and the Van Gogh. "I suppose my overall reactions could be classified in the 'God category,'" she writes, "although I didn't mean that I felt anything supernatural embodied in the works. It was more that the works were some kind of simulacrum."

These letters are very open and unacademic, and they have the problem in a nutshell. When "God" seems "too simple," and "beauty" doesn't lead anywhere, then "presence" is often the best word. There are even times when "presence" sounds too portentous, and it's best to find an even more noncommittal word. Rothko is a ready example of the slide of possibilities from outright religion down through presence and on to even more abstract ideas. The glow of a Rothko painting might be a sign of God or even a sign from God: but it could also be just a reminder of God. Or without the word "God," the glow could be the painting's presence, as many art critics like to say. "Immediacy" is another common word that nearly means the same as presence, except that it doesn't imply anything is really there. Even more gently, the glow could be said to be "poignant," meaning, perhaps, that it shows something about painting has ended, and from now on everything will be less easy and less direct. I think Rothko was right when he said his paintings are religious experiences, even though they don't seem to be. It is up to each person to decide when it is appropriate to mention such things, and when they are better cloaked in abstractions.

This is a subject that has to be thought about very carefully and slowly. If you love a painting, and are overwhelmed by it—perhaps even to tears—then you may be aware of a certain presence, an immediacy, or even a nameless *pushing*. Those words, like the word "God," come from places that cannot be reached by language. Most of the time they can be called by any number of names, but there are also occasions when they need to be named directly.

Crying in churches. If I could take a poll of everyone who has cried in front of a painting, I would bet the majority do not have much contact with the art world at all. They don't do their crying in museums, but in churches. They don't cry at famous old paintings, but at new ones.

The kinds of images that attract so many tears are usually second- and third-rate pictures of the Madonna or of Jesus. Large crowds are attracted to miraculous paintings of the weeping holy figures, and it sometime happens that the church authorities later find out that the tears were glycerin or salt water, secretly applied with a dropper. Occasionally people even cry at patterns they see in old walls. A few years ago in Chicago, people crowded around the outside of a church to look at some rust stains in a metal roof. People saw all sorts of things in the stains, and many of them cried even when the television crews were trying to interview them.

The same kinds of events took place in the Renaissance, and large churches were sometimes built around small provincial chapels that contained miraculous images. From my point of view, the only essential difference is that the Renaissance devotional images could be made by the best artists. Now the best artists only make ironic versions of religious icons, and they would run a mile from the "miraculous" religious images that end up on television. I doubt anyone could pray or cry looking at one of Warhol's "camouflaged" versions of Leonardo's *Last Supper,* even though Warhol intended his work to be very much in the Catholic tradition. (He was a practicing Catholic, and he set up his show of *Last Supper* paintings across the street from the original in Milan.)

In my experience the people who flock to see miraculous images do not often visit art museums, and vice versa. Some would want to deny this, but I think the separation runs deep and wide. Once a guard in the Art Institute came up to me while I was helping a student copy a painting showing Moses at the parting of the Red Sea. I had been talking about the artist, and telling the student how the painting was made. The guard's question came from a different world. He asked, "Do you think that really happened?" The thought hadn't even crossed my mind, but we stood there a moment looking at the painting and considering whether it was pious or impious, true or false. I asked him in return whether he thought the artist believed Moses had parted the Red Sea. He said probably not, because if he had believed, there would be more storm clouds and lightning, and less fuss about the colors and the composition.

Churches are without doubt the places where people cry most often in front of images. If I were to look for someone who had been paralyzed by a painting, I would ask in churches and not museums. Still, I won't have anything more to say in this book about popular religious imagery or "miraculous" crying images. The art historian David Morgan has written some excellent studies of popular worship in America, and I defer to him on this score. I am more interested in paintings that have value as paintings. At the same time, it's important to keep these phenomena in mind. Before fine art and religious painting went their different ways, presence would often have been the presence of God.

The miraculous Nachi Waterfall. Every once in a while, God does seem to be the right word. One of the most unusual letters in my file is about a painting in Japan that apparently *was* God, at least for a few people. My correspondent, Angela C., happened to be in Tokyo to curate a show on Warhol when a friend told her about an amazing painting of a waterfall that was about to be shown at another museum. The painting, Angela's friend said, "is supposed to be God." Angela wasn't sure what she meant, but she went along to see.

"Finally I found the famous painting of the waterfall," Angela wrote me, "which I could hardly get close to at all, since there were so many people around it. Although I couldn't look at it closely, the painting did strike me as quite beautiful—a faded gold landscape, with a faintly luminous white waterfall descending through it (colorplate 6). But more amazing to me was the behavior of the people looking at this painting. There was a crowd of people four or five deep pressed up against the glass wall in front of the painting, and pressed up against each other, all of them gazing in silence at the painting and almost all of them weeping. No one moved; it was as if the normal movement of gallery-going just came to a complete stop in front of this work of art, and became instead something like an overwhelming religious or spiritual experience."

Angela was puzzled that all the people looked "very intelligent and well-to-do," "probably university professors and the like, much like the crowd one would see at the Metropolitan in New York on

Sunday." Angela doesn't speak Japanese, and she didn't try to ask what was happening. The whole experience remained a mystery. She closed her letter by asking me to find out more.

It turns out the painting she saw is a famous one, and it is illustrated in many books of Japanese art. But the behavior she witnessed is a mystery. I asked several specialists in Japanese art, and they told me the *Nachi Waterfall* has overtones of the Shinto religion, but nothing that might make someone cry over it—not to mention calling it "God." Even the director of the Nezu Institute of Fine Arts was at a loss to explain what happened, though he remembered that André Malraux, the French intellectual, wept when he visited the museum years ago.

The *Nachi Waterfall* may be on its way to becoming a cult object, attracting people in search of a visible God. It seems odd, these days, to think of a picture somehow *being* God; but that is the exact proposition that led to extended debates in the Middle Ages. The challenge then was to encourage people to worship altars and icons that depict God and prevent them from starting to think that the painted images *were* God. The confusion seems ludicrous to us, but this is a subtle subject. Any prayer offered in front of an image of God is partly addressed to the picture itself. Christians are no longer in danger of forgetting that God is not lodged in the painting, but there is still a deep difference between praying with closed eyes and praying in front of a picture. Paintings of God *are* a little divine, even if that fact is almost lost when they are hung in museums.

My letters are peppered with phrases that show how close God can be. I heard about a young man who had lost his sister; a year after that, he went to Europe and was astonished at the art. "This is heaven," he wrote me, "my sister is here." Another writer was wandering through the Prado Museum in Madrid, and found himself face to face with Velázquez's *Las Meninas*. "I wanted to touch it," he says, "I felt the same religious feeling churchgoers do when they touch Jesus's hands or toes." The enigmatic *Nachi Waterfall*—a mystery I still haven't solved—shows how involved these questions can get.

Grace. Another art historian, Mary Muller, wrote to tell me that she cries occasionally, but tries to keep it to herself. In her way of think-

ing, crying comes from "a sense of recognition," which sets in even if you've never seen a picture before. She puts two of my themes together, talking about time and religious feeling in one breath: "There is a sudden total identification," she continues, "which makes time stand still and city noises hush, and makes one dwell within the picture—at least as long as one doesn't attract the attention of other visitors or guards. It is the recognition of something similar, the experience of being part of it, and maybe even a feeling of grace, a moment of unforgettable happiness."

Grace, Muller's word, appears in art history at least once (and perhaps exactly once), in an essay called "Art and Objecthood" written by the art historian and critic Michael Fried. The essay is partly a meditation on the difference between "presence" and "presentness." In Fried's lexicon, presence denotes the brute physical nearness of the object—the feel of the paint, the weight of its support. "Presentness," on the other hand, stands for the quality some artworks have of being immediately *there,* filling the field of experience, absorbing the viewer's gaze and thoughts. (That is the usual way people take the word "presence," and in this book, when I say "presence" I mean the same as what Fried means by "presentness.") The essay ends with a much-discussed sentence: "Presentness is grace." In that brief sentence, two worlds clash.

"Presentness" (that is, as I'm using it, "presence") is a common notion in art criticism. Except for that one sentence in Fried's essay, "grace" is virtually absent from the art world: but it is ubiquitous in theology. Fried's closing sentence has become famous because it is so utterly unexpected. It's as if he had pushed his way as far as he could go using the language of art criticism, and then broken through to a forbidden area. The essay puts tremendous pressure on that last word. "Grace" is the razor-sharp tip of an arrow that can fly through the secular world and pierce the sacred. That's a melodramatic way of putting it, but I think it helps explain why artists, historians, and critics continue to read "Art and Objecthood" nearly thirty years after it was written. The arrow is lodged in stone: all of it is visible except the very tip, which is forever buried in the domain of the sacred, out of the reach of secular discourse on art.

Grace is benign presence. Jane Dillenberger felt suddenly at home just before she cried in Rothko's studio, and one of the comments in the visitor's book says very simply: "How many places can one call home?" Another person, more sensitive to the enigma, wrote, "It's good to be back—but where am I?" Tears of joy may spring from the simple sense of being "at home." Bertrand Rougé points out to me that the etymological meaning of the word "religion" is "connection" (from the Latin *religere*), and so if a picture makes me feel at home, or if I feel somehow part of the picture, that conviction is religious in the original sense of the word.

More strange words. "Grace" is an angelic word, with more poetry to it than "presence." They're both synonyms, or rather euphemisms, for religious experience. Twentieth-century art criticism is full of other choices. Here are some, with pocket definitions:

Empathy: an unwanted, uncontrollable flow of emotions that merges the viewer and the viewed.
The numinous: the frightening, intimate, overwhelming presence of the sacred.
The aura: the gleam of unique objects, before we were jaded by photographs and reproductions.
The uncanny: Freud's idea of the creeping feeling that something is ghostly, and yet deeply familiar.
The enigma: for Giorgio de Chirico, the incomprehensible aroma of a place.
The abject: an object that has no proper place in the world because it is both a waste product and a part of us.

I could go on, but this is not a book of academic philosophy. Word lists like this, and their glorified cousin, the monograph, are the end of the line that starts from God and ends in a graduate seminar on philosophy. Beyond the word lists are numberless nameless states of mind where words have not yet found purchase. A mind that reels and races and does not know what is happening to it really has no

use for a cold fish like the enigma or the abject. St. Catherine didn't speak when she was struck with her painful revelations, and she scarcely managed to describe them afterward. All that matters is that each word is a strategy for not quite naming God.

The encounters I have described in this chapter and the last are responses to painting's plenitude. They are recoils from painting's pressure, its insistent presence. We can no longer have blazing, shattering religious encounters with paintings. We can't be crippled, or receive the stigmata. But we can be winded, and even knocked down. We can feel an uncanny residue, an inexplicable supplement, an aura, a presence that is indisputably *there* even if no one can see it. In saying so we link hands back to a distant past when that thing had the single name God.

All this, from paralysis to presence, is the second main reason people cry at paintings. (The first has to do with time, as I proposed in chapter 8.) The third and last reason is also religious, but it is even farther from God, more negative, and more characteristically modern. It is, I think, the most interesting possibility for contemporary painting.

11

Sobbing in lonely mountains

I stand in the shadow of the woods
As on the edge of life,
The lands are dimming meadows,
The stream a silver band.
 — Joseph von Eichendorff (d. 1857), "At Night"

But oh! that deep romantic chasm which slanted
Down the green hill athwart a cedarn cover!
A savage place! as holy and enchanted
As e'er beneath a waning moon was haunted
 — Coleridge, "Kubla Kahn"

Öd und leer das Meer
[Void and empty, the sea]
— T. S. Eliot, "The Waste Land"

IN THE LATE AUTUMN of 1990, the Art Institute of Chicago opened a small exhibition called *The Romantic Vision of Caspar David Friedrich*. It was an unusual show. The light was so low that when you first stepped in, it was hard to be sure how many people were in the room. A half-dozen paintings were hung at wide intervals, each carefully picked out by a hidden spotlight. The curators had fitted an

audio system, which was playing Schubert impromptus. The music rose and fell, sometimes loud, other times nearly inaudible. The rooms were dreamy and hypnotic. When people stood close to the pictures, a glow spread around them like the corona of an eclipse.

After the opening, I took an informal poll to see how it had gone over. Reactions were mixed. Some people found it hard to concentrate in the near darkness and hard to tune out the music. One woman I spoke to said she felt a bit bullied by the exhibit, as if the museum were trying to compel her to feel something when she didn't want to. She observed that paintings should be allowed to speak for themselves, and good paintings don't need an emotional boost from music or murky lighting. Other people thought the show was sentimental. One frequent visitor to the Art Institute observed that the show made it seem as if the paintings were too weak to speak for themselves unless they had Schubert to urge them on. Most visitors, I think, weren't charmed by the show.

Into the abyss. Yet at least one person thought otherwise. Tamara Bissell, a graduate student in art history, told me how she had cried openly and at length over one of the paintings. It is a scene of high mountains, looking across a mountain chasm toward a distant peak that is sheathed in snow (colorplate 7). Friedrich must have climbed very high to paint the picture, well above the tree line. Several rough boulders are scattered in the foreground. Beyond them a small, featureless gully leads downward. Far below, at the lip of the abyss, are some small pine trees, the only hint that there might be forests, pastures, and towns somewhere far beneath. (Deep in the hidden valley, out of sight, is the source of the Elbe River.) Farther on beyond the abyss the land rises again, culminating in the snowy peak.

It is an unusual picture, made from a place beyond the normal reach of living creatures. The distant ridges don't look like they could be climbed: if you try climbing them in imagination, your eye begins to fall, losing ground and grip, sliding backward toward the crevasse. Even the trees are barely holding on. It as if everything in the painting is slowly sinking down into the hollow center, like flour settling in a sieve.

Looking at the chasm, Tamara felt an acute attack of vertigo. She says she looked at the firm rocks in the foreground, to see if they could anchor her eye. The artist could have sat there, his feet dangling off one of the big rough-edged boulders, and he wouldn't have fallen; but sooner or later, he would have to climb down, picking his way down the steep, uneven ground. In a half mile or so he would reach the highest of the pines, where the path drops out of sight.

As Tamara watched, she began to feel herself being pulled, as if she were running down the slope, half hurtling, out of control, speeding toward the pines and then falling past them, into the crevasse—as if the painting had reached out and put a hand behind her head, and was trying to gather her in. Her neck tensed.

She stared for several moments, transfixed. Everything seemed to be falling, and yet nothing was moving, like a bedroom spinning in a childhood fever. She felt queasy, as if she were about to tip forward into the painting. She stared hard and tried to fasten herself in place. For a moment everything was still. Then she got an odd sensation, as if a tiny pin had punctured her heart. She took a sharp breath, and her eyes welled up with tears.

She cried for a minute or two, and then left.

Tamara's confession. Tamara was a student in a class I was teaching, and when it met later that same afternoon, discussion turned to the Art Institute exhibit. As I remember it, most of the students were firmly against the dramatic lighting and the piped-in music. They thought the exhibit was manipulative and sentimental. One said it was shamelessly romantic, and the museum should have known better.

"In that show they want you to love the paintings, not just appreciate them," he said.

That class had several graduate students in art history, and they were especially wary of falling for paintings. They liked the recent scholarship on Friedrich that they'd just read, which explained his sense of landscape and situated him in the early Romantic movement. But they had little patience for anything beyond historical studies.

"How can a person really *love* a painting, anyway?" asked a student named Michael. He had an unhappy expression, as if the word "love"

had made the conversation go sour. "You couldn't *love* a painting," he decided. "Paintings are *intellectual* things. It's not normal love."

He looked around to see if anyone wanted to admit to being in "normal love" with a painting. "It would be *ridiculous* to 'fall in love' with a painting." He was adamant. "You couldn't feel *that* strongly about a painting."

"I did," Tamara said.

Everyone looked at her. Her eyes were still red.

"It was very quiet and very beautiful." (She said the word "beautiful" very carefully.) "I was standing very still. And then I felt something funny. I was just standing there, and all of a sudden tears were streaming down my cheeks. I cried hard, for a while." She paused a moment, as if she were gauging how long she had wept. "It was wonderful, really wonderful."

The class was silent. They were a little embarrassed—partly for her, I think, and partly for themselves—and soon we turned to other topics.

After the class, I began wondering about what Tamara had said, and why she had confessed in front of everyone. In a way, her reaction was typical of her: if anyone would have cried at that exhibit, it was Tamara. She struck me as just the type: sharp-witted and prone to fleeting annoyances and affections. She might have confessed just to play devil's advocate against Michael's cold intellectualism. Yet I wondered if there might be something else to it: after all, each of us has our fleeting moods, our less than stable moments, our weaknesses. Would I have cried if I hadn't been so much on the defensive? If I hadn't been so intent on resisting whatever the show had to offer?

At the time I felt sure that Tamara had let herself be manipulated by the Art Institute's stagy lighting, and I thought she hadn't behaved as a good art historian should. She was a graduate student in art history: surely, I thought, it was her duty to understand how works of art were supposed to affect *other* people. If she had felt herself getting weepy, she should have tried to see how the exhibit managed its emotional effects. She should have been curious about how Friedrich's paintings have been received through history, and why the Art Institute's curators thought it was appropriate to encourage

emotional reactions to his paintings. She should have been analyzing the show, not letting herself get swept away by it.

Historical analysis is a tool of the trade, and initially it looked as if Tamara were just refusing to play the game. Yet it wasn't too long after the class that I began to feel a little uncomfortable about my judgments. Why *shouldn't* she have cried? The paintings are supposed to be deeply affecting, and the music was there only to encourage an imaginative encounter. In this age of television and video, perhaps we need some help to really respond to oil paintings. As far as it is possible to tell from the historical record, crying is entirely in line with Friedrich's intentions. Viewers were meant to be overwhelmed by his panorama of vast mountains, snow, and fog; they were supposed to be overcome by a nearly unbearable sense of solitude and loneliness. Could I really fault Tamara for responding in a way that Friedrich himself might well have wanted? Wasn't her reaction *more* historical than that of the other students?

In the weeks that followed I mentioned Tamara's confession to several friends, including some art historians. Their opinions were very different, and they opened my eyes to a curious problem: those friends who weren't art historians said that it was wonderful that Tamara cried, and those who were art historians said she shouldn't have cried. The art historians wanted her to resist, as I had. They pointed out that Friedrich's kind of German Romanticism was already on the decline a hundred and fifty years ago. In 1990 it was a thing of the distant past. To revive it in all its naiveté seemed misguided, or even perverse. My colleagues thought that Tamara's epiphany was one of two things, neither of them especially desirable: either an artificial experience brought on by the theatrical lighting and music, or (even worse) evidence of an overemotional frame of mind.

It was Tamara's experience that gave me the original idea for this book, because it got me thinking about how historians deal with unsettling works of art. I was surprised at the sharp division between people who weren't art historians and those who were (including the graduate students). It looked like the two sides could not agree or even talk productively to one another—the sign of a very deep, ingrained gulf.

The curator's view. The people who arranged *The Romantic Vision of Caspar David Friedrich* intended it as a bridge, allowing us to feel again what the passage of time had taken away. The exhibit was shown at the Art Institute from November 1, 1990, through January 6, 1991. (It later opened in the Metropolitan Museum in New York, but without the special effects.)

The exhibition was a collaborative project of James Woods, director of the Art Institute, and several curators. It was inspired by solid historical ideas: the purpose was to revive, in some measure, Friedrich's own practice of showing his works by candlelight. To that extent at least, the visitors and students who criticized the show for being too manipulative were misguided—they should have been criticizing Friedrich himself. Woods told me that the show had no clear precedent in modern museum display. There had been darkened rooms in exhibits of jewelry, and museums had shown valuable gold and silver objects under subdued lighting. In 1990 there were a few examples of dark rooms in museums: the room in London's National Gallery with the Leonardo drawing, and closer at hand a room in the Art Institute kept dark to showcase Joseph Cornell boxes. But the Friedrich show was different because its subject was painting. "We took a bit of a risk with that show," he told me, especially because of the decision to pipe in music. Several curators and museum employees had a hand in the music, and they eventually settled on Murray Perahia's performance of the Schubert piano impromptus—a fair match, they decided, for the time, place, and mood of Friedrich's paintings.

It has been ten years since *The Romantic Vision of Caspar David Friedrich* closed, and some details are elusive. The music was adjusted several times during the show, and it's not clear exactly what Tamara heard when she was there. Nor does she remember the other paintings in the show. Perhaps crying, like pain, slowly heals itself, like a wound fading back into perfect skin. The account I'm offering here mingles my memories with Tamara's recollections, in an effort to make a plausible story out of an encounter that was, after all, wordless. Still, enough remains to suggest that music and lighting only spurred Tamara's reaction, they didn't guide it. It's clear, too, that the central moment in the encounter was when Tamara felt somehow

pulled into an emptiness—into something that should have been in the picture, but wasn't, and so was oddly fascinating. That part didn't tally with the Romantic music and mood lighting.

A painting in Berlin. A couple of years before the exhibit, I had an experience similar to Tamara's while I was looking at another Friedrich painting, though I did not come close to crying. The painting is in Hanover. It shows a rainy-looking landscape in the evening. The sun has just set beyond a glade of large pine trees, and between their trunks the sky still glows in a diffuse horizontal rainbow of colors. The foreground is a rolling meadow, punctuated by a few bushes. Two small figures are walking toward the sunset, or maybe just standing and watching the light fade.

Looking at them there, in the middle of a darkening meadow, I remembered a similar landscape I had seen more than thirty years before. I had gone out past my parents' mowed field, and into a forest, and then I had gotten lost. I remember being scared but not terrified. I couldn't have been more than eight years old, but the memory is quite clear: after a while, realizing I had walked in a circle, I stopped in the middle of a clearing and watched as the land around me grew dark. The trees sank into a mass of black, and the undergrowth of the forest became a dark tangle. Looking at the painting, I recalled how I had stood there, watching the colors of the sunset slowly fading, until the world almost vanished—and then how I had bolted, and run out of the woods.

It occurred to me that the painting in Hanover tells the same story. I stood in front of the picture, thinking of that evening when I was young, and wondering about the pleasure of it. When I was standing in that field, I knew no one could find me, and there was a kind of happiness in disappearing, along with the world, into darkness. I was silent and motionless like the trees and grass, fading . . . a strange thought. I wonder if I understood the pleasure I felt in that half hour before I panicked and ran back to civilization.

In the painting the two figures certainly have a long way to go if they expect to get home before night. The grove of trees leads away

toward the left, as if to say that the way out might be in that direction. But it is dark over there, and even darker off to the right, where the woods look thicker. Where do those two people live? Is the way to their house through the woods, in the direction of the sunset? It looks empty, as if nothing much is out there. Or do they live back in our direction, on our side of the painting? In a funny way, it doesn't matter. In a few more minutes, they will be nothing more than blurry shadows, like the clumps of bushes on either side. In the logic of the painting, they will be there forever.

My eye wandered up toward the top of the painting, into the high branches of the trees. Some of the trees tower a bit overhead, as trees do in real life. I looked up, peering into the painted darkness, trying to see sky through the branches. I thought of the light rustling of branches that always sounds nearer and more unsettling at night. But the forest Friedrich has painted is a single mass. It is very high and cold and dark. Somehow too high, I thought. At that point, I turned away and went to look at other pictures. Perhaps I sensed that the painting, and my childhood experience, had no answer. Or perhaps it was about absence: the lack of a home, the lack of a place to stand, the lack of light.

Rainclouds. Other Friedrich paintings also meditate on impossible journeys through impassable darknesses. I have also admired a painting called *Rainclouds*. It is a view onto some endless plain, with a few sad-looking mountains in the far distance. It looks cold. The sun has set, and clouds threaten a night of rain. Pale iridescent colors give a faint light: a wan smear of red at the horizon, some lingering touches of yellow higher up. In the foreground, almost immersed in darkness, is a makeshift tent draped with some animal hide. Looking closely, I found the man sitting just outside the tent, next to a wagon that has no horse. The twilight is beautifully managed: a shade less light, and it would be too dark to see.

It is hard to figure out what the man could be doing there. Is he a hunter? He certainly isn't camping. A flock of small black birds is drifting down out of a dark cloud, and spreading out on both sides of

the tent. Even though the ground is nearly invisible, I could see that none of them has landed, though several are about to. The man must have been sitting still a long time, because the birds don't see him.

What does it mean? The painting is lonely, because the man is alone, but it is not clear what he could do to remedy that: where could he go in a wagon without a horse, or on a plain with no roads? He is not looking at anything in particular, because there is nothing much to see: just a few colors in the storm clouds.

The painting Tamara saw, the one in Berlin, and *Rainclouds* all have empty centers, voids where something should be. The first painting drains into an abyss, the second fades into darkness, and the third stretches off in a featureless plain. All of them are unaccountably alluring. They are empty and lonely, but it is not at all apparent what makes them so. What is it, exactly, that is missing? What is it that draws me to such pictures, and that made Tamara cry?

Tamara's second visit to the painting. For her part, Tamara hasn't cried in public since the exhibit. Some years have passed, and now she has her doctorate from a university in Prague. In May 1995, she had a chance to see the painting in the Hermitage Museum in St. Petersburg, and she wondered if it would have the same effect. It almost did: she had the feeling of choking back sobs, but this time there were no storms of tears. It may be that she already knew what to expect.

I asked her if she knew what had triggered her response. "I don't think it was any childhood memory," she told me. "Up to that point I was a pretty happy kid. Nothing was really going on besides work and school. The painting didn't remind me of anything at all. No visions, no associations, nothing."

I wondered if it wasn't the very lack of stories, of excuses, that made the painting so frightening. Any story would have been comforting, even some unwanted Freudian memory from her childhood. But the painting would not say, and it gave her nothing but discomfort.

"It was kind of an absolute nothing, a completely unique nonthing. And what it did was, initially, terrify and shock me, and at the same time I was unable to stop looking at it.

"The feeling was surely a kind of helplessness (at the fact that I

was unable to stop being engaged by this painting), and a kind of wonder (it is an amazing painting), and a kind of searching (for what, I don't know—perhaps for what it was in the painting that was doing this to me)."

When the crying came, it felt like a release—but Tamara still has no idea what she was being released *from*. First she was fascinated, then she was afraid, then she cried: there was no explanation, except the void in the picture that kept beckoning to her.

Haunting, and death. The longer I've looked at these paintings, the more I think they aren't just sad or lonely: they are sinister. The painting in Berlin promises nothing but unrelieved darkness. In a few more minutes nothing will be visible. The picture gives us the tail end of twilight, when even the most romantic person begins to head for home. Clearly, it's time to go. Why do the two travelers linger? Why don't they hurry off? Because there is a lure, a siren calling.

The mood reminds me of Goethe's poem "The Erl-King," another early Romantic work. In it, a man rides on horseback through a windy night, holding his young child. The child is frightened because he keeps hearing the lilting voice of the invisible Erl-King. "Can't you see him?" the child asks, but the father says no, "It's just the mist rising." The child looks around, and the Erl-King calls again:

> Come with me, you lovely child!
> We will play sweet games,
> We'll find bright flowers at the seashore ...
> You can dance all night with my daughters,
> They will rock you and cradle you and sing you to sleep.

The child is horrified, and he calls out:

> Father! Father! Can't you see where
> Erl-King's daughters beckon to me?

Of course the father doesn't see anything. He tells his son they are only gray willows, shifting in the dark. At last the Erl-King's demonic passion gets the best of him:

> I love you, I love your beautiful face
> And if you won't come with me,
> I will take you by force.

The child screams, the father spurs his horse, but it is no good: when he reaches their house, his son is dead.

There is almost no landscape in Goethe's poem: the wind, the gloom, some misty forms, old gray willows. Most readers will imagine much more: perhaps a marshy woods, where nothing is clear because it is so dark. All we know for sure is that the father is riding quickly, and that everything around is sinister and indistinct. The painting in Berlin is not haunted, at least not quite: but I feel a strange momentum in it, a kind of restlessness. I am being pulled, away from myself and into the landscape. Something is coercing me, singing to me, begging me to walk across the darkening field. Why can't I just stand and look? Why do I feel pulled (so gently, but so insistently) forward, across the uncertain ground, toward the pitch-black screen of trees, even through them, and onward toward—what?

The art historian Joseph Koerner has written some sensitive lines about the effect of those two figures in the painting. Put a finger over the painting, he suggests, blocking out the figures. Immediately the restlessness is calmed. Then you can look impassively because you are no longer involved. Lift the finger, though, and the landscape suddenly turns and centers on those two figures. They haul us into the scene, as he puts it, and from then on we are always moving: it is as if we are behind, rushing to catch up, and they are ahead, farther into the darkness. We are always late, even later than they are. The fading sunset that we see is really only "what they had already been seeing in a past long before our arrival."

What does it mean, this lateness? Because this is a painting, and the sun will never set, nothing will actually change. It is not just the time of day that is late, it is *we* who are late, and there is no way to ever make up the lost time. We will always be late. Every painting creates a world of its own, and this is not just a day that is ending: it is a world that is growing dark. A place where the sun has gone, time is sifting away, people are drifting into darkness. We do not know

where we have come from—what, after all, is behind us?—or where we can go. Yet we cannot stay here. It is as if we are already dead, and we no longer belong to the world. It is as if the painting is showing us a form of our own death.

Absence and presence. Friedrich's paintings are *hungry* paintings. They pull their viewers in, enticing them with loneliness. But you can't find your footing in the empty spaces, and you start to lose yourself.

This is the opposite of what happened to the people I described in the last two chapters. St. Catherine, St. Francis, and the others all suffered from pictures that had too much in them, that were too dense, too aggressive, too full. Friedrich's paintings are too empty, the things in them too far away. The paintings in the last two chapters *pushed* on people, hurling them away. These *pull* on their viewers, drawing them forward and in. These paintings, in short, are about absence: just as the others are about presence.

Something is missing from these pictures. It's hard to say exactly what it is, but ultimately, I think, the very idea of absence has to be religious. Just as the final model for presence is God, so the final model for absence is God's absence. That may sound a bit arbitrary, but after all, what is God if not a single object so impossibly full of meaning that it obliterates all other thinking? And what is God's absence except an ongoing thinning of meaning, where space opens and opens and never fills?

Religion as a hallucination. Saying Friedrich's paintings are ultimately about God isn't as absolutely loony as it may sound. Friedrich is well known to art historians as a painter who experimented with the absence of conventional religious signs. He didn't paint miracles, saints' lives, or any of the ordinary scenes of religious belief that were so central to pre-Romantic painting. In place of new churches, he painted ruined ones; in place of altars, lonely crosses on mountaintops; in place of tombs, prehistoric dolmens. For him the whole idea of ordinary churchgoing had washed away: there are no paintings of tidy churches with the doors opened to well-dressed congregations, no Easter Sunday crowds, no ministers preaching from the pulpit.

The church—as an institution, as a place to go—had nearly vanished. In some paintings there are churches far off in the distance, and in others the churches are like ghosts half melted in the mist.

The three paintings I have described go hand in hand with others that depict similar landscapes, but with crosses, old churches, or graveyards. Friedrich didn't evolve from a good churchgoer into a pantheist, though it almost seems that he should have: his early paintings should have been the ones with the churches; then he should have painted ruined churches and wooden crosses in the wilderness; and finally even the crosses should have fallen into disrepair, leaving bare mountainsides, billowing clouds, rainbows, and sunsets. The fact that things did not happen this way speaks for the vacillation in his mind. It seems that for him, organized religion—the church, its trappings, its liturgy—came and went like a hallucination. The shortcomings of the Protestant faith and the allure of a more pantheistic sense of divinity were very much on his mind. There are moments when he wanted to paint the comfort of a Sunday service, and others when he turned instead to a cold alpine forest.

Once, Friedrich made a painting of a cross on a mountaintop that could possibly—in just the right place, with just the right viewers—function as an altar painting, but usually he did not try to put his work in place of the sacred objects of the church. The unsureness of his purpose is poignant. As Koerner notes, an old pine tree, standing by itself on a mountaintop, might be an "emblem," a container of sacredness, or it might just be a tree. Either it means everything, and it is planted squarely in the domain of the sacred, or else it is just what it appears to be. All we know for certain is that we are barred from "the divine, the Idea, determinate meaning, belonging." We are lost, and we find meaning where we can. "To navigate this purgatory," Koerner writes, "where the artist fashions his works again as altars but must leave out the gods, is part of the historical project called Romanticism." The most powerful paintings "indicate a negative path, in which God cannot be found *in* a grain of sand, but at best in the unfulfilled desire that He be there."

The hollow centers of Friedrich's paintings can have as many names as you'd like: for different historians, they have conjured loss

of friendship, absence of love, and the departure of Christian truths. In this book, what matters most is that they are occasionally unbearable, and that their power to unsettle comes from a painful absence.

Painful absence—whether it is of God, or grace, or just presence itself—is the third fundamental reason people cry in front of paintings. It is the negative and opposite of painful presence. Together with dislocated senses of time, absence and presence account for at least half the cases I know, both in the twentieth century and before.

Presence and absence are a natural pair, and they can occur together in the work of a single artist. That's the dualism I was half-explaining in the opening chapter, in reference to Rothko. A single painting of Rothko's can be both overfull and infuriatingly empty. His larger canvases press forward and surround the viewer, stuffing the air with unwanted colors and disorienting smoky shapes. The same colors can then recede, revealing an unoccupied void. In terms of religious meaning, it is just as unconsoling to be surrounded by meaningless light and color as it is to be abandoned in an airless empty cavity. Rothko, I think, knew pretty much exactly how this worked. Like Friedrich, he was well in control of his allusions and evasions: religion didn't have to be mentioned, because its absence was everywhere apparent.

That's essentially the story I wanted to tell. It isn't an easy story, because it depends on so many things that can't be named. God is almost always the wrong word when it comes to modern art, and every viewer has to find her own way among the other options. Still, it's helpful to remember that religion provides the deeper history of reactions like Tamara's. "Presence" wouldn't mean much without its hint of the sacred. Tamara's experience was open, direct, and accurate: it was exactly the kind of reaction Friedrich would have wanted, but shorn of the trappings, the words, and the preoccupations, of the nature-religion of German Romanticism. Tamara's response shows that Friedrich's paintings still work, even if words like "void" and "emptiness" are all that remain from the sunken history of religious experience.

12

Crying at the empty sea of faith

A pine tree stands alone,
In the North, on a barren height.
It is drowsy. Ice and drifting snow
Blanket it in white.

It dreams of a palm tree
Far out in the East, alone,
Looking down in silent sorrow
From its cliff of blazing stone.
 — Heinrich Heine, "A Palm Tree"

The darkness is cold
because the stars do not believe in one another
 — W. S. Merwin, "Sunset after Rain"

THERE WAS A TIME WHEN cultivated audiences in Germany wept at concerts instead of clapping or shouting. Beethoven tells of giving a piano recital in Berlin and hearing no applause at the end; he turned to the audience and saw people waving tear-stained handkerchiefs. The practice annoyed him, because it seemed the Berliners were too finely educated. (The German phrase is *fein gebildet*, literally "well pictured," as if their educations had made them into beautiful images.) He wanted his audiences to be challenged, uplifted, and inspired.

One of Beethoven's idols was Goethe. Beethoven read his novels and set his poems to music, and when the two finally met, Beethoven played some of his music for Goethe. He turned to see the reaction, and Goethe was weeping. Again Beethoven was angry, and according to a witness he scolded the famous poet for behaving in such an immature fashion.

"When I read your poetry," he is supposed to have said, "I am inspired to rise to its heights."

Despite his greater age and fame, Goethe stood silently and took the rebuke, perhaps realizing the truth of it.

The end of Romantic emotion. Tamara's reaction was right for Friedrich, but wrong for my seminar, for the decade, and for the century. My ideas about Rothko's religiosity, the uncanny light in Bellini's painting, and the darkening voids in Friedrich's nocturnes are all leftovers from the nineteenth century. The anecdotes about Beethoven belong to the same country and the same decades as Friedrich's paintings. Even as he painted, tears were drying up.

The historian Anne Vincent-Buffault finds that suspicions about crying started even earlier, just at the end of the eighteenth century. She cites the writings of that enigmatic proto-Romantic Etienne Pivert de Sénancour. For Sénancour, "the truly sensitive man is not the one who is moved, who weeps, but who experiences sensations where others only find indifferent perceptions." He spent time wandering alone in the Alps, not in order to give himself up to the vast distances and sadnesses that entranced Friedrich and the Romantic poets, but to think about his own failures and blindnesses. He was looking, as Wordsworth said, for "thoughts that do often lie too deep for tears." "The night was already dark," Sénancour has his hero Obermann write,

> I slowly withdrew into myself: I walked at random, I was filled with dissatisfaction. I needed tears but I could only shudder. The early days are over: I have the torments of youth and none of the consolations. My heart, still weary with the fire of a useless youth, is withered and dried as though it were in a state of

exhaustion of cold old age. My fire is quenched without being calmed. There are those who rejoice in their ills; but for me all things have passed: I have no joy, no hope, no rest: nothing is left to me, I have no more tears.

This is an entirely new frame of mind, like air from another planet. The floodgates in the eyes have closed. Sénancour's is a disconsolate, unhappy mood, still pricked by the desire to feel or cry, but unable to do either. The step from here to modernism is very short: if Sénancour had given up his desire for naive effusions, and settled back into a permanent limbo of half-understood dissatisfaction and coldness, he would have been truly modern.

Sénancour is one of a group of early-nineteenth-century writers who were newly anxious about their dry eyes and the distance—always widening—between themselves and spontaneous emotion. In Germany there is Georg Büchner, who wrote biting satires on the simpering and gushing people of his day, and in Italy the Olympian pessimist Giacomo Leopardi, whose poems are written at a nearly infinite distance from human feeling, as if he were looking back from a Methuselan old age to an impossibly distant youth.

The nineteenth century began to look awry at emotions. Sensibility became sentimentality, and sentimentality became saccharinity. "Sentimentalism" meant the tendency to indulge in displays of emotion, rather than following the strict lines of reason. Still there were holdouts, old-fashioned followers of the cult of Romantic sensibility. Tears were still redemptive and sweet as late as Dickens and Thackeray. The historian Fred Kaplan, author of a book called *Sacred Tears: Sentimentality in Victorian Literature,* says that in the later nineteenth century pure undoubted tears were still a way of "returning to our first natures, our best human natures, our moral sentiments." They were "testimony to our never having been separated from our 'natural' selves." Yet even Thackeray was wary of what he called "the water-works." In Thackeray's *Pendennis,* the character Blanche Amory writes a book called *Mes Larmes* (My Tears). Yet "this young lady," Thackeray warns us, "was not able to carry out any emotion to the full; but had a sham enthusiasm, a sham hatred, a

sham love, a sham taste, a sham grief, each of which flared and shone very vehemently for an instant, but subsided and gave place to the next sham emotion." By the opening of the twentieth century, tears were hemmed in by mistrust.

Two versions of twentieth-century painting. One of the deepest disagreements among historians is over just how sober twentieth-century art really was. Perhaps modernism purged nostalgia and tears once and for all: perhaps it aimed to be as desperate and cold as Matthew Arnold's famous verses:

> The Sea of Faith
> Was once, too, at the full . . .
> But now I only hear
> Its melancholy, long, withdrawing roar,
> Retreating, to the breath
> Of the night-wind, down the vast edges drear
> And naked shingles of the world.
>
> Ah, love, let us be true
> To one another! for the world, which seems
> To lie before us like a land of dreams,
> So various, so beautiful, so new,
> Hath really neither joy, nor love, nor light,
> Nor certitude, nor peace, nor help for pain;
> And we are here as on a darkling plain. . .

Perhaps, on the other hand, modernism was steeped in nostalgia. Perhaps it was more like Philip Larkin's dry sentimentality:

> If I were called in
> To construct a religion
> I should make use of water.
>
> Going to church
> Would entail a fording
> To dry, different clothes;

> My liturgy would employ
> Images of sousing,
> A furious devout drench,
>
> And I should raise in the east
> A glass of water
> Where any-angled light
> Would congregate endlessly.

The debate I am conjuring here is a very serious one, and it has been joined by some of the best philosophers and historians. At root, it is this: Is modern and postmodern art an unrelenting "darkling plain," anarchic and disillusioned? Or does it covet those last shreds of Romanticism, nostalgia, and naive emotion? Historians like Vincent-Buffault would close the book on crying after modernism got under way, and so would the majority of philosophers and art historians I know. In different ways, they would be siding with Beethoven (though perhaps without his grandiose moralizing). Whole histories of twentieth-century painting assume that modernism has an analytic, deconstructive heart, that it's forward looking and progressive and stripped of any residue of Romantic longing.

The two poems I've excerpted put the question in religious terms, as I think it has to be. Arnold's bitter image of an ebb tide, draining religion out of the world, is an apt contrast to Larkin's New Age religion for teetotalers, based on "any-angled light" in a glass of water. (That is, in Larkin's pun, "Anglican light.") One is an anthem of absence, the other a hymn for presence.

If Arnold's version is right, then this book is untimely, to say the least. It couldn't speak to anyone except those who have not come to terms with what happened to painting after cubism and Duchamp. In the poem's language, this book could speak only to those who still hope that the tide of religion will surge back into the world, bringing "joy," "love," and "light" with it. This would be a book for closet Romantics, sentimentalists, and unrepentant antimodernists.

But if Larkin's version captures something that's true of modern-

ism, then what I've been saying might have a place *within* modernism and postmodernism—as part of their secret history. I'm on Larkin's side here, so to speak: in my experience even the most stringent and theoretically informed postmodern painting is suffused with a lingering nostalgia for a time when religion could be named, and tears could be believed, but I can't prove it because the subject—even in this age of apparent freedom of speech—is proscribed.

Absence. An empty "darkling plain," the blank void, nearly perfect solitude, lateness, pure silence, endless desert: they lead the eye on a restless search for meaning. Friedrich's paintings are siccative and parched: they draw meaning away, always leading it off to the horizon, absorbing it into stretches of blank paint. When there's nothing to fix on, the viewer's attention is diluted, like an eye dilated by drops. Eventually all the meaning disperses.

Or else the eye is acutely riveted on a single object, as if it could explain everything. Attention is focused brilliantly on one thing, like the blinding arc of a welder's torch. Everything else is lost. But that one thing turns out to be another absence: two enigmatic figures with their backs turned, or a deep chasm with no floor.

An abyss is literally a cleft in the world, and figuratively a fissure in meaning. As Tamara discovered, you can stare into it forever without hope of understanding it. Flat desert floors are another species of emptiness, just as seductive and treacherous for the eye. From Friedrich the history of painted emptiness branches and divides. Some of the most ambitious and challenging painting of the last twenty years of the twentieth century is also concerned with what is not shown, what cannot be represented, what must go missing. But that is for another book. Here, I only want to say what's essential: absences remain the most moving and important concern of postmodern painting. If Arnold were right, absences would have lost their poignancy long ago, and painting would only be attending to the "shingles" and "edges" of the world, emptied of meaning, with no sense of loss or gain. No one would mourn, no one would admit to caring. There is plenty of art like that. But then again, what is more

poignant, more deeply nostalgic, and more irresistibly moving, than Arnold's lines about the receding Sea of Faith, pulling back with a "melancholy, long, withdrawing roar … down the vast edges drear / And naked shingles of the world"?

I'll end where I began, in the Rothko chapel. The notes in the visitors' books are disengaged from current intellectual debates, and for better or worse they make continual unapologetic references to God.

"Horror!" one person writes, "gigantic almost black 'paintings' commissioned for this 'chapel,' displaying the Bible alongside the Torah and other religious books." (The visitor had been leafing through the twenty-odd holy books used by various religions, which are kept on display in the foyer.) "Even the stone floor is bleak. Olivia says the artist committed suicide. I could not worship here, except to praise God that I am not caught in this gloom and despair. Enclosed in a place of murky light, an eight-sided room with four benches placed in a square." The writer ends by worrying about one of his or her friends: "Sylvia loves this place—regards it as saved. She is falling further off."

That kind of literal religious talk is at a far extreme: absolutely inaccessible to the scholarly discourse on Rothko and out of touch with the plurality of entries in the visitors' books. It would be hard to run the chapel as an ecumenical interfaith center if too many people had opinions like this one. The visitors' books have a certain number of such entries, written by people as far outside the inner circles of the art world as Pluto is from Earth. What this person says about Rothko fits the facts (Rothko did commit suicide), and it adheres to some Christians' belief that suicide is a mortal sin, so that a suicide's soul cannot be saved. But it doesn't fit the way the chapel was intended to be used, or the liberal and secular responses to painting that have been on the rise since the fifteenth century.

Other visitors mention God less dogmatically, and more abstractly. Another writes only, "Deo abscondito dedicata," which means "dedicated to the concealed God." It is a Gnostic phrase, once used to invoke the God who remains hidden from human knowledge. Gnos-

ticism is another of those threads that link some premodern writing to some postmodern writing. It's a very frail thread, followed by only a few people, but it is also a way of sidestepping organized religion.

The writer incensed by Rothko's suicide, and the crypto-Gnostic, both register absence. Other visitors experienced the opposite flood of presence. "Seldom have I felt more in the presence of God," one writes. Another, thinking of St. John of the Cross's *Dark Night of the Soul,* mentions our inability to portray God in images. Still another left only the enigmatic words: "I can hear."

Another kind of visitor wanted to edge away from anything too openly religious, whether Christian or Gnostic. One notes that there was no "tangible manifestation of God, but the feeling of divinity suffused the whole." Another says that at its highest point, art must erase itself (*s'efface,* he writes, in French) in order to give us a view of the sacred.

My own sense of the chapel is even a little further from religion. I found my reactions well captured by the writer of a long note in one of the recent visitors' books. It says, "The *point* is: you look at the paintings, you scan the canvas surface for something concrete, visible, some touchstone to hold onto amid the rushing wave of color. Pushed to the limit, you find solace in the *texture* of the painted surface, the brushstroke, the running paint, the *lines* surrounding the panels." But then that consolation fades. The comforting surface texture is "difficult to see, you see it and yet perhaps it is not there, perhaps you were imagining. Rothko's idea is that this uncertain grasping for visual markers *is* equal to RELIGION: that is, searching for some proof of God in the face of a dark and powerful, uncontrollable world—where the final end is Death—the black void that the paintings seem at first to represent. And yet, just as there are glimmerings of hope in the world, so Rothko gives us *small, controlled* inklings of hope in the ever-so-slight variations of color, blotches, lighter zones—hope that we are *never* (*can* never be) sure of."

That description is a good mixture of my own experience in the chapel and the kind of hyperbolic language Rothko himself preferred. It is a very acute record, alert to the paintings and open to what they

actually show. I don't share this person's confidence that Rothko plotted things so precisely, and I am not sure that he wanted people to search among "ever-so-slight variations" to find signs of failed meaning. It seems more likely that the paintings are less systematic, and more intended to work as a whole. But it is salutary to find someone who is entirely ready to experience whatever the chapel reveals, whether it leads into minute examinations of the surfaces of paintings or into unfocused thoughts about God and death.

The only better formulation is Rothko's own, the one he gave to Jane Dillenberger when she asked him if his works were religious. For me Rothko's answer is an epitome and an epitaph for twentieth-century painting.

"My relation with God was not very good," he said, "and it has gotten worse day by day."

Envoi:

How to look and possibly even be moved

I'd weep, —but mine is not a weeping Muse,
And such light griefs are not a thing to die on;
. . .
And Juan wept, and much he sigh'd and thought,
While his salt tears dropp'd into the salt sea,
"Sweets to the sweet" (I like too much to quote;
You must excuse this extract, 't is where she,
The Queen of Denmark, for Ophelia brought
Flowers for the grave); and, sobbing often, he
Reflected on his present situation,
And seriously resolved on reformation.

 — Byron, *Don Juan*

 ... so farewell, sad sigh;
And come instead demurest meditation,
To occupy me wholly, and to fashion
My pilgrimage for the world's dusty brink.

 — Keats, *Endymion*

THE HISTORY OF ART is replete with images that are intended to affect us deeply: not just pique our curiosity, but move us to tears.

Yet we resist.

When pictures are openly out to move us, we find reasons not to be moved. We look at the old masters and say their religious dramas belong to the past. We don't believe their myths, we can't take their costume dramas seriously, we can't bring ourselves to care about their intricate cobwebbed politics. We can't understand the reasons they cried.

Painters have set out to shock and dismay, to confuse and delight, work magic, inspire prayers and pilgrimages, arouse violent and irrational urges. Most of that has gone, drained away into the history books. Why don't we cry at paintings anymore? Our sense of pictures has become anemic, according to the historian David Freedberg, on account of the pernicious influence of Enlightenment philosophy. He especially blames Kant for proposing that artworks be regarded as objects set apart from the rest of the world, dedicated only to the pursuit of beauty, and without any use except a kind of pale aesthetic pleasure. Freedberg's book *The Power of Images* is a wonderful compendium of the strong reactions people used to feel, and an indictment of the passionless present. I've often had it open as I wrote this book, comparing his accounts of images that inspired religious devotion, passion, and psychotic violence to my own stories about crying. Reading his book opened my eyes to many things that images can do, but it left me wondering what pictures can still do, here and now. Are we confined, like historians, to reading other people's responses?

I wonder, too, about pinning it all on Kant. Surely he was a symptom of his age, as much as our cold art is a symptom of ours. It's true that crying is out of tune with modern art. Twentieth-century painting is said to be difficult: it demands analysis rather than raw reactions. Modern painters have rarely tried to capture people's imaginations in that specific, intimate fashion that can lead to tears. (Rothko did say he wanted people to cry, but perhaps it was a mistake to say it so openly.)

So why don't people cry in front of paintings? Partly because times have changed. Modernism, whether it begins with Kant or with

Cézanne, is like a new continent that has raised up, dry and mountainous, out of the ocean of earlier painting.

History is part of the answer (probably the deep part), but there are other answers that are easier to grasp. Art museums, for example, teach viewers to look without feeling too much. Contemporary museums shuttle their visitors from label to label, and tell them very little that can promote genuine encounters with the objects. The breathless press of wall labels, exhibition catalogs, gallery guides, audio tours, and videotapes makes museums into schools. How much does anyone get from the average label, say, for instance, this one: "Ernst Heckel, *Untitled*. 1909. Graphite on beige paper. Munich. Accession no. 1964.354. Given by an anonymous donor, and by Douglas and Nancy Allen in memory of Elizabeth Barry." If you happen to know the Allens, or you were a friend of Elizabeth's, then the label might be important to you. Or you might be interested if you happen to be a Heckel scholar and you're wondering if the picture was done in 1908 or 1909. To the average visitor, the label would be intimidating or just useless. It is also condescending, because it says in effect: This picture is well studied by people who know far more than you. Sometimes museums add a few sentences explaining the work: "Heckel, a member of the German expressionist group *Die Brücke,* spent most of his career in Berlin." That kind of information is just as useless for most people, and it risks being unctuously ingratiating, as if to say: Art history is an extremely complex field, and this is the best we can do to explain this work in layman's terms.

Nearly without exception, audio tours and catalogs provide the dullest kind of information: artist's names, dates, and countries—spiced up, sometimes, with anecdotes and gossip. The result is a clattering caricature of real art history, a dried-up collection of stray facts. At best the information is interesting and informative, but at worst it is distracting and impossible to absorb.

(In all the years I have been going to museums, I have only seen one label I liked. It was affixed to the wall next to a portrait of the poet Jules Superville, painted by Georges Dubuffet. The label said that a curator had written to Dubuffet, asking who Superville was.

Dubuffet wrote back, informing the curator that he hadn't the slightest idea who Superville was, but that his head reminded him of a camel! In one stroke that label tore down the wall of erudition that usually blocks the way to paintings.)

Art historians are really to blame for the desiccated museum pedagogy. University departments of art history and criticism, where many of the people who make labels are educated, contribute to painting's cold public face by parading the knowledge of past cultures in front of their dazzled students. Students are taught to comb through archives and old books to see how the original viewers once responded. Their own reactions are typically ruled out of court. Such scholarship is necessary to build a sense of history and to avoid solipsism, but it is a bloodless pursuit. The original viewers—the Diderots and St. Catherines—are examined with professional detachment, as one pries at a frog's intestines to see how it is put together.

In the world of academia there is little incentive to sit quietly and patiently with a picture and let it do its work. Academics are hurried: they want information and knowledge. Students work under deadlines, and they need to learn quickly. The last thing a student needs is to become truly entangled in a picture, to the point where it begins to insinuate itself into her thinking, prodding and teasing her expectations, changing her mind, undermining her certainties, and even affecting the way she thinks. If they are given the chance, pictures can ruin our stable sense of ourselves, cutting under the complacent surface of what we know and starting to chafe against what we feel. None of that is of much use to art historians looking for a definitive and efficient bottom line.

Still, it wouldn't be right to blame art historians or museum labels. The safe, low-volume emotion of our museums is an arrangement that seems to suit most people; there's no mass movement to make museums more viewer friendly. Our tearless condition is our chosen state. I don't think the majority of museumgoers would have it any other way. It is probably comforting to know that a guild of experts guards and interprets our cultural treasures: but that is the function of any protective force, whether it's museum personnel or police.

That same guild keeps people shy and unsure about themselves, and hesitant to find their own way toward objects—and that's the price they pay for the security of knowing the paintings are safe. The vast apparatus of art historical knowledge always stands ready to step in and tell us what ought to be thought, and the vast gleaming halls of museums are always there to nudge us along if we become entranced by an image. We're in a prison, in short, of our own making.

When it comes to twentieth-century painting, a dry approach fits quite well. It was the tenor of the times, the right note for the twentieth century. Unfortunately our dryness is not confined to the art of the twentieth century; it runs very deep. It cuts us off from those periods and places where crying was a normal response. We must misunderstand them radically, at a level so fundamental there may be no way to speak about it directly. I assume we have lost whole territories of feeling and understanding. Possibly entire traditions have become invisible to us. At the same time, we cannot gauge what is missing from our imaginative encounters with older pictures: how could we, unless we could feel, just once, the emotions the makers intended?

In this cloud of uncertainty I recognize my own limitations. My failure to weep a single certifiable tear for a painting cripples my understanding of some paintings, shutting me off from a fuller response. Until I can look at Greuze and feel something stronger than amusement, I am not willing to say I understand him. Nor am I willing to say I understand Rothko or Friedrich: no matter how much I read, I still won't know whether my missing emotions might be genuinely relevant to what I glean from books.

All of us in the tearless present share this liability to some degree. It is as if we are standing on a seashore in a fog: the crash of waves and the calls of seagulls are proof that something big is out there, but there is nothing to see except some watery sand right at our feet. The history of art is little more, in this respect, than a frail science dedicated to inspecting the odd seashell or bit of driftwood. Art history does not look up, and rarely notices where it is: and it is traditionally, monumentally, complacent about that fact. Studying history is like

smoking: they're both habits that give us pleasure, but they are very bad for us. One kills the body, the other the imagination.

So why don't we cry at paintings? For many reasons. The twentieth century has gotten us out of the habit. Our museums and universities breed people with a cool demeanor. Weeping doesn't fit the ironic tone of postmodernism. There is a list of other reasons, but the best single answer, if I had to choose just one, is that it's comforting to think that paintings require only domesticated, predictable emotions. Everyone knows more intimate encounters might be possible. That's why some paintings are masterpieces. But we also like them safely locked away in museums.

I'll add one more reason why people don't cry. At the eleventh hour, when this book was about to go to press, the Irish art historian Rosemarie Mulcahy came up with an explanation as simple and as wonderful as it is devastating. Perhaps, she said, painting is simply weaker than the other arts, so it can't move people as music, poetry, architecture, or movies do. (It's like what Leonardo said, that painting cannot "disturb the emotions" enough to provoke tears.) What a brilliant and annoying idea. I just hope it isn't true.

What is to be done? Here are some practical suggestions. They are recipes for strong encounters with works. If you follow them, you'll have a better chance of discovering if paintings can speak to you.

First, go to museums alone. Seeing paintings is not a social event, not an opportunity to spend quality time with relatives and friends. It takes concentration and calm, and that is not easy when you are with someone else.

Second, don't try to see everything. Next time you go to a museum, resist the temptation to see the whole collection. Get a map of the museum, and choose just one or two rooms. When you find those rooms, look around and choose just one painting. Pictures do not work well all together, unless you are trying to use them to learn about a certain culture or period—and in that case, you're only using paintings, not really looking at them.

Third, minimize distractions. Make sure the room is uncrowded.

It's best to choose a painting in an out-of-the-way corner. Don't even bother to look at a picture that's in a bright, crowded hallway. Make sure there is no glare on the canvas, so you can see the whole picture clearly. If a guard starts staring at you, choose another room. (Rich people have an advantage in this, because they can have major paintings in the privacy of their homes. Philip II of Spain cried looking at Titian's *Christ Carrying the Cross*—but it was in his own private oratory, lit by candles. Most of us have to put up with the local museum and its fluorescent lights.)

Fourth, take your time. Once you've chosen the painting, give it a chance. Stand in front of it and think a bit. Step back, and look again. Sit down and relax. Get up, walk around, come back, and look some more. Paintings are very slow. It can even take weeks, even years before they decide to speak.

Fifth, pay full attention. You need to do nothing but look, care about nothing but looking. Absentminded staring, like that of the people who meditate in the Rothko chapel, won't do it. You have to concentrate on understanding what you see. That takes sustained and focused energy. There's a strange state of mind involved, in which you forget yourself just enough to lose track of the boundary between the picture's world and your own world. Michael Fried, the art historian who wrote on "presentness" and "grace," calls the state "absorption." Bertrand Rougé thinks of it as crossing over a bridge into the painting's world. However it is named, it means you have to pay strict attention to the picture at the expense of everything else.

Sixth, do your own thinking. It would be wonderful if more writers in my field would admit how little we understand about some pictures, in order to instill skepticism about the mass of received ideas. Read as much as you like, take the audio tour, study the label, buy the book: but when it comes to looking, just look and make up your own mind.

Seventh, be on the lookout for people who are really looking. Virtually everyone who visits art museums moves at the Official Museum Pace: an ambling walk, punctuated by stops to glance at paintings and slight forward bends to read labels. There are always a

few people who don't walk at the Official Museum Pace. If you can find such people, watch them for a few minutes. Notice their patience, and the concentration they bring to bear on the pictures. If they take a break, go talk to them. In my experience, many have interesting stories about the paintings they go to see. Virtually all the people who wrote me letters had that kind of relationship with the paintings that made them cry.

Eighth, be faithful. Once you've spent time with a painting, promise yourself you'll come back to see it again.

That is general advice, for everyone. For my colleagues in academia, I'll draw a different moral: let's just say what we see. If a picture seems to mean something personal, emotional, or otherwise unacademic, let's say so. Why continue talking in such straitjackets?

If a painting attracts you, then by all means let yourself be taken in: allow yourself any thoughts, no matter how bizarre. Let the painting do its work. Fantasize about the picture, if you want. Project your thoughts onto the painting. Let the painting hypnotize you. That is the only way to really experience a picture, and it should never be dampened by thinking of what's proper or true.

Then (if you're an historian) you can try to understand what you felt. Some of your responses will correspond with what other people have felt. A few might even have been recognized by the painter, or by the painting's original viewers. All that is history, and it is up to you to fit your ideas into the responses other people have had down through the centuries.

Other things you feel in front of the painting will be yours alone, and not fit to share with other people. They will have come from your childhood, or your surroundings. Yet even those responses have historical value, because they can help you understand where you're coming from. My long disillusionment about Bellini's painting is a case in point. When I first encountered the picture I projected ideas from my childhood into it. Now, many years later, I know where I got those ideas. Knowing that I was a late-Romantic admirer of landscapes helps me to understand how I react to many other pictures.

It's depressing knowledge, since it proves to me that my thoughts were thought by other people long before I was born, and that I was only a latecomer to them—yet it's helpful knowledge because it situates me in cultural history. It is sobering but helpful to know that Ruskin or Keats thought something I thought, only much better and a hundred years before I was born.

That's the recipe. Allow yourself the most intimate and naive encounter, and then dissect it into knowledge of historical value. Put your historically valid reactions to the test of the bell curve, to find out how passionate or dispassionate they were in relation to other people's. (If Stendhal collapsed, did you at least feel *something?*) Let your historically invalid ideas inform you about yourself, and your own interests.

This is not a recipe for intense imaginative encounters with *every* painting. Out of the sum total of pictures, Western and non-Western, only a small minority will be able to make connections to your particular memories and proclivities. That is also a salutary bit of knowledge for historians, since it means they don't have to keep trying to understand the endless number of paintings in the world. Paintings outside your imaginative reach have to be understood differently, in a more bookish fashion. Art history can make it appear as if it's possible to understand any work if you try hard enough. But that kind of "understanding" is external to imagination.

I'd also say: let yourself be a little less consistently rational. When I started writing this book, I thought crying was interesting because it could not be fitted in with other kinds of information about pictures. Now I think more or less the opposite: crying is on the continuum of normal human responses to the world. There is no scale of relative rationality, where a conservator's report would score a perfect 100, and a bout of crying would fail to make the grade. We think while we cry, and we feel while we think: it's really that simple, and people who believe otherwise may be trying to defend themselves against some dangerous influx of passion. It's said that only sober thoughts are reliable. But if sobriety can bridge centuries, why not passion? Do we know that our crying is different from the original

viewers' tears? How could we know that? Are we sure that our strong responses tell us nothing about the original viewers' emotions? What logic could lead to that conclusion?

Tears obliterate clear vision, but they do not wipe away the possibility of a balanced understanding. Hot tears and cold logic are parts of normal human response. A tear is always mingled with a thought, and the more interesting thoughts are the ones that aren't quite dry.

Art historians set themselves a simple goal: to understand how pictures *used to work,* how people *used to react.* That kind of research is indispensable, and I have no objection to it. But there's a danger of complacency, because art historians can mistake their explanations for full accounts of the ways pictures work. I would like to hold out for something better. When an account of the "rhetoric of tears" in the eighteenth century can serve as an adequate explanation of Diderot's amazing criticism, something has gone badly wrong with our concept of understanding. History is important, but it is only part of what pictures are—the easy part.

Now my book is finished. It has been a curious experience, trying to write about so many things that won't go into words. Crying, passions, confusions, echoes of religion: they belong in people's experiences, not in books. There are writers, more prudent than I am, who don't even broach theology when it comes to art. Religion seeps through everything that's written about modern art, but it's the thought that dare not speak its name. I've risked being a bit hamfisted by bringing it onstage. At the same time I have worked to keep the architecture of this book as open-ended as I can, so that each reader can find a different path through it.

Throw yourself into looking, and be ready to accept whatever you see: it can seem that is the only key you need. I'll close the book with a story that makes the point, and shows its dangers. It's a haunting and ridiculous short story by Honoré de Balzac, called "Gillette, Or the Unknown Masterpiece." In it, a painter named Frenhofer works on a single canvas for ten years without showing it to anyone. To Frenhofer's "ecstatic" eyes, his picture is the most perfect image of a

woman ever put on canvas: it is more his lover than his picture, more a living companion than an object. Yet when he finally unveils it, his friends see nothing but "a shapeless fog" with one "delicious foot" off in a corner. Frenhofer looks again, and realizes his masterpiece is nothing but "a chaos of color, tones, and vague hues." He sees that he has wasted ten years of his life, and he staggers back, weeping.

"Nothing! Nothing!" he moans, "The work of ten years! What a crazy old fool I am! I have no talent, no skill!"

His friends look on in dismay and pity. In a stroke Frenhofer has lost his masterpiece, his ambition, his talent, and his mind.

"The Unknown Masterpiece" was written more than a hundred years ago, but it continues to exert a fascination for tortured painters and perfectionists of all kinds. It haunted Cézanne, who identified with Balzac's tragic hero, and it was illustrated, somewhat carelessly, by Picasso. It is still assigned by teachers and read by painters, as an emblem of the madness of the search for absolute perfection. It's a little hard to believe Frenhofer (how could he fail to see his beloved figure was invisible?), but he is a wonderful epitome of hopeless obsession.

Yet the story isn't only about Frenhofer's delusion. Nicolas Poussin is also in the story, and he is depicted as a level-headed pragmatist eager to learn the secrets of his chosen profession. Before the climactic scene in Frenhofer's studio, there is a dialogue between Poussin and his lover Gillette. She complains that when she models for him, he looks at her as if she were a painting—she stops being his lover and becomes his mannequin. Balzac wants his readers to conclude that Frenhofer makes the opposite mistake: he thinks his painting is a woman, and he even talks to her and expects her to answer. Frenhofer and Poussin are both ambitious artists, but the difference is enormous: Frenhofer's ambition is feverish and latently psychotic; Poussin's is coldhearted and wholly sane. Eventually Poussin trades Gillette for a look at Frenhofer's painting, giving up love in the hope of gaining a trade secret and advancing his career.

I know a few Frenhofer-type painters, and I know many cold Poussinish people, both artists and academics. They have chosen calm

calculation over Frenhofer's dangerous enthusiasm. They express their admiration with fastidious care, as if opinions were little snakes that might curl back and bite them on the hand. They consider and reflect, and try not to get carried away by anything. They have small passions, like tempests in teacups—very polite and well controlled. Like Poussin in the story, they are professionals. The art historian Georges Didi-Huberman has taken note of Poussin's canny ways in "Gillette, Or the Unknown Masterpiece," and he concludes that is why Poussin's paintings fill our museums and there isn't a Frenhofer in sight.

Frenhofer is the tragic hero of the story, and all the danger and glamour are on his side. He literally loves his painting, and he goes insane when he realizes he has lost her. "Gillette, Or the Unknown Masterpiece" is a subversive story, because at first it seems Frenhofer's passion is enviable, even if he took it too far. But Didi-Huberman is right: most of us, painters and spectators, have ended up siding with Poussin. Professionalism is safe, because its passions can be calculated.

We say we love paintings: but do we really? A gallery owner might be fervent about his job, but he also has to be canny like Poussin in the story. Postmodern painters can be as unbalanced as Frenhofer, but they also need to keep an eye on their careers. Art historians can be deeply involved in their periods and specialties, but they need their critical distance. I don't begrudge any of these enthusiasms. Art historians, for example, usually need to speak the language of the painters they study, to read what they read, and even to live in the towns where they lived. Eventually a good art historian will start to melt away into the long-gone cultures she studies. Surely that is love, if anything of the sort can be. It may not be insane love like Frenhofer's, but it is genuine love nevertheless.

Well, it may be. Passion, commitment, admiration, engagement, fervor, involvement: those are all words of love. But do they really add up to love? Or something a little more businesslike? It seems to me many professionals don't really love paintings, but—to borrow an idea from that wonderful historian of love Denis de Rougemont—they are in love with the idea that they are in love. Art historians are often enthusiastic, and sometimes even passionate. But what they

feel, I think (and again I am including myself here) is an academic passion, an intellectual enthusiasm, packed in the chill of modern irony. They might be in love with being in love with paintings, but they are not in love with paintings as individuals.

To be in love with a painting—to cry—you need to risk being as crazy as Frenhofer. You need to be able to believe a painting can be alive: not literally, but moment by moment in your imagination. The experience can be disarming, as it was for me long ago looking at Bellini's picture. It *should* be disarming. Everything else is just business.

Still, as Didi-Huberman says, that's what many of us prefer. That way paintings can be beautiful and safely dead, propped up by the hundreds of little facts that we have placed around them like so many votive offerings. There is no imaginative contact, no risk. The eye is rebuffed by the dim canvas, and keeps falling back into the lazy chair of clichés—"How beautiful," people say, without thinking how flat that sounds. In that fallen state, people can still get excited about paintings, but it's a temperate excitement, full of the ease and complacency that comes with the sure knowledge that nothing, in the end, will actually happen.

So who does love paintings? The people who wrote me letters have all loved paintings, at least once. Diderot certainly did, and so did many others from the Middle Ages onward. The rest of us do not, and that is the mystery with which I began.

What does it mean to say you love paintings, and yet never be *in love* with a painting?

What does it mean—this is the question that taxes me the most, and it continues to vex me now that I've finished this book—for people to spend their entire lives looking at objects clearly designed for expressive purposes, and not to be moved even once (in any circumstance, for any reason, no matter how indefensible) to the point of actually shedding a tear?

I am still not sure. But I know that a loveless life is easy to live.

Appendix

Thirty-two letters

THESE ARE THIRTY-TWO of the four hundred letters I received in the course of writing this book. Most are mentioned in the book, but I wanted to let them speak for themselves.

Many of my correspondents wanted to remain anonymous; some, as they say in newspaper jargon, are on "deep background." (Some of the most prominent members of my profession are hidden among these pages, unwilling to go on the record.) Others have consented to be named: a brave act in a century so inordinately proud of its self-control. When a person has wanted to remain anonymous, I have invented a first name and an initial, like this: Joseph K. When a name is given in full, it is the person's real name.

I have silently edited many of the letters, omitting passages that are irrelevant or that would give away the writer's identity. In the case of letters from other countries, I have translated freely, and where the letters were in faulty English, I have rearranged syntax and edited solecisms. In all this I have tried to be faithful to the writers' spirit and intent.

LETTER 1

First, two letters about the Second World War. In this one, a woman recounts a sad moment in exile.

November 19, 1996

Nice. 1942. In the Rue de France there was a store which, if it still exists, is now probably called a gallery—but which in 1942 was satisfied with the sign "Tableaux." It had two windows, one on either side of the door.

On that particular day, there stood in the left window a painting of pleasure boats in a small harbor, signed Vlaminck. It was a sparkling of blues, whites, reds, and yellows, riotously joyous and pleasing. Passing to the right window, I saw a somewhat subdued painting which, at first glance, seemed to be made by a clumsy beginner. It showed a "coin de banlieue": a curving lane, unevenly surfaced; a fence made of weathered boards, entirely hiding whatever might be behind it; a tree with meager foliage; and part of a blind wall to the right. The sky was overcast. There was an abundance of ochre and gray. It was by somebody called Utrillo.

The name meant nothing to me: I was nineteen then and didn't know much about painters. But I stood looking at the Utrillo painting for a long, long time—and the more I looked, the less clumsy it seemed. It was as if I could walk along that dismal lane, along that old fence which would surely be followed by another one no less ugly, no less secretive. All the dullness and drabness of the northern banlieues of Paris oozed from this picture.

I had grown up in such a banlieue, disliking it. When the German army occupied France, my family and I fled south as far as we could go, seeking the "safety" of Nice, in Vichy-France. I enjoyed the light, the palm trees, the blue Mediterranean, the gaily colored houses. But now, looking at the Utrillo, I was overwhelmed by nostalgia—a nostalgia I didn't understand because it was for something so sadly ugly.

When I tore myself away from the contemplation of the painting and climbed back on my bicycle, I discovered I couldn't see properly because my eyes were full of tears.

To this day I cannot explain those tears. Was the cause objective: the evocative, slightly childish style of the painting? The absence of "beauty," caught by Utrillo's almost photographic eye? Was it subjective: the unconsciously repressed feeling of being but a stranger, an onlooker in this lovely Nice which was not my home?

In the further course of my life my tastes in painting have developed. Among my favorites now are Botticelli, Gainsborough, Magritte, and Edward Hopper. Yet I have never cried looking at any of their works. I don't particularly care for Utrillo and I loathe primitives, so I don't expect to cry at their paintings. I didn't cry at Ryoan-ji (though I felt wonderfully at peace there); nor have I cried at Delphi or at Canterbury—and not even at the Western Wall.

It remains a mystery.

<div style="text-align: right">

Yours very respectfully,

Mrs. B. L. Libgott

</div>

LETTER 2

The second war story. This one reveals that even Hemingway had a soft spot for sentimental pictures.

August 13, 1997

Dear Mr. Elkins,

In 1944 in May, I was aboard ship conveying war materials from New York to Great Britain. I was serving on a Canadian Corvet.

On this particular trip we arrived in New York from overseas in the early part of May. We had three days' shore leave before we would again leave New York with a convoy to Great Britain. My buddy and I went ashore the first day and ended up at the Gladstone Hotel in downtown New York. How we ended up there I cannot really recall. In any event, we had several drinks at the hotel and were just going to leave when Ernest Hemingway came into the hotel lobby. I easily recognized him and in fact had read all of his books that had been published to that date.

I approached Hemingway warily as I had heard of his so-called bullying tactics, but when he recognized our Canadian Naval uniforms he insisted that we all have a drink together. He said that one of his sons had served in the Royal Airforce. We of course agreed to go for a drink and we went to a bar on Third Avenue called Costellos, or some similar name. When we arrived at this bar there were several people who knew Hemingway and greeted him enthusiastically. We all went into a dining area of sorts, and there was a large amount of food eaten and many drinks consumed. In fact, we were all certainly in a very happy frame of mind.

When we had entered the dining area I had noticed several wall murals or paintings and during the meal and the imbibing, Hemingway pretty well dominated the conversation (which of course pleased me) and referred to these drawings on many occasions. He seemed to be drawn to some aspect of them that deeply affected him.

I do not know how long this memorable meal went on, but for a young sailor from Canada who had read Hemingway's books, this was indeed a heady experience. In any event, when the party broke up, Hemingway, who had certainly consumed his share of potables, pointed to the murals on the dining room walls and said, "These make me very sad, and I am going overseas again in a few days." With that he began to weep uncontrollably and was, for a few minutes, inconsolable. We were all rather embarrassed, and

everyone commiserated with him; and within a few minutes he was all right. He then said, "For one reason or another those pictures make me very sad." I asked the party—now fifteen or sixteen people—about the murals. They were surprised that I did not recognize them as being the work of James Thurber.

<div style="text-align: right">

Yours very truly,

Edward A. Graf

</div>

LETTER 3

From a woman who wept because real art wasn't as good as a movie.

Dear Mr. Elkins,

I first saw Piero della Francesca's *Nativity* in the National Gallery in London forty years ago. Other than slides or book illustrations, it was the first time I'd seen an actual painting by Piero. I cried immediately and thought, "My God, this painting has a silver glow!" When I was an undergraduate at Cornell, Piero was first brought to my attention by an architecture student— a beautiful boy to whom I was inordinately attracted. Together we admired the artist's sense of "detached monumentality," his "architectural compositions," and his "cool remoteness." "If Mies Van der Rohe had painted, he would have been Piero," etc. etc. etc. This boy was remote—much like my father, remote, larger than life.

In Ithaca in the '50s, I watched a black-and-white film about Michelangelo, called *The Titan*. It is a beautifully photographed short biographical film, showing his life through his works. I cried intermittently throughout the entire movie—overcome by the power of the sculpture (I *never* did like his painting), especially the bound slave series, and the pietàs. Swore I'd return to Florence after graduation. I did. There I nearly wept for despair. The statues were not as great as the *photographs* of them! Without the benefit of carefully orchestrated lighting and a moving camera which created chiaroscuro that notably enhanced the work, it actually suffered by comparison. Had I *first* confronted the bona fide Michelangelo in Italy, even with good lighting, would they have swept me away??

Mr. Elkins, I love your topic—and will surely buy a copy of the book after it's published, providing, that is, that you use a decent printer (Japanese or Swiss perhaps), so that the illustrations are of such high quality as to drive one to tears.

Good luck,
Kristina A.

LETTER 4

Part of a letter written about an encounter in Budapest. The ellipsis (...) is in the original letter.

Dear Dr. Elkins,

Q. Did you ever weep in front of a painting?

A. Yes. The word *szép* in Hungarian is the same as the Dutch word *mooi,* and I think the English word is beautiful, fine, or nice ... On a cold autumn morning in the museum of art in Budapest, I found myself crying (or weeping) while I was looking at a painting. It was a Madonna with a Child, by El Greco. In the room a guard, seeing me, smiled and nodded.

"Szép-szép," she said, quietly and sympathetically. (It's pronounced "s-thaip.") "Szép" is the only word I know in Hungarian; I have friends in Hungary who have that name and are from a town called Szép. I don't remember this just because of the word *szép,* but because of the feminine gesture of understanding that the guard made when she said it.

<div align="right">Gré Bravenboer-Beekenkamp</div>

LETTER 5

From a man who cries at Kiefer, and claps at Rothko.

Dear James,

I'm not one who cries easily over a painting.

Paintings are somehow distant. But I remember some that did make me cry; they were at an exhibition of Anselm Kiefer's work in the Stedelijk Museum in Amsterdam, about ten years ago. "Paintings" may not be the right word for these vast tableaux made of zinc sheets with earth, straw, glue, and rivulets of molten lead and stones tied on with iron wires. They were overwhelming, and there were names of German towns and historical figures painted on them.

It is one thing to look at one of Kiefer's paintings from a distance. With every step that takes you closer, you see a new painting, right up to the moment when your nose is up to the surface, and you see straw or a glittering particle of sand.

I cried. At the time I didn't know why; it had something to do with the war, and with the charred, burnt-up books in the next room. It was only when I read Simon Schama's book *Landscape and Memory* that I understood that what had moved me was the connection Kiefer makes between history and the "guilty landscape" of Central Europe, which witnessed the destruction of six million Jews and hundreds of thousands of soldiers. Kiefer managed to solidify the sorrow that is inherent in nature—that cruel perpetual force that carries us on, willy-nilly.

A question comes to mind, however. When does one clap for a painting? We clap for actors, dancers, and musicians, but we never clap for painters. Is it because they are not there, because they are represented only by their work? Or is the act of viewing a work of art too private, even though there might be a couple of dozen people looking at the same painting, and maybe even sharing the same feeling?

I do remember wanting to clap for a painting. It was in New York, probably in the Museum of Modern Art. I walked past a recess, and as I passed by I had the feeling something had pushed me. It was akin to the feeling you have when you're snoozing on a train, and you suddenly have to open your eyes because you feel someone is staring at you. In the recess there was a painting by Mark Rothko, a reddish area in a dark surrounding. Its presence was so unmistakable, I nearly wanted to step forward and warm my hands on it.

That was when I lifted up my hands in an involuntary gesture, because I wanted to applaud. But I immediately felt ridiculous, and refrained. The sound of two hands clapping does not go well with paintings.

Rob Klinkenberg

LETTER 6

This is written by a painter who is moved by the objects themselves: the colors, the paint, and even the nails that hold the canvases to the stretchers.

Dear Dr. Elkins,

First, I want to note that I very, very seldom cry over or about or behind or in front of anything, though I think I would be healthier if I did!

My first experience occurred last February in Washington, D.C., at the National Gallery, at the New Wing. My husband and I first went to the little room of small French paintings, most, I think, by Vuillard.... Then I went to the two small rooms of Rothkos and Diebenkorns, and it was there I began to feel like crying, and almost cried, so that the guard asked if I was all right. Looking at those paintings was terribly exciting and moving. I was seeing things I hadn't seen before, I think, and I was experiencing them both as designs and as objects—paint on canvas stretched on boards. When I left those rooms I found a bench off by myself where I could sit alone, with my back to the room, and cry without being seen, which I did. In fact, I had to work at stopping crying and not crying through the rest of that visit. And I would almost cry again when I attempted to tell friends about this strange experience....

I saw them as paintings—as lines and washes and paint on canvas. I even counted the nails that attached the canvases to the boards. The works were so interesting as a record of the painter making them. But they were also fabulous design solutions in the way the Vuillards were—paintings to read and work in and through. The Rothkos were similar except that color primarily created the structure, the tensions, and the resolution.

One additional note. I don't know what the connection is exactly, but I have the sense as I try to make art that it demands great courage. I find myself always feeling the need to have more courage. When I cried in front of those paintings, I also did so in response to the painter's courage, because I felt the painter ... had been out on the edge, held it all together and made it work—and that may be the best explanation of what made me cry.

Sincerely yours,

Helen D.

P.S.: When the guard saw me crying, he commented that I was probably a painter because painters are more apt to cry looking at paintings. I took that, irrationally, as a compliment.

LETTER 7

From a woman who finds Rembrandt cramped and depressing.

Dear Jim,

Several years ago I visited the Rembrandt exhibit in Amsterdam, and the crowded gallery and the small, dark, gloomy pictures depressed me so much that I began to cry.

My crying was a response to 2 different elements of the exhibit.

1. The gallery was *very* crowded—I felt like I was at a County Fair viewing cattle, or maybe I *was* one of the cattle. This was especially frustrating because the pictures were so small.

2. THE PICTURES WERE SO SMALL—I felt like Rembrandt had created a tiny, closed world—I felt suffocated when I saw his pictures—they were so intimate that I couldn't fit into them. I felt shut out. The darkness of the pictures contributed to this. It was like looking into one of those Easter eggs that is hollowed out with a picture painted inside—you can scrunch up to get a glimpse, but all you can ever get is a glimpse.

I had anticipated this exhibit with a lot of excitement. I wanted so much to be allowed into a world of beauty or at least humanity. When I got there, I found Rembrandt's world hard to enter because of the smallness, and because his vision was dim—dark colors, dark lighting, subjects that were hard to reach. Very few of the pictures spoke to me, called out to me.

I felt emotionally Rembrandt resigned himself to a dullness of mind, of the world, that I found discouraging. There was no struggle with the darkness (like in Van Gogh) and there was no transcendence. The pictures depressed the hell out of me.

Amy K.

LETTER 8

From a famous, tearless, and unrepentant art historian.

Dear James Elkins,

Your next project on the Niobe syndrome (art historians moved to tears by what they are seeing) sounds most engaging; and I am intrigued to learn that the response to your questionnaire has been "overwhelming." For myself, I would rather not participate, even at the risk of confessing to a stony, unfeeling nature.

With warm regards,

Professor Gusztáv L.

LETTER 9

A slightly abridged letter from the art historian E. H. Gombrich.

Dear Prof. Elkins

Thank you for your letter of 28 Sept.

I see that you are going to disprove the passage in Leonardo's *Paragone* (33, fascicle 14), "The painter will move to laughter, but not to tears, for tears are a greater disturbance of the emotions than laughter."

To answer your question, no, I don't recall having wept in front of a painting, though certainly at the movies or reading a book.

I believe Oskar Kokoschka told me that he had shed tears in front of a Memling, if I remember correctly, seeing the naked feet in water, because he was so moved.

I have a confused memory of a painting (by Chodowiecki?) of Frederick the Great weeping on looking at the painting of "Calus Taking Leave of his Family." [Chodowiecki's picture of *Calus Taking Leave of His Family* is a typical eighteenth-century piece, and it is no wonder people cried over it. I couldn't find the painting of Frederick the Great crying over Chodowiecki's painting, but I can also imagine people crying over *that*.—J. E.]

By the way, I have spent a lot of time on the history of caricature, but hardly ever *laughed,* and barely smiled!

Yours sincerely,

E. H. Gombrich

LETTER 10

From Robert Rosenblum, an art historian who writes about nineteenth- and twentieth-century art.

Dear Mr. Elkins:

Your letter about "The Crying Game" takes me by surprise. Such an odd, but then, such a fascinating question. It elicits some soul-searching on my part, and I must end up confessing that, unlike Diderot's, my own lachrymal ducts have never responded to a work of art. On the other hand, if you're interested in physiology, I have truly gasped (jaw dropped, breath caught, etc.) from the sensation of what I guess we might still call Beauty, or some other kind of magic in art; and I distinctly remember the works that prompted this involuntary swoon: 1) Vierzehnheiligen, 2) Matisse's *Bonheur de Vivre,* 3) Ingres's *Baroness James de Rothschild;* and 4) Friedrich's *Monk by the Sea.* In each case, it was a response to my first view of the work. By the time of the second, I was already invulnerable. I suspect we art historians, in particular, wear too much armor; but thank you for suggesting that we might shed some of it.

Yours sincerely,

Robert Rosenblum

New York University

LETTER 11

This woman wants very much to cry in front of a painting. The most she has managed is "dry tears."

Usquert, 20 November 1996

Dear Mr Elkins,

I myself believe that crying in front of a painting is one of the best things a person can do! It could save you from having to see a doctor or a psychiatrist.

I guess that to a viewer, something is revealed that he had thought was forlorn or lost, or even impossible to experience. Not many people are prepared to completely open their souls or their minds when they see a picture. If they would, probably many more people would cry!!

If you *listen* to the words people *say* when they look at paintings, it's mostly things like ... "Oh, how wonderful!" (or something like that); or else they are just discussing the details of the picture, or trying to find out what the symbols mean, or other technical stuff. But if you can see the picture just for what it is, without restraining yourself, you might be overwhelmed by its beauty, which breaks all the resistance, and tears down all the walls between the object and the observer—even "inner walls." In that case it doesn't matter at all who the painter was, and you just forget him. For instance it doesn't matter anymore if the painting is by Van Gogh or Gauguin or Matisse ... the painter and the observer grow into one another. They are united, like Siamese twins.

I don't agree with what your colleagues say, that there's no relevant relation between emotional reactions and the works themselves. There surely is.

One thing I hope for myself is that I will cry, just once, seeing some special painting. I just cannot. When I visit galleries and museums, I feel bothered by the crowds around me. I hate to have to share all the beautiful paintings with other people. It's hard to feel close and intimate with the paintings when there are so many people around. I was quite HAPPY, though, seeing Vermeer's *Milkmaid* in the Rijksmuseum in Amsterdam a few years ago, on a Sunday afternoon with only a few people around. The canvas is hung in the same room as Rembrandt's *Night Watch*. My husband was explaining the painting to my little daughter (she was eight at the time), telling her how he had painted his own portrait in the picture. So in the meantime I

looked at Vermeer's *Milkmaid*. It is such a lovely painting I remember hav-ing had "dry tears." Nobody bothered me; no one was around to see.

Landscapes, early in the morning or in the evening at dawn, can make me cry instantly. So if it happens to me in front of a painting, I will write you again. I believe that it is a normal thing to be deeply touched by paintings, and that you can't hold back your tears. And you should never try to.

<div style="text-align: right">

With kind regards,

Matilde W.

</div>

LETTER 12

This art historian proposes that art history is a "soft" discipline, so we have to be especially self-controlled and serious.

Jim—

I have been musing on our correspondence re dry-eyed art historians. And, as usually happens when I muse, I have gone in two directions.

Path 1: I cry much more at novels and films; and I think that it is because of the narrative pull over time. And, I confess, the less artful the novel, the more likely I am to cry.

Path 2: Art historians are embarrassed to admit that they *have* cried before paintings. My dissertation advisor eons ago confided to me that he had cried when first seeing the Breughel collection in Vienna, because he saw them in the still-bombed-out museum. The entire scene really overpowered him. He told me this as we were discussing why it was art historians never "went public" about the preference for "quality." Now, why don't we? Is it because art historians were mostly men operating in a suspiciously "feminine" field, and they had to look tough? Art history, as a very "soft" area of study, was trying to look more "objective" and therefore more scientific; could it be that saying, "I like this work to the point of tears," made us sound too much like critics? Are we just prigs?

<div align="right">Joan L.</div>

LETTER 13

From a historian who will look seriously only at a work that has moved him.

Dear James Elkins,

I have sometimes been moved emotionally on encountering great art in public places, in Rome or in the Italian section of Washington's National Gallery. It always involved figures, faces, and eyes—all eternally lonely, but friends to whomever is able to share their thoughts with the artefact and the artist.

But I clearly recall one occasion, when I was traveling in the U.S. It was a Persian watercolor that did it. I think I was in the basement of the Worcester Art Museum in Massachusetts. The painting described a weeping man in plain lines; I couldn't read the accompanying Farsi text, but to me the painting was about love, about love at an age when one ought to be wise. Considering his beard and belly this man must have been over fifty years old and could barely stand upright. It seemed that someone was pushing him over. Obviously the scene matched my own state of mind and loosened up memories of so short a time ago. But that is another story.

I believe that even in ancient times, when art was meant to please the extraterrestrials, the gods, it was made "sol per sfogar il core," only to vent the emotions, as Vicino Orsini put it in 1552. Sometimes art does this to me. It is then an intimate meeting.

Inevitably this viewpoint has consequences. I apply it to all styles and all periods, in order to come to terms with a piece of art, to measure my relation to it. What doesn't measure up I consider an exercise.

Sincerely,

Martin Hesselbein

LETTER 14

This is not a letter, but an entry in the visitors' books for the Rothko chapel, Houston.

January 1985

This is where it stops. Depthless.
Time out.

[Unsigned]

LETTER 15

A very reflective letter by a woman who cried because art helped her remember who she was.

Dear sir,

In 1967 I visited Florence for the first time, with other students from the University of Amsterdam. We all had to research a work of art; mine was the Medici Chapel. So I knew Michelangelo's sketches and plans, as well as his sculptures. Because I was very young, everything in Florence made a big impression on me, and especially the Medici Chapel.

But when I was there again in 1984, 17 years later, I realized that the chapel had stayed completely unchanged during all those years, years in which so many things had happened. And that it had not changed in all the centuries since Michelangelo created it. As if time stood still there. I remember the stillness in there. I remember that I felt very much "at home."

After an hour I left the chapel, crying. My husband was puzzled and asked why I cried, and I stammered, "It is so beautiful."

At such moments I know that I am experiencing what life *in reality* is all about. Time stands still, or does not exist. A certain stillness, while I am moved emotionally at the same time. A feeling of being touched, of great happiness. Being home. To me it seems that this is the real purpose of art: to attract you to your very self by breaking certain barriers (isn't crying just a melting of the heart?), by way of a certain harmony. To unite you with who you really are.

This brings me to an essential point I would like to make: art is a matter of the *heart, not* of the head. Only if you take it by heart, only if you are involved completely, can you say that you know anything about it. You can write pages and pages without really knowing, or saying, anything. A real artist, like Michelangelo, or Mozart, or Beckmann, *knows*.

With kind regards,

Mardien Abeling

LETTER 16

From a well-known psychoanalyst (the letter is edited to protect his identity, at his request).

Dear Mr. Elkins:

Around 1971, during a time of considerable personal stress and sadness, I was in San Francisco, I recall, and visited a museum. I paused in front of a fairly large painting by Bonnard. It was the view he often painted, of a spectator looking out through a window. Suddenly I found myself crying, rather overwhelmed by intense sadness.

Later on, collected, I thought about the experience, and even though I am a psychoanalyst, the best I could come up with (and I'm comfortable with my interpretation) is that the utter serenity and harmony of the painting so shockingly contrasted with my own inner turmoil that it became a devastating experience.

I think you are onto something fascinating, and I wish you good luck in your research.

Sincerely,

Werner D.

Prof. Emeritus of Psychiatry

LETTER 17

This letter is not unlike the previous one: both writers feel some paintings are too perfect to bear.

Dear James Elkins,

Responding to your provocative inquiry ... I can report one such occasion only. In the interest of absolute accuracy, I confess I don't recall if tears were actually shed or if, rather, I felt close to tears but restrained them, to avoid the predictable embarrassment that accompanies crying in public.

The painting was Goya's *3 May 1808,* displayed at the San Francisco Palace of the Legion of Honor, about fifteen years ago. Though I had seen and admired reproductions of this work many times, no reproduction had prepared me for my overwhelming experience of the original. I stood before it for ten minutes or more, feeling rooted to the spot, as if mesmerized, unable to move, or even to see the other paintings in the exhibit.

In retrospect, I can say with assurance that my repressed tears had little to do with the horrific nature of the scene. Rather, what moved me was simply being in the presence of a creative act so close to pure perfection as to seem an impossible achievement—and yet there it is: someone has actually *done* it: a human being can do *that!* Possibly others have had the same reaction watching Neil Armstrong step onto the moon.

Good luck with your book,

Wendy D.

LETTER 18

From a woman who was moved by a painter famous for his lack of emotion.

Dear James Elkins,

Here's my story. Some years ago my husband and I went with friends to an exhibit of paintings by Joseph Albers at the Guggenheim Museum in New York. His work has never been a special favorite of mine, but I love looking at just about everything. As we wandered along the curving ramp, my husband and two friends got ahead of me, and as I stood looking at the next painting, I began to cry. It felt totally unintentional, and for a few minutes, unstoppable. Some of the others came back and saw what was happening—and I remember saying "I don't know *why* ... there's something so powerful, sort of wrenching in that painting.... "

It wasn't a bad feeling, but very amazing. The colors, as I remember vaguely, were mostly blue and green, sort of an uneven square within the rectangle of the frame. There was *tension* there.

Sorry, I can't remember the name of the work—though I thought I always would!

Helen A.

LETTER 19

From a novelist, recounting his fifteen-year obsession with a painting.

Dear Prof. Elkins,

I can think of works of art which *should* move people to tears: Albert Pynkham Ryder's *The Racetrack* in the Cleveland Museum of Art, a childhood nightmare given overwhelming adult ferocity; or Vuillard's *View of the Artist's Studio* in Milwaukee, a glimpse from a former happy life of contented work, now permanently exiled. (Or, in certain moods, Joseph Cornell's entire life's work.)

But from all my years of museum haunting, I can retrieve only one sure occurrence. I first saw Van Gogh's *Olive Trees* at the Minneapolis Institute of Arts in 1975, during a day trip with my family. This was painted on the 28th of September 1889; it is one of the large assertive canvases done during his stay at Saint-Rémy at the end of his life.

When a friend moved to Minneapolis in 1978, I gained not only an alternate home, but the chance to encounter firsthand, over and over, a painting I instinctively felt was mine. During each one of the sixteen or seventeen trips I made in the ensuing years, I never missed a viewing save when it was on tour in 1990. The next autumn, both of us were in our respective place again, and I couldn't help thinking back on my first sight of the painting, when I was with my family. I thought, too, about the several friends I had discussed the painting with, and the anguish and triumph Van Gogh was undergoing in that period, out of which he summoned the spirit to send us this image of another world across a century. Though I did not know that circumstances would prevent my seeing *Olive Trees* face to face again, I found I had to wipe tears from my face.

Yet familiar as I had grown with the painting, years passed before it occurred to me that something about the painting was skewed. A character in a novel I was writing was obsessed with the picture, and at the end of the book, as she floated in a canoe down the St. Croix River in Minnesota, it suddenly became clear what was wrong with the picture. In her words:

> It portrays two distinct times at once,—predicts its own future, reverts to its past. Note that high above the cool lavender mountains, the blazing late-afternoon sun stands due west; but the actual light source casts tree-shadows that slant in from the left, the southwest, off the canvas, from autumn ... —Moral

light, thrown from a differing angle, a different source: where daylight would fall, later on in the year, once this tangible season was history. (From *An Unfinished Life*)

<div style="text-align: right">

Sincerely yours,

Warren Keith Wright

</div>

LETTER 20

From a woman who had the wind knocked out of her by a Pollock painting.

Dear James Elkins,

I can remember specific instances of feeling punched. I certainly did the first time I saw Picasso's *Girl with a Mirror* and Van Gogh's *Starry Night,* there in their stairway at the old Museum of Modern Art the first time I went to New York, as well as with the big Pollock in the new Museum. In the first case, it was because I had used the painting in reproduction for a lot of studies in a drawing class (I'm from California, so everything was in reproduction, just about) and when I saw it I didn't recognize it at first—it was such a shock of non-recognition.

Similarly with the Pollock, but that time I had written exams on Pollock with what I thought was some confidence, but without ever having seen a real one, and then I walked into that big room, through the back door, I guess, as the painting was hung to confront the viewer head-on and I didn't even see it until I got across the room and turned around and POW! I had to sit down on the floor, pow. Everything I had ever written, that I had been taught, etc., was wrongheaded, and that painting was the absolute evidence of it—all I had to do was look at it to see that. I was overwhelmed.

But not overcome.

Elithea Whittaker

LETTER 21

The young critic John Ruskin writes home to his parents during his first trip alone to Italy. This is the beginning of a long letter.

24 September 1845

My Dearest Father,

I have had a draught of pictures today enough to drown me. I never was so utterly crushed to the earth before any human intellect as I was today, by Tintoret. . . . He took it so utterly out of me today that I could do nothing but lie on a bench & laugh.

LETTER 22

This is also part of a longer letter, with several stories of crying—at Rembrandt, Breughel, and Vieira da Silva.

Dear James Elkins,

I have some stories. Plural, because, well—who cries only once?

One pertains to two paintings: Jacques-Louis David's *Portrait of Madame Récamier*, and René Magritte's *Portrait of Madame Récamier*. Although I have never seen them together, when I first saw the David, I was stopped short by her gaze, the sense in the painting of the "stilled beyond." When I later came on the Magritte, my mind's eye brought them into a kind of resonant reciprocity. Each stands alone, but the latter is, of course, illuminated by knowledge of the former. I thought of beauty's ineffable brevity, its transfiguration, and the permanence of dust: "thoughts that lie too deep for tears." There is something infinitely moving to me in Mme. Récamier's gaze. If it had appeared as innocence (something trite), or as erotic invitation, or as a sly tease, then David would only have achieved a magnetizing vision of loveliness. But it is our sense of her agelessness, the stilled grace with which she bears her knowledge (that we all return to dust), that enlarges the painting. I love her grace, her elegance, the way her face is turned to something past the viewer; and I love her foot, which is poised, perhaps, to step down and rejoin the passage of time. In her, I wept for the loss of myself.

Magritte's painting does not have the power to stir tears. To evoke emotion, yes: but objectively, intellectually. Magritte's painting is amplified and extended when it is taken in along with the *thought* of David's painting. Those who think Magritte's painting is simply a parody are mistaken. *This is what beauty comes to, this is what we all come to,* it says. Magritte gives me a sense of the resonance of objects, and how they will endure even when we do not. So it gives me the impression of a cacophony of voices. Of time. Brevity. Loss. And finally, tears of impotence.

Best wishes,
Sandra Stone

LETTER 23

A sad letter, from a woman whose life has recently become lonely.

Dear Mr. Elkins,

In late May of this year, I went alone to Florence for a week, having last been there in the fall of 1958. I believe it was in the Academy Museum that I saw a painting, the right panel of a triptych, the center of which is in Munich. Filippino Lippi (1457–1504), son of Fra Filippo Lippi (1406–1469), had painted a standing image of Mary Magdalen, a mature woman in sack cloth with lots of long, dark hair. Her attitude and expression conveyed to me unassuageable, loving grief, and I immediately began to cry. No other painting has called forth that emotion.

I attribute my crying to the image's reawakening the sadness I experienced for about two years on each occasion when two of my friends died. First was my friend since 1940, Philip Lin, who died following a liver cancer operation August 6, 1989; and the other was my friend since 1938, William Arrowsmith, who died suddenly of a heart attack on February 20, 1992.

I had not expected to live in a world where these persons were absent. Their deaths changed everything even though they were not friends with whom I was in frequent contact.

Why Filippino Lippi's work affected me as it did I can't say. I have studied art most of my life and find it inspiriting and interesting—art from everywhere. I am 74 years old and have lived an active public and private life. I live now on a farm 70 miles west of Washington, D.C., deep in a forest.

Diana Bird

LETTER 24

My favorite letter, of all the ones I have received.

Hello.

I cried in a museum in front of a Gauguin painting—because somehow he had managed to paint a transparent pink dress. I could almost see the dress wafting in the hot breeze.

I cried at the Louvre in front of Victory. She had no arms, but she was so tall.

I cried (so hard I had to leave) at a little concert where a young man played solo cello Bach suites. It was in a weird little Methodist church and there were only about fifteen of us in the audience, the cellist alone on the stage. It was midday. I cried because (I guess) I was overcome with love. It was impossible for me to shake the sensation (mental, physical) that J. S. Bach was in the room with me, and I loved him.

These three instances (and the others I am now recollecting) I think have something to do with loneliness ... a kind of craving for the company of beauty. Others, I suppose, might say God.

But this feels too simple a response.

<div align="right">Robin Parks</div>

LETTER 25

An account of a painting in Japan, and its mysterious cult following.

Dear Professor Elkins:

I saw your query about a history of crying in front of paintings, and it reminded be of an experience I had in Tokyo last April. I was in Tokyo for a week for the opening of a Warhol retrospective at the Museum of Contemporary Art (I had curated the film section of the exhibition), and on the last day I finally had some time to visit some museums. A friend of mine, the artist Yumi Domoto, told me about a new exhibition opening that day at the Nezu Institute of Fine Arts, which was displaying a number of treasures from its collection which had not been seen in many years.

Yumi told me that in this exhibition there was a painting of a waterfall which she had been waiting to see for twenty years: "The painting of the waterfall," she said, "is supposed to be God." I didn't know exactly what she meant by this (the waterfall is supposed to be God? the painting is a picture of God? the painting itself is God?), but I paid my $20 and went in.

Since it was opening day and a Sunday, the exhibition was extremely crowded with people who struck me as probably being something like the intelligentsia of Tokyo—an extremely well-dressed, distinguished-looking, older crowd with many women elaborately dressed in traditional kimonos. I walked through the museum, looking at the various ancient works displayed behind glass, all of them hard to see because of the crowds of people in front of me. Finally I found the famous painting of the waterfall, which I could hardly get close to at all, since there were so many people around it. Although I couldn't look at it closely, the painting did strike me as quite beautiful—a faded gold landscape, with a faintly luminous white waterfall descending through it.

But more amazing to me was the behavior of the people looking at this painting. There was a crowd of people four or five deep pressed up against the glass wall in front of the painting, and pressed up against each other, all of them gazing in silence at the painting, and almost all of them weeping. No one moved; it was as if the normal movement of gallery-going just came to a complete stop in front of this work of art, and became instead something like an overwhelming religious or spiritual experience. There was nothing peasantlike or simpleminded about this crowd; they struck me as very intelligent and well-to-do people, probably university professors and

the like, much like the crowd one would see at the Metropolitan in New York on Sunday. And yet I was totally unable to imagine a crowd of New Yorkers behaving in such a manner in front of *any* work of art, no matter how famous or impressive it might be.

I was left with the conviction that those people did feel that the painting was, in itself, God, not just a picture of God. I know very little about Japanese culture or Japanese art, and don't know any Japanese at all—so this experience remains somewhat mysterious to me. I am enclosing a photocopy of an illustration of this painting from the Institute's brochure; it is identified only as "Nachi Waterfall, Kamakura period." If you happen to uncover any further information about this work, I'd be curious to learn more about it and its history.

With best wishes for the success of your project.

Sincerely,

Angela C.

LETTER 26

This woman says people cry at paintings because they recognize something in the painting—even if they have never seen it before.

Hilversum, The Netherlands

Dear Mister Elkins,

My friends say they have never seen anyone cry in front of paintings. But the truth is that I happen to cry sometimes. I am a woman and an art historian. The first time it happened was with a pastel by Odilon Redon in the Petit Palais, without any apparent reason, fifteen years ago. Of course if one cries in a museum one tries to hide this, which might partly explain the rarity of the phenomenon.

Although crying because of music is generally much easier and more socially accepted, crying because of paintings does occur, and for a different reason. I think people cry at paintings because of a sense of recognition, even if they have never seen the pictures before. There is a sudden total identification, which makes time stand still and city noises hush, and makes one dwell within the picture—at least as long as one doesn't attract the attention of other visitors or guards. It is the recognition of something similar, the experience of being part of it, and maybe even a feeling of grace, a moment of unforgettable happiness.

Wishing you luck with your research and lots of childlike open-mindedness toward the real arts,

Mary Muller

Letter 27

Another entry from the visitors' books at the Rothko chapel.

Rothko Chapel—

Horror! gigantic almost black "paintings" commissioned for this "chapel," displaying the Bible alongside the Torah and other religious books. Even the stone floor is bleak. Olivia says the artist committed suicide. I could not worship here, except to praise God that I am not caught in this gloom and despair. Enclosed in a place of murky light, an eight-sided room with four benches placed in a square.

Lord God there is so much more to celebrate. Sylvia loves this place— regards it as saved. She is falling further off....

[Undated and unsigned]

LETTER 28

Another entry.

January 2, 1982

I can hear.

C. E. S.

LETTER 29

Here the idea is that looking into paintings is looking for God.

February 1, 1988

Dear Mr. Elkins:

The *point* is: you look at the paintings, you scan the canvas surface for something concrete, visible, some touchstone to hold onto amid the rushing wave of color. Pushed to the limit, you find solace in the *texture* of the painted surface, the brushstroke, the running paint, the *lines* surrounding the panels.

This comfort is difficult to see, you see it and yet perhaps it is not there, perhaps you were imagining. Rothko's idea is that this uncertain grasping for visual markers *is* equal to RELIGION: that is, searching for some proof of God in the face of a dark and powerful, uncontrollable world—where the final end is Death—the black void that the paintings seem at first to represent.

And yet, just as there are glimmerings of hope in the world, so Rothko gives us *small, controlled* inklings of hope in the ever-so-slight variations of color, blotches, lighter zones—hope that we are *never* (*can* never be) sure of.

David S.

LETTER 30

Rothko's boast, as recorded by a neighbor.

June 1, 1982

Rothko lived next door to my family during the 1960s. He stopped by for a drink one evening after a trip to Rome. He was then at work on the murals. He had visited the Sistine Chapel in Rome, and he was greatly relieved.

"I am a greater artist than Michelangelo," he said. I can remember supressing a laugh at the time, but perhaps he was right.

[Signature illegible]

LETTER 31

For all the good intentions in the world, it is hard to see pictures openly and fully. I asked Tamara Bissell—the student who cried over Friedrich's painting, now a professional art historian—whether she would mind my using her real name, and telling some of her story. She wrote this in reply; it's a kind of credo of open-mindedness. She swears allegiance to her feelings, and vows to resist the dryness of art history:

Dear Jim,

Why not remember? Shoot, I would PAY for that again. It might renew my faith in the field.

I don't have any qualms about going on the record. I have utterly nothing to be ashamed of, nor do I find it acceptable that an art historian would be so loath to admit their being moved by an artwork. It seems to me that the fact that art can move us in this way is precisely why one should get into art history; others, I am led to understand, don't buy this, which distresses me. I knew, of course, that it wasn't "cool" to be caught doing this; after all, I was studying to be a "professional" art historical type person.

I know it was not received favorably by my classmates, and, well, I felt bad about it as anyone does when they are rejected for doing something "stupid" (or naive, which I think is the right word in this case) which they feel is fine, or even good. I did feel as if I had failed some essential test, and, well, I was wrong. Perhaps it all boils down to naiveté, or at least one's willingness to be surprised or moved. My guess is that too many people approach paintings with some sort of classification system at work, and they can't get back to when they were a little more open to seeing something new. By this, I guess, I mean a kind of childlike wonder, but I think that even erudite folks would be able to do this. This is possibly owing to art history itself, and the way in which the discipline has shaped us.

And so I think our loss of sensitivity is attributable to our "consumption" of art; we just don't look at it in the same way anymore. We just process it and "conquer" the concepts within. People ask, "Do you know that work?" as if you "get" it, you're in the club, so to speak. Not that you have experienced the work (or even seen it), and I think this is an important distinction. If you don't know the whole story about Duchamp's *Étant donnés,* well, you're just an unqualified viewer. And why *wouldn't* a "lay" person be intimidated by that? Everyone I know is. The only way my dad will go to

the art museum is if there's an evening mixer with a band, so he can see the art while everyone's gossiping and looking good. He can lurk and not be noticed, so he doesn't have to feel embarrassed that he looks at the wall text three times. And that he scratches his head and squints at it. He's trying. Nobody else is.

I mean, what the artist does is, really, magic, and I pity those who fail to see that. If paintings can't move people, then why are they important at all? Why do they sell for so much money? How did they become socially prestigious?

So I hope this is remotely helpful. I would appreciate any comments or questions at any time, and hope that your work progresses as smoothly as possible. So, until next time, best wishes.

Tamara

LETTER 32

And finally, a succinct letter from a colleague, a friend of mine and an art historian. The moral here is just to admit, every once in a while, that feelings get the better of us.

Tuesday, October 20, 1998

... I also got a bit choked up talking about going to the Van Gogh show. Now if that isn't kooky.

I shed a tear in one of the galleries—I was such a f*+#%^ cliché—I was overcome by his emotive color. Three paintings lined up together were just too much for me.

Add that to your book.

Mark K.

Sources

CHAPTER 1: *Crying at nothing but colors*

W. S. Merwin, from "Night Wind," *The Carrier of Ladders* (New York: Athenaeum, 1971), 74.

James Breslin, *Mark Rothko, A Biography* (Chicago: University of Chicago Press, 1993), 484. (Quote from conversation with Motherwell: 333; Breslin's theory about graves: 326; on deprivation: 267; on mortality, being in large paintings, smothering unity: 280.)

Robert Rosenblum, *Modern Painting and the Northern Romantic Tradition, Friedrich to Rothko* (New York: Harper, 1975).

Sean Scully, review of *Mark Rothko* (New York: Whitney Museum of American Art, 1998), and *Mark Rothko,* edited by Jeffrey Weiss (New Haven, CT: Yale University Press, 1998), in the *London Times Literary Supplement,* November 6, 1998, 4.

Anna Chave, *Mark Rothko, Subjects in Abstraction* (New Haven, CT: Yale University Press, 1989).

Leo Bersani and Ulysse Dutoit, *Art of Impoverishment, Beckett, Rothko, Resnais* (Cambridge, MA: Harvard University Press, 1993), 132, 140, 137.

Rothko's statements about ecstasy, etc.: Selden Rodman, *Conversations with Artists* (New York: Devin-Adair, 1957), 93–94.

Rothko's injunction to stand eighteen inches from the canvas: Teresa Hensick and Paul Whitmore, "Rothko's Harvard Murals," in *Mark Rothko's Harvard Murals,* edited by Marjorie Cohn (Cambridge, MA: Center for Conservation and Technical Studies, 1988), 15, and see Breslin, *Mark Rothko, A Biography,* 281.

CHAPTER 2: *Crying no one can understand*

Prince de Ligne, *Correspondance* (Paris: Mercure de France, 1965), 118, quoted in Anne Vincent-Buffault, *The History of Tears: Sense and Sensibility in France,* translated by Teresa Bridgeman (New York: St. Martin's Press, 1991), 41.

Proust, *In Search of Lost Time,* vol. 1, *Swann's Way,* translated by C. K. Scott Moncrieff and Terence Kilmartin, revised by D. J. Enright (New York: Modern Library, 1992), 294–95. The meanings of the sonata are explored in E. K.

Brown, "Expanding Symbols," in *Rhythm in the Novel* (Toronto: University of Toronto Press, 1967), 33–58.

George Crile, *The Origin and Nature of the Emotions: Miscellaneous Papers* (Philadelphia: Saunders, 1915).

Beaumarchais, *Essai sur le genre dramatique sérieux* (1767), quoted in Anita Brookner, *Greuze, The Rise and Fall of an Eighteenth-Century Phenomenon* (London: Elek, 1971), 35.

Studies of tears: see Cureau de la Chambre, *Les Characteres des passions* (Amsterdam: Antoine Michel, 1663); Helmuth Plessner, *Lachen und Weinen, Eine Untersuchung nach den Grenzen menschlichen Verhaltens* (Bern: Francke, 1961); Balduin Schwarz, *Untersuchungen zur Psychologie des Weinens* (Ph.D. diss., Munich, 1928); Charlotte Spitz, *Zur Psychologie des Weinens* (Ph.D. diss., Leipzig, 1935). Each of these is cited in Shiela Bayne, *Tears and Weeping, An Aspect of Emotional Climate Reflected in Seventeenth-Century French Literature* (Tübingen: Gunter Narr, 1981), 104–105 n. 1.

Rykwert on beauty: in the *London Times Literary Supplement,* November 6, 1998, 4.

CHAPTER 3: *Crying from chromatic waves*

Graziela Magherini, *La Sindrome di Stendhal* (Florence: Ponte alle Grazie, 1989).

Caravaggio and the Counter-Reformation: Helen Langdon, *Caravaggio: A Life* (London: Chatto, 1998); Catherine Puglisi, *Caravaggio* (London: Phaidon, 1998).

Samuel Clemens, *Traveling with the Innocents Abroad, Mark Twain's Original Reports from Europe and the Holy Land,* edited by Daniel Morley McKeithan (Norman: University of Oklahoma Press, 1958), 57–58.

Jonathan Turner, "That Swooning Feeling," *Art News* 88, no. 10 (1988): 150–53; Louis Inturrisi, "Going to Pieces over Masterpieces," *New York Times,* November 6, 1988, section xx, 43.

Henry Ward Beecher, *Star Papers, Or, Experiences of Art and Nature* (New York: J. C. Derby, 1855), 59. I thank Richard S. Lowry for this reference.

James Jackson Jarves, *The Art Idea,* edited by Benjamin Rowland (Cambridge, MA: Harvard University Press, 1960), 44. I thank Richard S. Lowry for this reference.

CHAPTER 4: *Crying because you've been hit by a lightning bolt*

David Lubin, *Act of Portrayal: Eakins, Sargent, James* (New Haven, CT: Yale University Press, 1985), 94. I have changed Lubin's singular constructions to plurals to avoid confusion with the woman who reported her encounter with the painting.

CHAPTER 5: *Weeping over bluish leaves*

Dante, *Inferno,* canto 33.

Millard Meiss, *Giovanni Bellini's St. Francis in the Frick Collection* (Princeton: Princeton University Press, 1964).

CHAPTER 6: *The ivory tower of tearlessness*

Shakespeare, *As You Like It,* 3.4. "Dressed in boy's clothes" added, from 2.4.

Erwin Panofsky, *Meaning in the Visual Arts* (New York: Doubleday, 1955).

Pierre Bourdieu, *Distinction: A Social Critique of the Judgment of Taste,* translated by Richard Nice (Cambridge, MA: Harvard University Press, 1984), especially the tripartite classification of artworks, from high to low, 16, 264, 339, 342, 350, 360, 362, and 526–27. I thank Greg Perry for this citation.

Curt Ducasse, *The Philosophy of Art* (New York: Dover, 1966). I thank Greg Perry for this reference, and for sharing his work on emotional responses to artworks.

John Dewey, *Art as Experience* (New York: Perigee, 1934).

Robin G. Collingwood, *The Principles of Art* (Oxford: Clarendon Press, 1938).

CHAPTER 7: *False tears over a dead bird*

Milton, "Lycidas," lines 12–14.

Orgasms in Greuze: Anita Brookner, *Greuze, The Rise and Fall of an Eighteenth-Century Phenomenon* (London: Elek, 1971), xv, 1, 154.

The Greuze girl: John Rivers, *Greuze and His Models* (London: Hutchinson, 1912), 1–3.

Critic who looked at Greuze for hours: Mathon de la Cour, *Troisième lettre à Monsieur **** (Paris, 1765), 3–5, quoted in Edgar Munhall, *Jean-Baptiste Greuze, 1725–1805* (Dijon: Davantiere, 1977), 104.

Diderot on Greuze: translation from *Diderot on Art,* vol. 1, *The Salon of 1765 and Notes on Painting,* edited by John Goodman (New Haven, CT: Yale University Press, 1995), 97–100. Original text: *Diderot, Salon de 1765,* edited by Else Bukdahl asnd Annette Lorenceau (Paris: Hermann, 1984), 179–84.

"Gift of tears": Voltaire, Letter to d'Argental 11 April 1767, in *Correspondance* (Paris: Gallimard, 1975), vol. 4; Vincent-Buffault, *The History of Tears,* 63.

Mlle. Aïssé, *Letters Portugaises de Marianne Alcoforado avec les réponses,* edited by A. Asse (Paris: Charpentier, 1879), 71, letter 14. Translation as in Vincent-Buffault, *The History of Tears,* 3. (Suffocating in tears: quoted in *The History of Tears,* 12–13; dampening the paper: vii, 7; friends embrace weeping: vii; the liquid economy of tears: 16–18; rhetoric of tears: 15.)

Louis Sébastien Mercier: *Mon Bonnet de nuit, suite aux Tableaux de Paris* (Paris, 1874), vol. 2, 131; as translated in Vincent-Buffault, *The History of Tears,* 45–46.

Baculard D. Arnaud: the quotation is from Élie Fréron, *L'Année littéraire ou suite des lettres sur quelques écrits de ce temps* (Amsterdam: M. Lambert, 1774–75), vol. 2, 195. Translation from Vincent-Buffault, *The History of Tears,* 5.

Tears of admiration, regret, and desire: reported in Clause Lambosse, *Lire au VII^e siècle, La Nouvelle Héloïse et ses lecteurs* (Lyon: Presses Universitaires de Lyon, 1985), 96, quoted in *The History of Tears,* 11.

Bayne, *Tears and Weeping,* esp. 71.

Abbé Du Bos and Diderot: both quoted in Brookner, *Greuze,* 50.

CHAPTER 8: *Crying because time passes*

Margaretta Lovell, *Venice, The American View, 1860–1920* (San Francisco: Fine Arts Museums of San Francisco, 1984), esp. 13.

Michel Poizat, *The Angel's Cry: Beyond the Pleasure Principle in Opera,* translated by Arthur Denner (Ithaca, N.Y.: Cornell University Press, 1992).

David Carrier: personal communication, September 25, 1996.

Mei Yao Ch'en, *One Hundred Poems from the Chinese,* translated by Kenneth Rexroth (New York: New Directions, 1956), 48, 50.

CHAPTER 9: *Weeping, watching the Madonna weep*

Hedwig Kenner, "Weinen und Lachen in der griechischen Kunst," *Österreichische Akademie der Wissenschaften, philosophisch-historische Klasse,* Sitzungsberichte 234, no. 2 (1960): 1–96, esp. 24.

Sandra McEntire, *The Doctrine of Compunction in Medieval England* (Lewiston, NY: Edwin Mellen, 1990).

Antony Abbott, *Patrologia cursus completus . . . series Graeca,* edited by Jacques-Paul Migne (Paris: J.-P. Migne, 1860 ff.), vol. 40, 994, quoted in McEntire, *The Doctrine of Compunction,* 15.

Gregory the Great: "extensam mentem compunctio poenitentiae ultione transfigit." In *Patrologia cursus completus . . . series Latina,* edited by Jacques-Paul Migne (Paris: J.-P. Migne, 1844–64), vol. 76, 275, as translated in McEntire, *Doctrine of Compunction,* 37.

Benedict of Nursia: quoted in McEntire, *Doctrine of Compunction,* 1.

Meanings of *punctum,* etc.: McEntire, *Doctrine of Compunction,* 82.

St. Francis, *Analecta Franciscana sive Chronica Aliaque varia Documenta ad Historiam Fratrum Minorum* (Florence: Quarocchi, 1941), vol. 10, 137, quoted as in Marion Habig, *St. Francis of Assisi* (Chicago: Franciscan Herald Press, 1983), 371.

Mary, "her face flowing with tears": in *Patrologia cursus completus . . . series Latina,* vol. 182, 1139; quoted in McEntire, *Doctrine of Compunction,* 120.

Andachtsbilder: Sixten Ringbom, *Icon to Narrative, The Rise of the Dramatic Close-*

Up in Fifteenth-Century Devotional Painting, second edition (Doornspuk, The Netherlands: Davaco, 1944), esp. 12, 48, 52.

Alberti: *Trattato della pittura,* edited by H. Janitschek (Vienna, 1877), 120.

When the Virgin seems to laugh: see for example a Pietà by Giovanni da Milano (Florence: Accademia), illustrated in Horst Janson, *History of Art,* fifth edition (New York: Abrams, 1995), 380.

Painters thinking about crying: Armenini, *De' veri precetti della pittura* (Ravenna, 1586), 188.

Michelangelo's remark: Francisco de Hollanda, *Four Dialogues on Painting,* translated by Aubrey Bell (Oxford: Oxford University Press, 1928), 15–16.

Michelangelo's tear-stained drawing: see the discussions in my *On Pictures and the Words That Fail Them* (Cambridge: Cambridge University Press, 1998).

Chapter 10: *Crying at God*

Thomas à Kempis, *The Imitation of Christ,* translated by William Creasy (Macon, GA: Mercer University Pres, 1989), chapter 21, "Sorrow of Heart," and opening of chapter 22. Translation modified.

Passage depicted in the *Navicella:* Matthew 14:31.

Biblical passages: Psalm 6:7, 41:4; Jeremiah 9:10, 4:28. Translations from McEntire, *The Doctrine of Compunction.* The other passages are Leviticus 9:24; Numbers 22:27, 22:31; Job 38:4.

Modern stigmata: Ian Wilson, *The Bleeding Mind: An Investigation into the Mysterious Phenomenon of Stigmata* (London: Weidenfeld and Nicholson, 1988).

John Ruskin: Letters of 23 and 24 September 1845, in *Ruskin in Italy, Letters to His Parents, 1845,* edited by Harold Shapiro (Oxford: Clarendon Press, 1972), 210–12.

John Rosenberg, *The Darkening Glass, A Portrait of Ruskin's Genius* (New York: Columbia University Press, 1961), 3.

David Morgan, *Visual Piety: A History and Theory of Popular Religious Images* (Berkeley: University of California Press, 1998).

Chapter 11: *Sobbing in lonely mountains*

The exhibition: *The Romantic Vision of Caspar David Friedrich: Paintings and Drawings from the U.S.S.R.,* edited by Sabine Rewald (New York: Metropolitan Museum of Art; Chicago: Art Institute, 1990).

Goethe, "Erlkönig," in *Johann Wolfgang von Goethe, Selected Poems,* edited by Christopher Middleton (Boston: Suhrkamp, 1983), in German on p. 86; my translation.

Joseph Koerner, *Caspar David Friedrich and the Subject of Landscape* (New Haven,

CT: Yale University Press, 1990), 233. (Emblems and the purgatory: 92, 20; God in a grain of sand: 16.)

CHAPTER 12: *Crying at the empty sea of faith*

Heine, "Ein Fichtenbaum steht einsam," translated by Aaron Kramer, in *The Poetry of Heinrich Heine,* edited by Frederic Ewen (New York: Citadel, 1969), 74, translation modified.

W. S. Merwin, from "Sunset after Rain," *The Carrier of Ladders* (New York: Athenaeum, 1971), 136.

Etienne Pivert de Sénancour, *Rêveries sur la nature primitive de l'homme* [1799] (Paris: Merlant, 1910), 142; as translated in Vincent-Buffault, *The History of Tears,* 100.

Wordsworth: quoted in Fred Kaplan, *Sacred Tears: Sentimentality in Victorian Literature* (Princeton: Princeton University Press, 1987), 41.

Obermann: Sénancour, *Obermann* [1804] (Paris: Éditions 10/18, 1965), letter 15, 92; as translated in Vincent-Buffault, *The History of Tears,* 103.

Sentimentalism, sentimentality, moral sentiments: Kaplan, *Sacred Tears,* 17, 60.

Thackeray: *Pendennis,* chapter 3, cited in Kaplan, *Sacred Tears,* 104.

"Water," in *Philip Larkin: Collected Poems,* edited by Anthony Thwaite (London: Faber and Faber, 1988), 93.

The wasteland and the abyss: Thomas Weiskel, *The Romantic Sublime, Studies in the Structure and Psychology of Transcendence* (Baltimore, MD: Johns Hopkins University Press, 1976), 22–33.

Book on absence in postmodern painting: Elkins, *How Pictures Die: Six Stories from the End of Representation* (work in progress).

ENVOI: *How to look and possibly even be moved*

David Freedberg, *The Power of Images: Studies in the History and Theory of Response* (Chicago: University of Chicago Press, 1989); it should be read along with Leo Steinberg, "Art and Science: Do They Need to Be Yoked?" *Daedalus* 115, no. 1 (1986): 1–16.

Philip II: José de Sigñenza, *La Fundación du Monasterio de El Escorial* (1605), section on the Royal Oratory, 380. The passage is quoted in Rosemarie Mulcahy, "El arte religioso y su función en la corte de Felipe II," in *Felipe II: Un Monarca y su Epoca,* exh. cat. (Madrid: Museo del Prado, 1998), 163. I thank Rosemarie Mulcahy for this reference.

Balzac, "Gillette, or The Unknown Masterpiece," translated with an essay by Anthony Rudolf (London: Menard, 1988), 30–31, and see Rudolf's comments on p. 47. (I have modified the translation.)

Georges Didi-Huberman, *La peinture incarnée: Suivi Le chef-d'oeuvre inconnu par Honoré de Balzac* (Paris: Minuit, 1985).

Index